D0782363

Charles Rosen

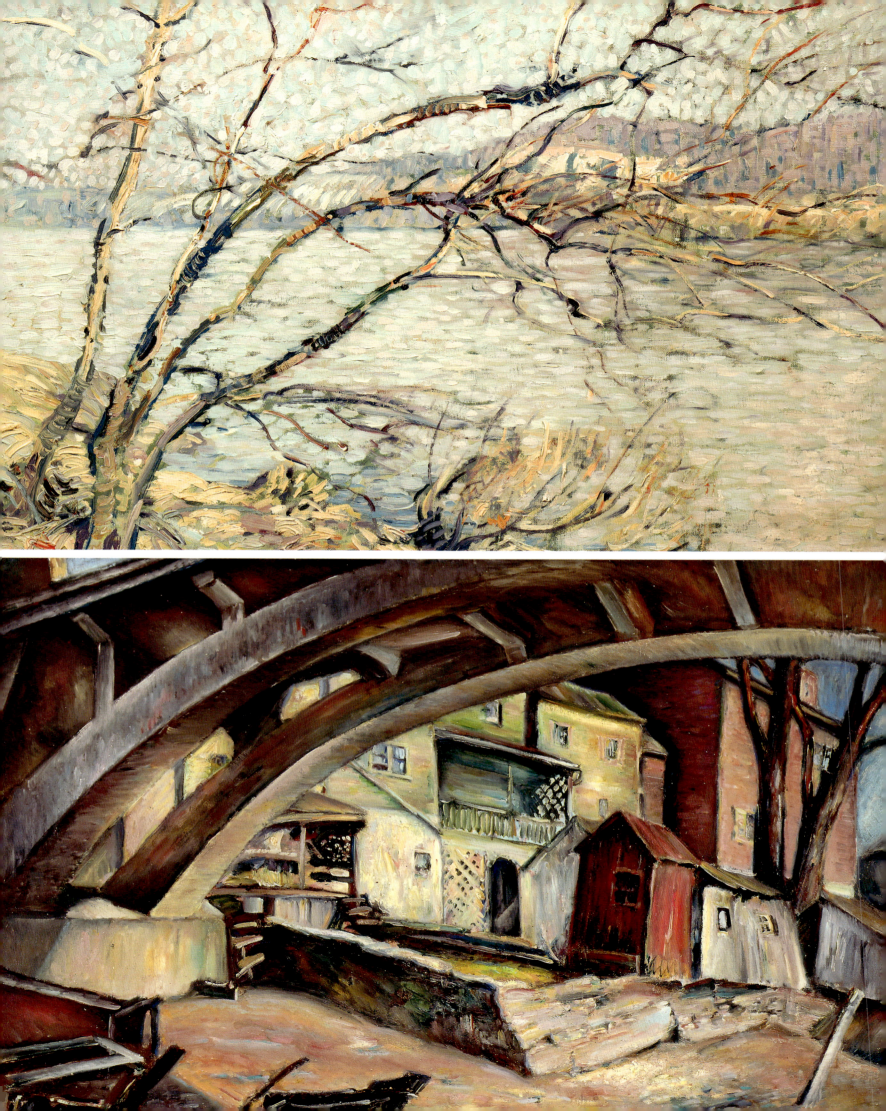

Form Radiating Life
The Paintings of Charles Rosen

BRIAN H. PETERSON

WITH AN ESSAY BY TOM WOLF

JAMES A. MICHENER ART MUSEUM
BUCKS COUNTY, PENNSYLVANIA

UNIVERSITY OF PENNSYLVANIA PRESS
PHILADELPHIA

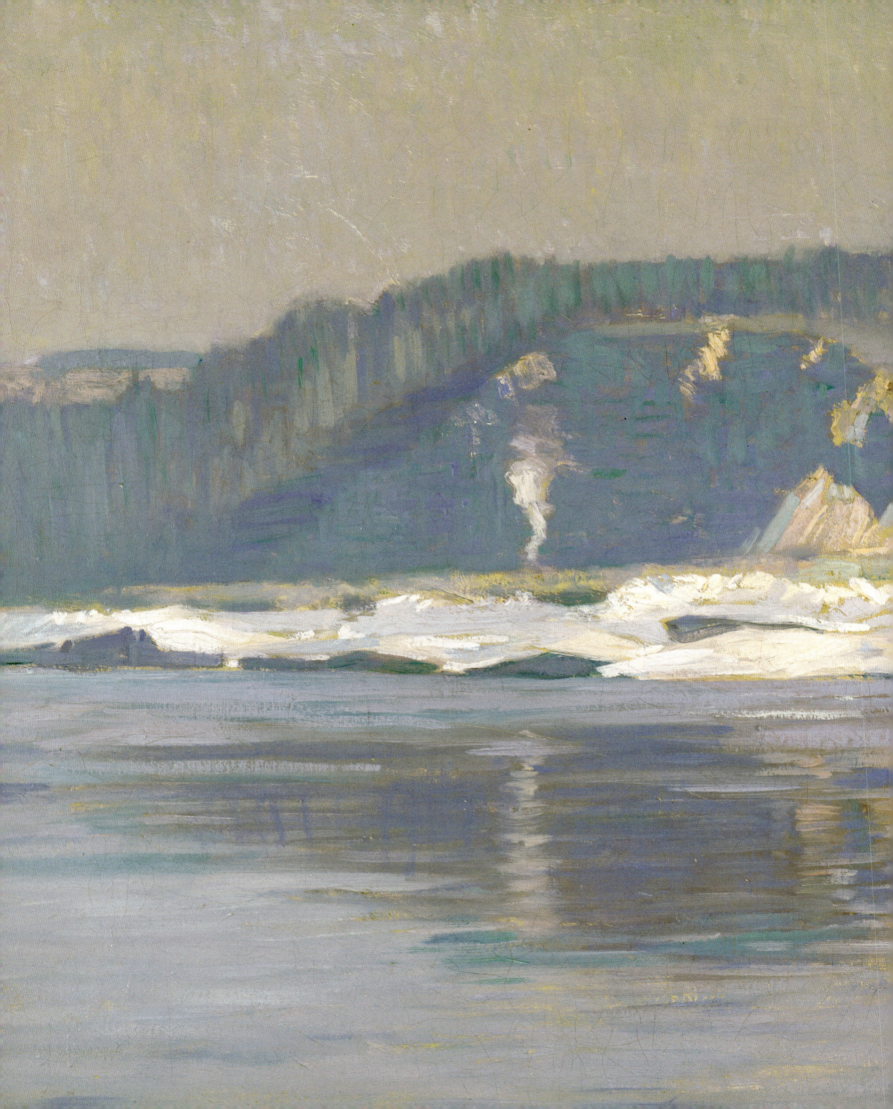

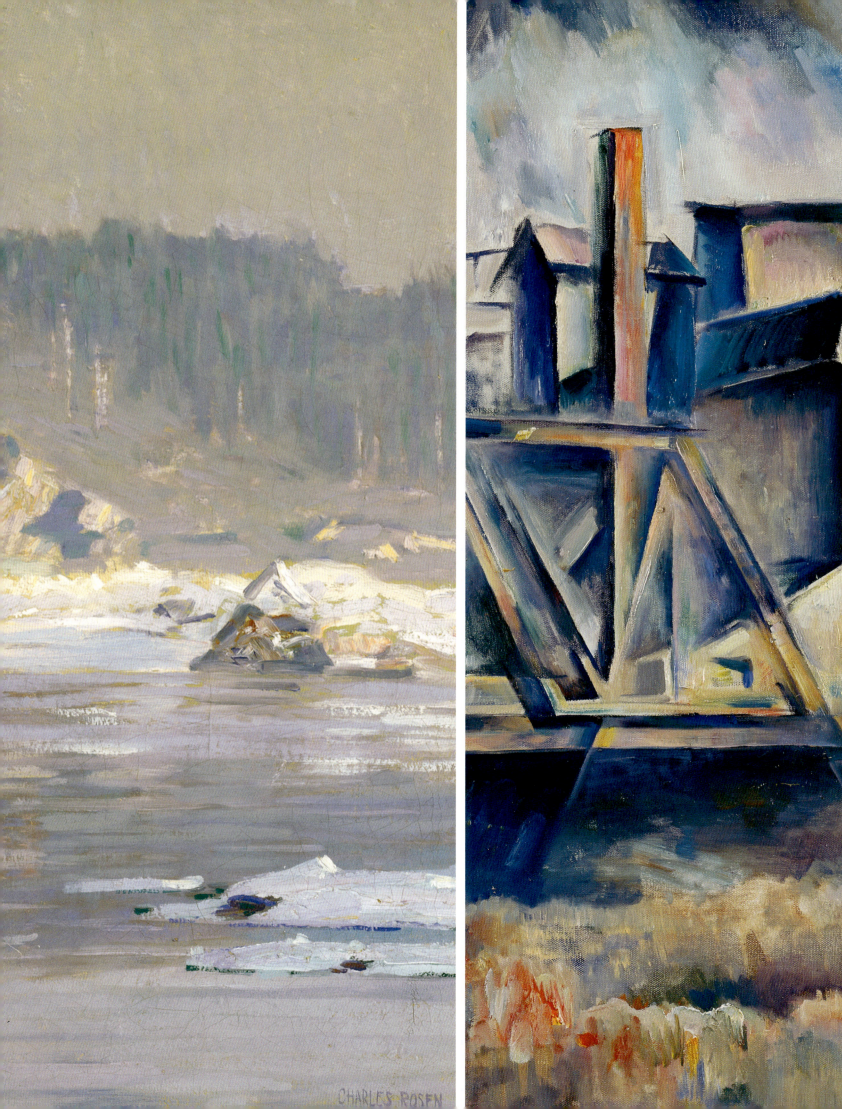

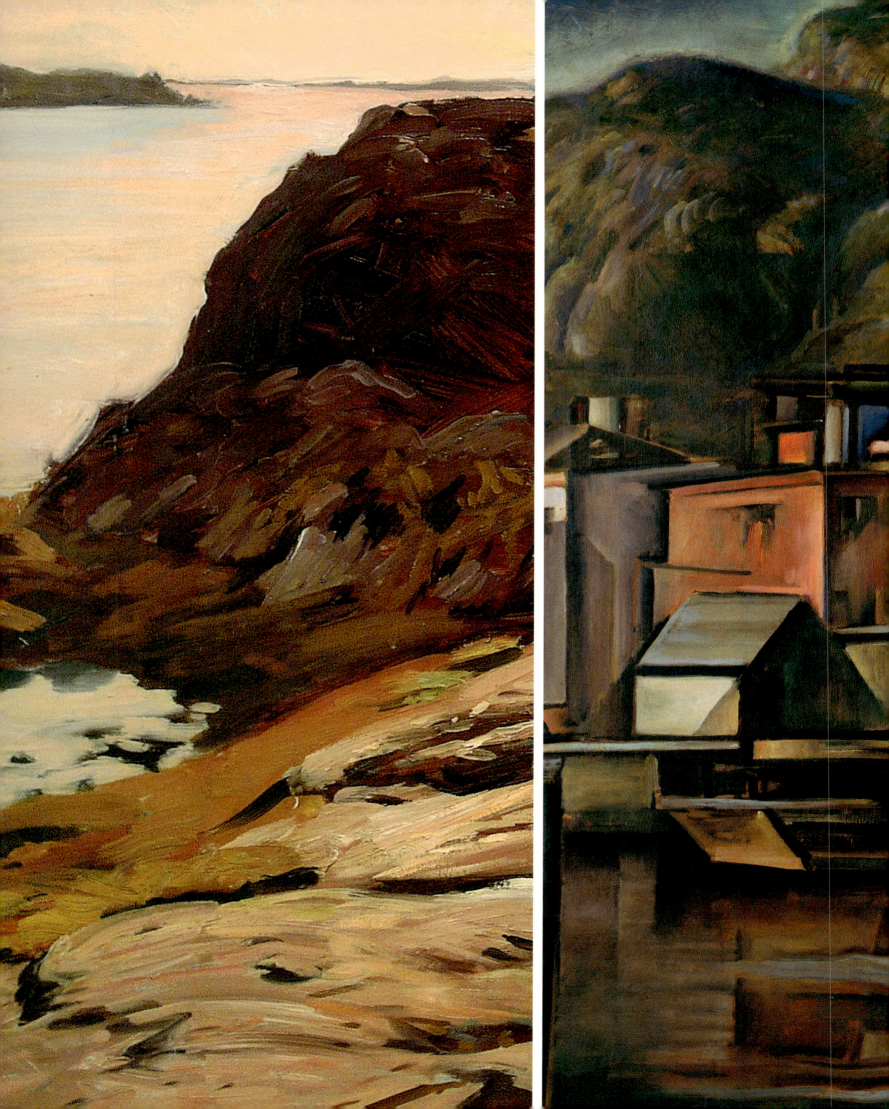

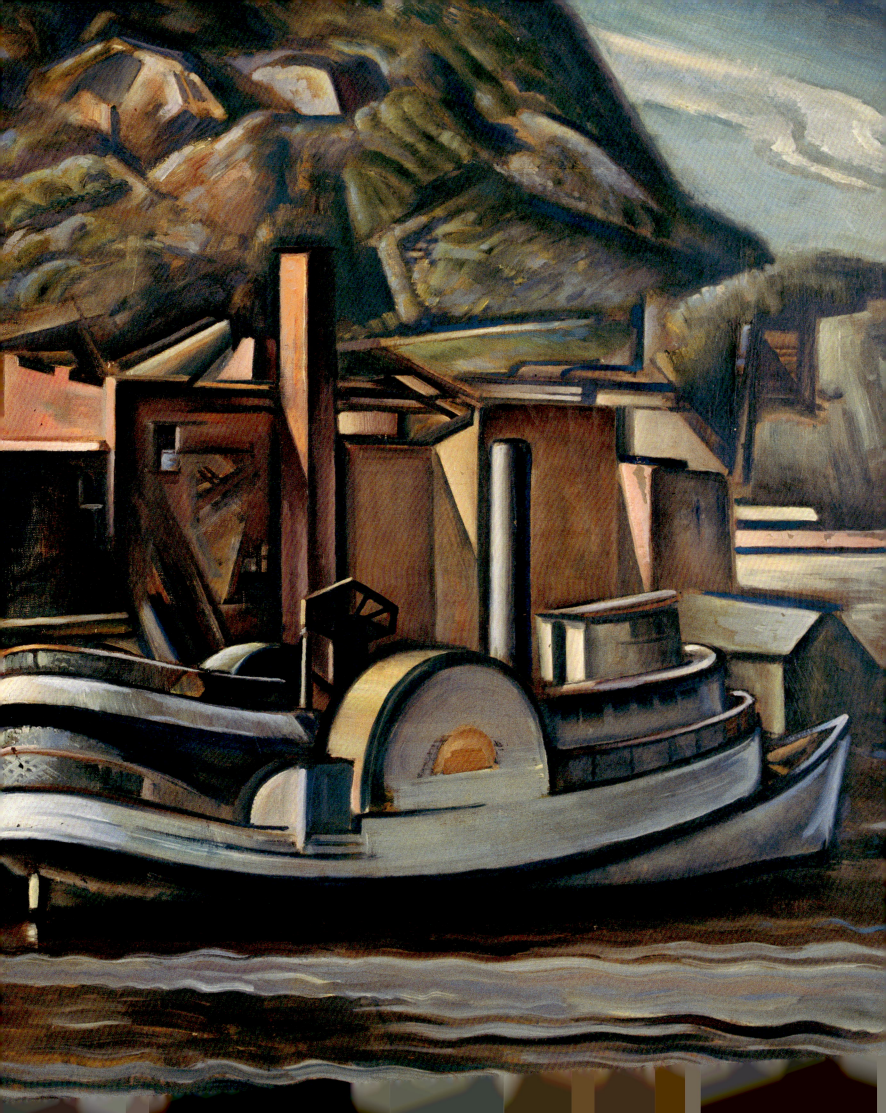

Special assistance with this project was provided by the Samuel Dorsky Museum of Art, State University of New York at New Paltz

This book accompanies the exhibition *Form Radiating Life: The Paintings of Charles Rosen,* at the James A. Michener Art Museum, October 13, 2006–January 28, 2007; and the Samuel Dorsky Museum of Art, State University of New York at New Paltz, February 24–May 13, 2007

Copyright © 2006 James A. Michener Art Museum
138 S. Pine Street
Doylestown, PA 18901
(215) 340-9800
www.michenerartmuseum.org

Copublished by the James A. Michener Art Museum and University of Pennsylvania Press
3905 Spruce Street
Philadelphia, PA 19104-4112
www.upenn.edu/pennpress

All rights reserved.

Library of Congress Cataloging-in-Publication Data
Peterson, Brian H.
 Form radiating life : the paintings of Charles Rosen / Brian H. Peterson ; with an essay by Tom Wolf.
 p. cm.
 Includes bibliographical references and index.
 ISBN-10: 0-8122-3988-1
 ISBN-13: 978-0-8122-3988-1 (hardcover : alk. paper)
 1. Rosen, Charles, 1878–1950—Exhibitions. I. Rosen, Charles, 1878–1950. II. James A. Michener Art Museum. III. Samuel Dorsky Museum of Art. IV. Title.
 ND237.R7175A4 2006
 759.13—dc22 2006017108

Designed by Jeff Wincapaw
Edited by Paula Brisco
Proofread by Barbara McGill and Anita Oliva
Photography by Will Brown, Ben Caswell, Randl Bye, and Adria F. Jefferies
Color separations by iocolor, Seattle
Produced by Marquand Books, Inc., Seattle
 www.marquand.com
Printed and bound by CS Graphics Pte., Ltd., Singapore

Frontispiece (top): *Water Birches,* ca. 1917 (detail, see pl. 25)
Frontispiece (bottom): *Under the Bridge,* ca. 1918 (detail, see pl. 35)
Pages 4–5: *The Quarry, Winter,* ca. 1910 (detail, see pl. 9)
Page 5: *Railroad Bridge,* 1925 (detail, see pl. 53)
Page 6: Untitled, 1908 (detail, see pl. 16)
Pages 6–7: *Side Wheel in the Rondout,* ca. late 1930s (detail, see pl. 39)
Page 8: *Brickyard Buildings,* n.d. (detail, see pl. 45)
Page 14 (left): *Apple Orchard,* n.d. (detail, see pl. 68)
Page 14 (right): *The Frozen River,* ca. 1916 (detail, see pl. 21)
Page 32 (left): *Canal Locks, Spring,* ca. 1916–18 (detail, see pl. 34)
Page 32 (right): *The Village,* 1935 (detail, see pl. 43)
Page 50 (left): *Three Tugs,* ca. early 1930s (detail, see pl. 63)
Page 50 (right): *Tumbling Brook,* ca. 1916 (detail, see pl. 32)
Pages 72–73: *The Delaware Thawing,* 1906 (detail, see pl. 1)
Page 73: *Winter Morning,* ca. 1913 (detail, see pl. 33)
Page 110: *Sawmill Interior,* ca. 1935 (detail, see pl. 51)
Pages 110–11: *Railroad Bridge,* 1925 (detail, see pl. 53)
Page 146 (top): Untitled [Nude], n.d. (detail, see pl. 73)
Page 146 (bottom): "*In Memory of a Wonderful Day on Martha's Vineyard,*" ca. early 1940s (detail, see pl. 75)

Contents

Foreword

In 1918, when Charles Rosen began teaching at the Art Students League summer school in Woodstock, New York, his bifurcated artistic life had already begun. Unlike most artists who, after a period of youthful experimentation, find a singular way of expressing themselves and then work in that style throughout their lives, Rosen at mid-career turned his back on the highly successful landscape style he had so carefully cultivated as a member of the New Hope school. Instead, he shifted both his creative voice and his home—the former to a more modernist style, the latter to Woodstock, New York, where the aesthetic environment was more receptive to his modernist ideas. This dramatic change was not a reflection of weakness or indecision but, rather, was a sign of strength. As with many other artists of that period who took up the modernist cause, Rosen's decision was a powerful expression of artistic freedom, in his case growing out of a restless personality as well as the courageous pursuit of an independent voice, unconstrained by the external forces of financial success and public recognition.

Born in 1878 in Reagantown, Pennsylvania, a coal-mining region in Westmoreland County, Rosen began his artistic career at age sixteen as the owner of a photography studio. After study in New York City, he and his new bride, Mildred Holden, moved to New Hope, Pennsylvania, in 1903, where his impressionist landscapes soon received national attention and even brought him some financial success—a feat that is unreachable to so many artists. Perhaps it was his awareness of the changing artistic currents that were reaching these shores from Europe after the Armory Show in 1913, or perhaps it was his own inner drive to explore new ideas and find a means of expression better suited to his temperament—whatever the reasons, for some thirty years Rosen then lived and worked in Woodstock, successfully balancing his role as a painter and teacher with his life as a father, grandfather, and friend. He was one of those rare artists who, in his lifetime, was respected for both his work and the life he led; he was a revered member of both the New Hope and Woodstock art colonies, and his friendships were legendary—with George Bellows and Eugene Speicher in Woodstock, and with William L. Lathrop, Robert Spencer, and Daniel Garber in New Hope.

It's ironic that collectors of Rosen's impressionist paintings are often troubled by his later work, while many admirers of his modernist pictures are unaware of his earlier canvases. This book, along with its accompanying exhibition, represents an unprecedented attempt to examine both sides of Rosen's artistic personality. Brian H. Peterson, senior curator of the James A. Michener Art Museum, has taken the lead in this effort, building a productive institutional relationship with the Samuel Dorsky Museum of Art at the State University of New York at New Paltz, as well as a productive intellectual partnership with Tom Wolf of Bard College. This book represents Brian's third major monograph in a seven-year period, a stretch of time that also included the publication of the major book *Pennsylvania Impressionism,* of which he was both editor and principal author. We are grateful for Brian's leadership as he completes yet another important chapter in the story of the Pennsylvania impressionist painters.

The Michener Art Museum is a center for the collecting, exhibiting, researching, and publishing of work by and information about artists from the Bucks County region. In our ongoing effort to honor and celebrate our community's rich artistic tradition, the Michener is proud to add this book to the growing body of scholarly publications that document and explain our region's cultural heritage. These efforts are made possible by our dedicated staff, our loyal members, our generous donors, and most importantly by the substance of the artistic talent that has lived and worked in our community. This idea of community is indeed a subtext of this particular project: as you explore the world of Charles Rosen, you will better understand how his impressionist paintings reflect his life in Bucks County just as his modernist works largely arose from the Woodstock environment. Often community is the soil from which an artist grows, and one can rarely separate an artist's identity from the place where he or she finds a home.

BRUCE KATSIFF, DIRECTOR AND CEO
JAMES A. MICHENER ART MUSEUM

Project Funders

This publication was made possible by major lead gifts from Carol and Louis Della Penna and Kathy and Ted Fernberger.

Major support was provided by Marguerite and Gerry Lenfest; The Warwick Foundation of Bucks County; Carolyn Calkins Smith; and Senator Joe Conti, Bucks and Montgomery Counties.

The Michener Art Museum's research and publication activities are supported by the Virginia B. and William D. Williams Endowment Fund.

Sponsors:
Avery Galleries
Thomas and Karen Buckley
The Hortulus Farm Foundation Museum
Lee and Barbara Maimon
Elizabeth Leith-Ross Mow
Bonnie J. O'Boyle
Penn Color
The Pfundt Foundation
Mike and Marika Sienkiewicz
In memory of Abigail Adams Silvers, M.D.
Barbara and David Stoller
Gordon and Katharine Taylor
The Barrie and Deedee Wigmore Foundation
Mary and David Wolff

Additional support was provided by Robert and Amy Welch; an anonymous donor; and J. Lawrence Grim Jr. and Kathleen O'Dea.

The Charles Rosen exhibition at the James A. Michener Art Museum was sponsored by Rago Arts and Auction Center.

Acknowledgments

Those of us who live and work in the museum world usually use the word *scholarship* to describe books such as this one. We all assume that we know what this word means, though we don't often talk about it. Scholarship, it would seem, has something to do with the acquisition of knowledge; the Merriam-Webster online dictionary offers as synonyms such concepts as erudition, learning, lore, and inquiry. My own tastes lean toward the last word in the list—inquiry—because it implies that the activity of scholarship is a process without a final resting point: a search for something rather than a simple accumulation of information.

What are we searching for? At the risk of sounding terribly pretentious, I would boil it down to this: scholarship, at its best, is a search for truth. Well what, then, is truth? In the context of research projects such as this monograph on Charles Rosen, truth has two aspects: the disciplined search for the facts of the man's life (the "who, what, when, and where"), and the passionate search for a deeper kind of understanding that integrates the artist himself, as a unique individual, and the larger cultural forces that he worked both with and against (the "why," if you will). Each aspect is of equal importance. Fact without understanding makes for a shallow endeavor indeed! But understanding is built on a very shaky foundation without fact.

My own conviction is that there is something sacred about this search for truth. I'm not sure why I feel this way, but I do. Getting to the bottom of something, throwing yourself into it, really figuring it out—this is a sacred trust that curators like me are lucky enough to have been given. And museums are in a unique position to carry out this search, uninfluenced by the needs and values of the marketplace, which more often than not lead us away from truth rather than toward it.

These two aspects of scholarly inquiry—understanding and fact—require different mind-sets and methodologies. Understanding involves a solitary journey of writing and thought. But getting the facts is much more communal, as is the process of bringing the project to fruition, and neither can be successfully undertaken without the help of countless people who give of their time and energy in many ways both large and small. I'm especially grateful for all the assistance provided by Rosen's four grandchildren: Kit Taylor (and her husband, Gordon), Virginia Callaway, Holly Goff, and Peter Warner. Their memories of their grandfather helped to make him a human being to me, and the documentation of his life they provided was invaluable; this project could not have been completed without their cooperation and enthusiasm. I also want to acknowledge the important work of Dr. Thomas Folk on Rosen; Tom was the pioneer scholar who paved the way for all subsequent studies of the Pennsylvania impressionists, and his contributions to the field have been invaluable.

Because of Rosen's stylistic and personal connections to both New Hope and Woodstock, I concluded early on that the success of the project depended on developing a relationship with a Woodstock-area institution that could mount the show as well as assist with the research. Fortunately such a relationship quickly materialized in the form of the Samuel Dorsky Museum of Art at SUNY–New Paltz and its director, Neil Trager. Neil has been the prime mover in creating a thriving and highly professional organization at the Dorsky, and his help with the Rosen project was crucial. Among many other things, he put me in touch with Arthur A. Anderson, a leading collector of Rosen's Woodstock works, and Tom Wolf, who is the leading scholar of the Woodstock art colony. Tom's contributions to the project can be seen in the pages of this book. To put it simply, he was great to work with; his dedication and insight added much to *both* understanding and fact. Arthur not only gave me complete access to his collection, he also organized a delicious dinner for my wife and me, and on a subsequent trip even put me up for a night in his lovely Woodstock-area home. Many thanks to Neil, Tom, and Arthur for all you contributed to this effort!

I once heard a lecture by a prominent curator at the National Gallery of Art who casually referred to her research staff of fifteen people for a particular project. My jaw dropped. Needless to say, the Michener does not have such resources, but we do have a committed group of staff members and volunteers whose research help has been absolutely crucial. Chief among these is Birgitta H. Bond, our museum's librarian, who has truly become my research pal. It takes a special kind of zeal to get excited about

such things as transcriptions of old lectures and random birth-dates, but Birgitta and I share this maniacal fervor for minutiae, and I've very much enjoyed working with her on this project. I've also been grateful for the work of fellow staff members Pam Sergey and Faith McClellan, who helped with image research and acquisition, as well as volunteers Mary O'Brien and Owen Medd, who helped greatly with general research and image acquisition respectively. Judy Eichel skillfully transcribed my two essays from my monotonous dictation. I also want to thank Robert Welch, an avid collector of Bucks County art, for making his personal research on Rosen's paintings available to me.

Many other people too numerous to mention helped with research for this project. Among them are Deedee Wigmore, D. Wigmore Fine Art, Inc.; Roy Pedersen, Pedersen Gallery; Marjorie Searl, chief curator, Memorial Art Gallery of the University of Rochester; Linda Freaney, director, Woodstock Artists Association; Amy Fulkerson, registrar, Witte Museum; Elizabeth Hopkin, associate registrar, Columbus Museum of Art; Mark D. Mitchell, assistant curator of nineteenth-century art, National Academy of Design; Elisabeth Botten, archives technician, Archives of American Art, Smithsonian Institution; Wendy Hurlock Baker, photo order coordinator/reference services, Archives of American Art, Smithsonian Institution; Kathy Scafidi, Inglis House customer service; Marianne Reynolds and Bruce Sherwood, reference librarians, Public Library of Cincinnati and Hamilton County; and Antony Maitland. Several people kindly helped me locate paintings, including Malcolm Polis, Paul Gratz, Carl David, Debra Force, Andy Newman, and Alasdair Nichol.

When the subject of editors comes up, most writers furrow their brows and mutter veiled expletives. Not so with Paula Brisco, who did her usual excellent job editing this book, and as always did so with both wisdom and grace. Similarly, the folks at Marquand Books helped to make the often harrowing process of book production both efficient and enjoyable; I want to thank Ed Marquand, Jeff Wincapaw, Larissa Berry, Sara Billups, Maggie Lee, Jeremy Linden, Linda McDougall, Marissa Meyer, Gretchen Miller, Marie Weiler, and Carrie Wicks.

Two other parties deserve a special tip of the hat. The Michener's Director and CEO, Bruce Katsiff, is a true friend of our research and publication program, and we simply would not be able to make all these books without his support. This is even more true of the many wonderful folks who help us pay the bills. Each time I've entered into a fund-raising campaign for our publications, a little voice inside has said, "Why would people want to give up their hard-earned dough just so we can do our books?" Each time that skeptical voice has been proven wrong. Every book we've created has been paid for through outside donations, and I am deeply grateful for the support and friendship of the many generous donors to our publication program.

It's all well and good that scholarship is a search for truth—but what if there is no truth to find? What if there's no real substance to the subject matter? That would be the scholar's worst nightmare—to throw yourself into something, only to be left, as one of the Psalms puts it, with "chaff in the wind." So in the end it's the artist himself who has most earned our gratitude, for doing something worthy of the search: for living the life of the artist honestly, for making pictures that still have meaning to people, and for adding something to the lives of others not only through his work but through his teaching and the many relationships he formed with friends, family, and community. Mr. Rosen, I've enjoyed getting to know you. Many thanks.

BRIAN H. PETERSON, SENIOR CURATOR
JAMES A. MICHENER ART MUSEUM

This book is dedicated to my parents, Jim and Gladys Peterson—sine qua non.

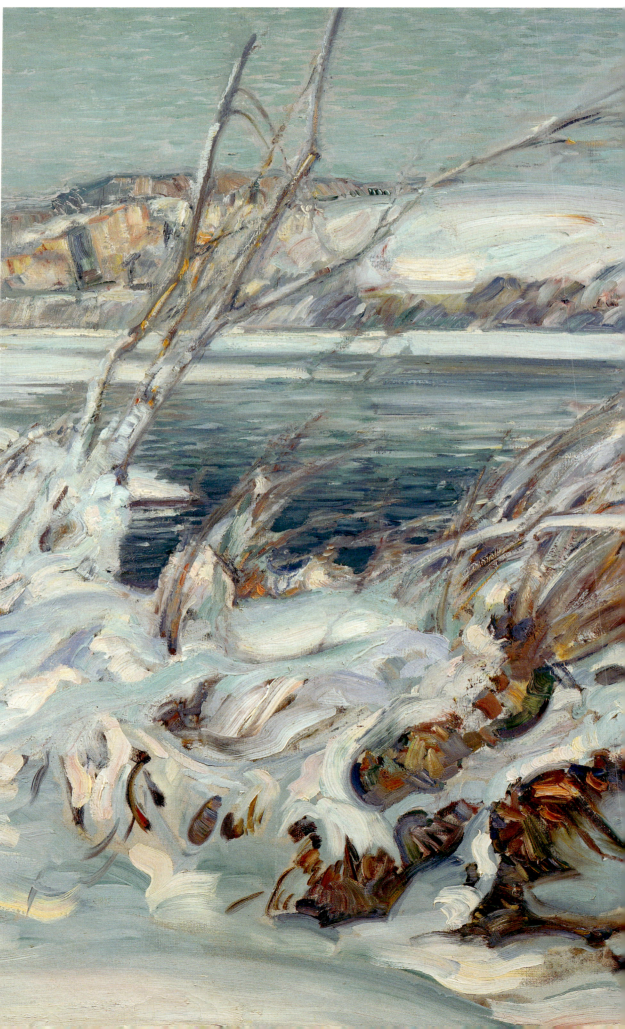

Charles Rosen . . . had the moral courage to abandon an easy fame
for a deeper and more sincere understanding of painting.[1]

BRIAN H. PETERSON

The Life of Charles Rosen

For some painters one idea is enough. It might be landscapes or portraits, it might be the bright colors of impressionism or the cerebral rhythms of modernism—a single way of working can sustain an artist for many years or, occasionally, for a lifetime. This was not Charles Rosen's story. During the first twenty years of his creative life, Rosen built a highly successful career as a landscape painter, exhibiting his work at prestigious museums and galleries around the country and winning many important prizes. In these years Rosen was a mainstay of the now-famous art colony centered in New Hope, Pennsylvania, a group of painters associated with American impressionism and referred to variously as the Pennsylvania school of landscape painters, the New Hope school, or the Pennsylvania impressionists.

Had he been so inclined, Rosen easily could have pursued a career as a traditional landscape painter for the rest of his life, and he almost certainly would have been fabulously successful at it. But in his late thirties and early forties, Rosen made a radical shift in his work, completely abandoning traditional landscapes in favor of a manner of working that might be described as modernist and semiabstract, one that used man-made structures as subjects and was based on a passionate exploration of form as a living, organic phenomenon. Rosen himself described this as "form that radiates life" and spoke of the "effort to achieve this in paint."[2]

This change in his painting occurred around the same time that he made a change in where he lived and worked. In 1918, at age forty, Rosen began to teach in Woodstock, New York, and two years later he pulled up stakes in New Hope and moved his family to Woodstock permanently, where he became one of the most respected and successful members of the Woodstock art colony (fig. 1). This art colony stylistically was more eclectic than the New Hope painters, with a much greater emphasis on the modernist point of view, and Rosen lived there happily for the rest of his life. While he found creative satisfaction in his Woodstock years, he did not sell as many paintings, and of necessity he took up a teaching career—in Woodstock and, later, in Ohio and Texas.

While it's not uncommon for an artist's work to evolve over a lifetime, the kind of abrupt and irrevocable transformation that happened to Rosen's work is unusual. In his case the shift in style was accompanied by an equally abrupt change in residence, with new artistic friendships and a new profession (teaching). The two art colonies—Woodstock and New Hope—were both physically and stylistically unconnected. Yet even today each area has a close-knit community, rooted in

f.1

Rosen with pipe, ca. 1920. Courtesy of the Charles Rosen Papers, Archives of American Art, Smithsonian Institution

15

the local geography, that takes great pride in its history and artistic achievements. All this has led to a strange situation in which Rosen's New Hope and Woodstock periods are treated almost as if he were two different people.

In Bucks County, Rosen's Woodstock paintings are rarely seen. They are generally thought of as inexplicable anomalies at best, and at worst, utterly deranged. The only conceivable reason why this skillful painter would abandon his perfectly beautiful landscapes in favor of those strange modernist abstractions must be some form of demonic possession! While Woodstock's artistic identity is more complex, that community is arguably proudest of its modernist heritage, especially George Bellows and his circle—of which Rosen was an important and beloved member. In Woodstock today, Rosen's New Hope paintings are almost completely unknown, viewed as part of some mysterious and faraway yesteryear that happened before he found his true home and calling.[3]

Of course Rosen was not two men, but it's understandable how the two halves of his bifurcated life could have become so disconnected. This book attempts to bring those two halves together, first by recounting the basic facts of his life with an emphasis on his relationship with the New Hope art colony. In the second essay, Tom Wolf looks in greater depth at Rosen's Woodstock years, providing some background on the Woodstock art colony and exploring his connections to modernism and the Bellows circle. The third and final essay examines Rosen's paintings in greater detail, comparing and contrasting the two periods, looking at the cultural and aesthetic forces that influenced him, and seeking some unity within the confusing diversity of his work.

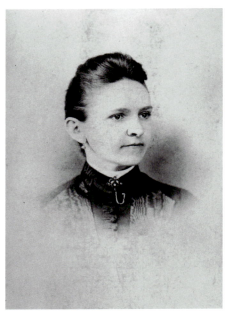
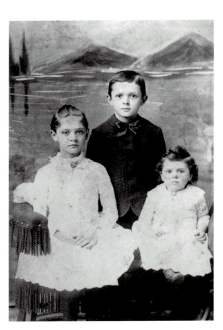

f.2
David Rosen, ca. 1885. Courtesy of Katharine Worthington-Taylor

f.3
Loraine Rosen, ca. 1885. Courtesy of Katharine Worthington-Taylor

f.4
Lulu, Charles, and Maude Rosen, ca. mid-1880s. Courtesy of Katharine Worthington-Taylor

Charles Rosen was born on April 28, 1878, in Reagantown, Pennsylvania, a coal-mining region near Pittsburgh in Westmoreland County. Very little is known about his background and early years, though his parents were "of old American stock—Pennsylvania Dutch on his father's side, Scotch-Irish on his mother's."[4] The 1880 census for South Huntingdon, Westmoreland County, lists a "David Rosin," age twenty-five and born in Pennsylvania, and his wife, Loraine, age twenty-three, with their two children, Lessler (female, age four) and "Charly" (male, age two) (figs. 2–4).[5]

There is conflicting evidence about Charles's relationship with his parents. His children apparently only saw their grandparents occasionally: his daughter Polly said, "I may have seen my grandfather once, but I never knew my grandmother."[6] According to one source Charles was born "in a home devoid of books and pictures."[7] This lack of interest in art and culture perhaps was a reflection of the elder Rosen's Pennsylvania Dutch heritage. It's not hard to imagine some degree of tension between father and son, given the son's artistic leanings. The fact that Charles opened his own photography business at age sixteen (in West Newton, Pennsylvania) suggests a desire for early independence from his parents (fig. 5). On the other hand, his grandchildren have a number of later pictures that show the family together, including the mature Charles visiting his family in western Pennsylvania around 1940. And there is no hint of any ill feeling in a letter from Charles to his sister following their father's death: "Try not to be too unhappy. Dad had a long happy life and leaves nothing but love behind and hosts of friends to miss him."[8]

As the owner of a photography studio, Charles learned that to make a living he had to keep his customers happy (fig. 6). One letter survives from those years, a plaintive note (undated) from a dissatisfied customer addressed to the Rosen Artistic Photographer Company: "Dear sir: Enclosing these few lines to let you know that I would like for you to send me my photographs this week, for I would like to have them. I was always waiting on them but you never sent them."[9] At least this customer was only seeking pictures of "my wife and baby and myself." Rosen sometimes had to undertake a much more onerous task: photographing the bodies of men killed in mining accidents. "Set him up in the corner so he looks natural," was how his daughter Polly recalled her father describing the instructions of the grieving widows.[10]

It's not known exactly how long Rosen maintained this photography business, though his stamina for taking pictures of dead bodies soon flagged. By 1898, at age nineteen, he had enrolled at the National Academy of Design in New York City,[11] and before moving to New York he lived briefly in Salem, Ohio, where he had gone to help a friend who was running a photography studio there. One can only speculate about what drove him to become an artist; there is no record of any mentors in his formative years, although "he used to draw a little

f.5
Charles Rosen, ca. mid-1890s. Courtesy of Katharine Worthington-Taylor

f.6
Portrait of an unknown subject by Charles Rosen showing Rosen's studio insignia, ca. mid-1890s. Courtesy of West Overton Museums, Scottdale, Pennsylvania

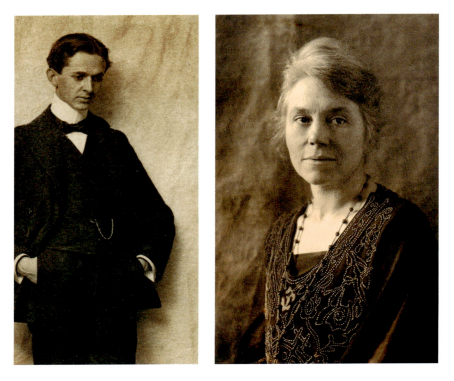

f.7
Charles Rosen, ca. 1900. Courtesy of
Virginia Callaway

f.8
Mildred Holden Rosen, ca. 1920. Courtesy
of Virginia Callaway

and took lessons from an old maiden lady."[12] His Ohio friend may also have run an art gallery, and it's possible that this was Rosen's introduction to the art world.[13] While the source of his motivation to study art is unknown, it's clear by his actions that he was powerfully motivated.

To get into the National Academy of Design, Rosen (like all prospective students) had to submit examples of his drawings to one of the school's instructors, who had to feel that the young artist showed potential before admission to the school was permitted.[14] It took both courage and conviction for a farm boy from the Pennsylvania hinterlands to move to the big city and study art at such a well-known institution, and perhaps an equal amount of courage to enroll, soon after, at the New York School of Art, where he studied with two of the most famous painters of the day, William Merritt Chase and Frank Vincent DuMond.[15]

Like many young artists, Rosen had little or no money, and had to devote some of his creative energy to keeping body and soul together (fig. 7). His daughter Polly said that he lived with some friends in a "cold water flat" and that they "ate whatever they could,"[16] with their most common source of sustenance being oatmeal. He began to support himself through commercial and advertising art, and at one point supplemented his income by ushering at the Criterion Theater:[17]

> *The salary was small, but he augmented it under the direction of the head usher who had a racket whereby he bought cheap opera glasses from a pawn shop and had the ushers rent them to the theater patrons at a good fee. The money so earned was split between them, and it provided sufficient income to keep Rosen going.*[18]

He met a young woman named Mildred Holden at the New York School of Art, a fellow art student whose father was a teacher at the West Point Military Academy (fig. 8). Though Mildred's family "looked down on Rosen"[19] because he was an artist, love won out and the two were married in 1903. They spent their honeymoon in New Hope, and liked the place so much that they decided to move there later that year.

Rosen's arrival in 1903 made him one of the earliest members of the New Hope art colony. The first artists to take up residence there were Edward W. Redfield (1898) and William L. Lathrop

(1898/99), both of whom were well-known figures in the American art world by the time Rosen came to New Hope.[20] Lathrop had also moved there from New York, and his fame as a landscape painter as well as his art classes attracted many private students to the area. Typically Lathrop would meet his students at the New Hope train station, ferrying them up the Delaware Canal in his "old tub of a whaleboat"[21] to a favorite painting spot along the Delaware River. Then at the end of the day, they would retire to his house just north of New Hope where his English wife, Annie, would serve tea to everyone. Sometimes students even rented rooms at Lathrop's home, which became the hub of the growing art colony.

There are no records that would indicate why Rosen and his young wife chose to honeymoon in and then move to New Hope, but it's hard to imagine that the presence of Lathrop and Redfield was not a factor in this decision. Both artists had strong New York ties, and both were older than Rosen and far more seasoned as artists (Lathrop was in his mid-forties, Redfield in his mid-thirties). While Redfield rarely taught and generally was not known to mentor young artists, Lathrop routinely took his younger colleagues under his wing. Rosen's early landscapes show some similarity to Lathrop's, the two men lived near each other, and there are letters that suggest a close friendship—all of which points to Lathrop's presence in New Hope as a factor in Rosen's decision to move there.

Given New Hope's proximity to New York, Rosen went there with full confidence that he would be able to continue to make a living through commercial art assignments. But the agent on whom he relied for these assignments "became involved in difficulties," and soon "there was no commercial art for [Rosen] to work at."[22] While it's probable that his wife came to the marriage with some financial resources,[23] it was not enough to sustain them, and the young painter was forced to become more aggressive in his efforts to build a career and sell his work.

From his late twenties to his late thirties, he was increasingly successful in this effort. In January 1905, for example, he sold a painting for $150 through an exhibit at the National Academy of Design. A year later he sold paintings at the Pennsylvania Academy of the Fine Arts (Philadelphia) and the Society of American Artists (New York),[24] as well as to the architect and collector William W. Renwick, who was the grandson of the famous architect who designed the original Smithsonian Institution and St. Patrick's Cathedral in New York (pl. 1). "The picture in question hangs in my bedroom," said Renwick in a July 3, 1906, letter to Rosen, "and is very pleasing to look at in this warm weather." Renwick's wife was less enthusiastic. "Mrs. Renwick thinks that the river-grass in the foreground is a little too strong in color, and that it is too dark, and I fancy she may be right." As if anticipating the young artist's chagrin at reading these unflattering remarks, Renwick concludes his letter on an upbeat note: "Nevertheless, I am very well satisfied with my picture and wish you success."[25]

Within a few years Rosen had become one of the most successful and respected artists in New Hope. He received many honors for his work in this period, including prizes from the National Academy of Design and the Salmagundi Club (New York), the Carnegie Institute (Pittsburgh), and the 1915 Panama-Pacific Exposition (San Francisco). He was elected an associate (A.N.A.) of the National Academy of Design in 1912, and a National Academician (N.A.) in 1917. Eventually his paintings were bought by such notable institutions as the Whitney Museum of American Art (New York), the Smithsonian American Art Museum (Washington, D.C.), the Philadelphia Museum of Art, and the Butler Institute of American Art (Youngstown, Ohio).

Rosen's New Hope paintings were a reflection of his searching, exploratory mind-set in these years. As Mrs. Renwick observed, his earlier canvases tended toward a darker palette, with a poetic

Residence of C. S. Rosen,
New Hope, Pa.

f.9

Glen Cottage, Charles and Mildred Rosen's
first Bucks County residence. From the
collections of the Spruance Library of the
Bucks County Historical Society, SC-36,
27–116

quality reminiscent of Lathrop as well as the late nineteenth- and early twentieth-century movement known as tonalism. But as he gained confidence in his technical and expressive gifts, Rosen began to experiment with different ways of making landscapes: his oeuvre includes large-scale, bravura snow scenes with sweeping brushstrokes and a bright palette, painted largely outdoors; quiet river scenes with more detailed brushwork, probably painted largely in the studio; classic impressionist canvases with dappled brushstrokes and an emphasis on light; and an occasional landscape with thick, uneven paint application and highly varied colors, with compositions reminiscent of Japanese prints. Through it all, Rosen maintained a high technical standard as well as an uncanny ability to express elusive emotional and poetic qualities in his work.

Probably in 1915 he moved from a smaller house called Glen Cottage (fig. 9), located just down the street from the Lathrop property, to a new house on a nearby property along the river, built by Rosen and his wife.[26] His daughter Katharine was born in 1905 (fig. 10), and a few years later she joined her parents on a lengthy cruise to Italy, where her father was able to visit some of the great monuments of European culture in Rome and Florence. Portions of Rosen's diary from this trip have survived (see Appendix 2), and the document contains a wry, self-deprecatory commentary on his first experience of being seasick:

> The night of the second day out became stormy. The Arctic meeting up with what the ship's log chose to record as "a heavy gale." Thus there was the golden opportunity for discovering just how good a sailor Mr. R. was. Mr. R. has discovered that he is not a good sailor and is willing to make affidavit to that effect before any notary public.

Between storms Rosen discovered another experience typical of ocean cruises: boredom.

> Nothing to do particularly except walk, that is, nothing that one cared to do, so that Mr. R. walked, walked, and when he had rested he walked some more. It is a curious thing that one can be induced to say good morning for the privilege of walking to Italy, for I assure you that Mr. R. walked the greater part of the way.[27]

In addition to rough seas and endless hours with nothing to do, Rosen and his wife may have experienced yet another common feature of ocean voyages. While it's not known how long their

European trip lasted, their second daughter, Mary (nicknamed Polly), was born some months later, in 1910.

As would be true of his years in Woodstock, Rosen developed close friendships with his New Hope colleagues. Many letters to Rosen survive from Redfield and from Daniel Garber (one of the most prominent New Hope painters),[28] the kind of everyday, casual correspondence that occurs between friends. "In case it is stormy this afternoon," said Redfield in a note of March 31, 1908, from his nearby home in Center Bridge, Pennsylvania, "do not come tomorrow (Wednesday) as I have something that will hold me, anytime after will be O.K." In an October 12, 1911, letter Redfield advised Rosen about how to price his paintings in a New York exhibition, and ended the note with the encouraging words, "Meanwhile—keep working!"[29] Similarly, there are many letters from Garber to Rosen that are full of news and warm wishes: "I am delighted to hear of your success in New York and here are my hearty congratulations" and "I had hopes of seeing you in New York last Friday but times were too hard for me to think of the trip. . . . Could you tell me if you saw any of my things and how they were placed?"[30]

Lathrop was a particularly close friend and mentor, as he was with so many of the New Hope artists. In the summer of 1907, Lathrop was teaching in Connecticut, and while he was away he loaned his canal boat—named *Sunshine*—to Rosen. Apparently the boat's engine broke down, and Rosen, feeling some responsibility, wrote a letter of apology to Lathrop. This letter did not survive, but Lathrop's reply is revealing about the strength of their friendship: "Undoubtedly the accident to the boat was not due to any fault of yours. Probably if I had run the boat another trip or two it would have happened to me." The letter goes on with a lengthy explanation of the finer points of engine maintenance and concludes with such friendly lines as "Annie [Mrs. Lathrop] wants me to thank you again for your very great kindness to her" and "I shall expect to see some bully work on your canvasses when I get home. Not having the Lathrops to play with, you should do the work."[31]

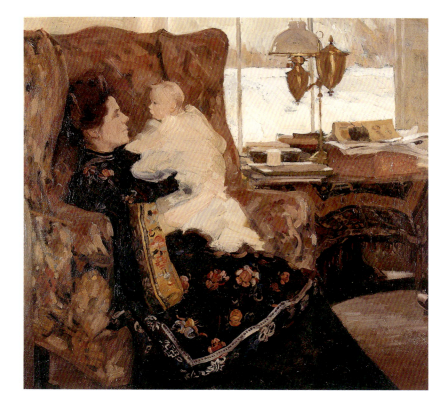

f.10
Charles Rosen, oil portrait of Mildred and Katharine Rosen, ca. 1905. Collection of Katharine Worthington-Taylor

Despite his many professional successes, Rosen was dissatisfied with his paintings. He never was able to settle on a single, characteristic way of making landscapes, and in the words of his daughter Polly, he "felt unhappy, restless—he wasn't doing what he wanted to do."[32] He was aware of the new currents in art from Europe, and began to feel that there was something he wanted to say that was not possible in landscape painting. He spent the winter of 1914–15 painting the Maine coastline; according to his granddaughter, he went there in part because he was troubled about his work, and needed a "change of scenery" where he could "think things over."[33] His friend and fellow New Hope artist John Folinsbee, after describing a particularly successful canvas called *Winter Sunlight* (ca. 1916; pl. 26), says that Rosen remarked, "That is the last picture of its kind I will ever paint."[34] True to his word, by 1918 Rosen had begun to make the radical shift in his painting style from the traditional landscape to the modernist approach. One of the first canvases in this new style, *Under the Bridge* (ca. 1918; pl. 35), is a view of the undergirders of a Delaware River bridge and the backs of nearby buildings in which the various elements are arranged in a rhythmic, geometrical fashion. This semiabstract but realist style characterized Rosen's way of working for the rest of his life.

It's not clear how Rosen was first introduced to Woodstock, but by the summer of 1918 he was teaching there in the summer school of the Art Students League, a well-known art school based in New York City. Rosen must have found Woodstock to be a more lively place than New Hope; the artistic community in Woodstock in the late teens was much more diverse, with a healthy representation of painters with more conservative leanings as well as a group of artists more sympathetic to the modernist aesthetic that was beginning to preoccupy Rosen.

A possible motivation for shifting his attention to Woodstock was in part financial—not due to the possibility of increased sales (quite the contrary!) but because Woodstock afforded him more opportunities to teach. He must have known that abandoning his career as a landscape painter would have financial repercussions. His daughter Polly recalled that in the New Hope years the

f.11

Rosen teaching in Woodstock, ca. early 1920s. Courtesy of the Charles Rosen Papers, Archives of American Art, Smithsonian Institution

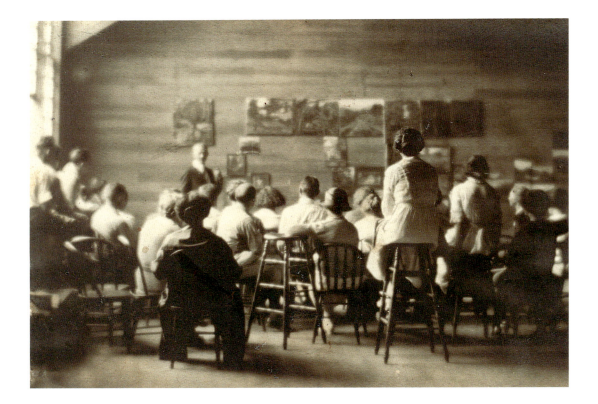

f.12

The Rosen family home in Woodstock, 2005. Courtesy of the Michener Art Museum Library and Archives

family was more comfortable financially, but that in Woodstock, in the years when he wasn't teaching, "we often were very poor."[35] Polly's sister, Katharine, told her son that Christmas presents in the lean years consisted of an orange plus a peppermint stick; as a special treat the girls would suck orange juice through the peppermint stick! Years later Katharine was still able to show her son how the two sisters managed to accomplish this difficult task.[36]

In the late teens Rosen must have felt that he was entering unknown territory as a painter, and that he would need to find the right working environment if he was going to master this new way of making paintings:

For ten years he retired from the scene to work at his own salvation as an artist. It would have been easier had he been making a fresh start from art school, but there was so much he had to unlearn and so much to disgorge. For ten years, or thereabouts, he was like a man who had lost the old faith without having gained a new one. For ten years, studying, reading, observing, experimenting, he fought his way out of the old standards and conception of painting toward a new vision, a vision not poetical, not sentimental, but honest and sincere. . . . He became interested in the challenge of homely things, in their structure and in their reality, and a new Charles Rosen was born.[37]

Clearly he would not have received much help with this struggle in New Hope. In fact, despite his many friendships there, most likely he would have encountered outright resistance. Two of his closest friends, Edward Redfield and Robert Spencer, were openly hostile to modernism. According to Redfield, modern art was like "hens sitting on addled eggs. Sooner or later they all explode."[38] Spencer's antipathy to modernism was even more intense. "The art of today is as chaotic as is society," said Spencer. "It does not seem to be going anywhere, just traveling in aimless circles at full speed. . . . If Matisse and Picasso represent life—if that is how wine and food and life should taste—then the world for me is dead!"[39] Lathrop was disinterested in the whole debate: "The marvelous drawings in the prehistoric Cro-Magnon caves of the south of Europe doubtless started with a discussion of Modernism which has gone on ever since. But it is a squabble of camp followers. The real champions are not in it. They are too busy."[40]

With these kinds of attitudes prevalent among his closest friends, it's understandable that Rosen would have looked for greener pastures elsewhere. So in 1920 he moved his family permanently to Woodstock, and soon he was just as much a part of the Woodstock community as he had been a part of New Hope (fig. 11). Rosen formed many close friendships with Woodstock artists, including the major figures George Bellows and Eugene Speicher. Rosen, Bellows, and Speicher lived near each other in an area of Woodstock called Rock City, located not far from the original home of the art colony known as Byrdcliffe (fig. 12). Rosen's daughters were the subjects of paintings by Bellows and Speicher (fig. 15), and his younger daughter, Polly, spoke fondly of Woodstock's social life—including a famous party in which her father "dressed as a ballerina!" (figs. 13–14).[41]

Rosen continued to teach in the Art Students League's summer school until the league closed the school (temporarily) in 1922, at which point he started his own school—known as the Woodstock School of Painting—along with fellow instructors Andrew Dasburg and Henry Lee McFee.

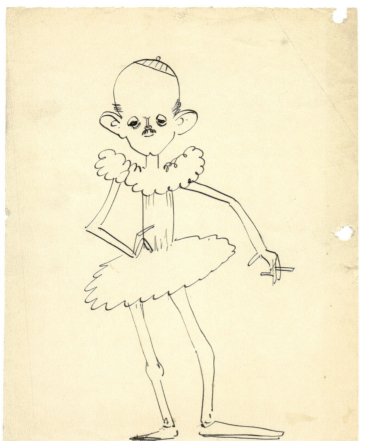

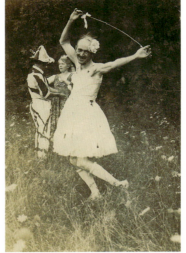

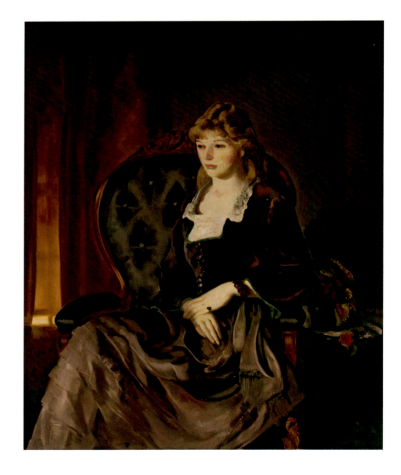

f.13
George Bellows (1882–1925)
Charles Rosen as Ballerina, 1925
ink on paper
8⁹/₁₆ × 6¹¹/₁₆ inches
Center for Photography at Woodstock;
Permanent Print Collection Gaede/Striebel
Archives; On Extended Loan to the Samuel
Dorsky Museum of Art, State University of
New York at New Paltz

f.14
Charles Rosen as a ballerina at the Maverick
Festival, 1925. Vintage photograph by
Hughes Mearns. Center for Photography
at Woodstock; Permanent Print Collection
Gaede/Striebel Archives; On Extended Loan
to the Samuel Dorsky Museum of Art, State
University of New York at New Paltz

f.15
George Bellows
Katharine Rosen, July 1921
oil on canvas
53 × 43⅛ inches
Yale University Art Gallery, Bequest of
Stephen Carlton Clark, B.A., 1903

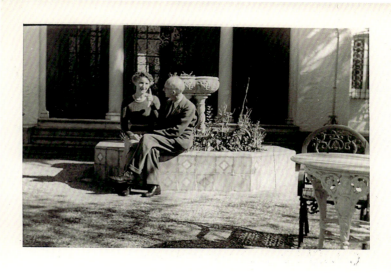

In subsequent years Rosen did not confine his teaching to Woodstock. Between 1924 and 1927 he was on the faculty of the Columbus Art School in Columbus, Ohio, and in 1927 he was head of the painting and drawing department at that school. This institution at the time was affiliated with the Columbus Gallery of Fine Arts; eventually the school and the gallery separated, the former becoming the Columbus College of Art and Design, the latter becoming the Columbus Museum of Art.[42] Rosen lived in Columbus only during the school year, still maintaining his permanent residence in Woodstock; his daughter Polly said, "The family went there [Columbus] on vacations."[43]

In the early 1940s Rosen had a similar position in San Antonio, Texas, where he was director of the Witte Museum School of Art (1940–41). After that school folded, he became the first director of the San Antonio Art Institute. His connection with San Antonio almost certainly grew out of his friendship with fellow Woodstock painter Henry Lee McFee, who preceded him as director of the Witte School.[44]

Rosen maintained his Woodstock residence while teaching in San Antonio, though by this time the circumstances of his life had changed considerably. Some ten years earlier his wife, Mildred, had been stricken with ovarian cancer, which took her life in 1932. Two years later Rosen had married Jean Inglis, a woman more than fifteen years younger with roots in Philadelphia (figs. 16–17).[45] Rosen was in his early sixties when he began to teach in San Antonio; his children had grown up and he was already a grandfather. Both he and his second wife spent considerable amounts of time in San Antonio, where they "were very active in the community."[46]

During the Depression years of the 1930s, Rosen joined many other artists of the day who supported themselves through government-funded public art projects. In 1937 he was hired to execute an extensive set of murals for the post office in Beacon, New York (fig. 18): "A sweeping 40 foot by 80 foot pictorial map of the Hudson Valley divided into counties runs the full length of the room with scenes of Beacon at each end. They include waterfalls, Mt. Beacon, churches and a hat factory, plus city and county seals and a map of the city. Among the little identifying images along the Hudson River is one labeled 'Home of Franklin D. Roosevelt, Hyde Park.'"[47]

This post office was one of six in the Woodstock region that the president took a personal interest in; Roosevelt "determined the unique Dutch Colonial architectural style" of the structures, and requested that "a historic building in each locale be used as a model."[48] This interest of the

f.16

Marriage license, Charles Rosen and Jean Inglis, 1934. Courtesy of Katharine Worthington-Taylor

f.17

Charles Rosen and Jean Inglis Rosen, probably in San Antonio, ca. early 1940s. Courtesy of the Charles Rosen Papers, Archives of American Art, Smithsonian Institution

president led to an exciting moment for the Rosen family, when Roosevelt's wife, Eleanor, along with Mrs. Henry Morgenthau Jr., the wife of the secretary of the U.S. Treasury, visited Rosen's studio "to see the work being done for their neighboring Hudson River town."[49] Mrs. Roosevelt later reported on this visit in her famous syndicated newspaper column called My Day:

> At 9:45 yesterday morning Mrs. Morgenthau and I left in my car to go to Woodstock, New York, an artist's colony back of Kingston. We wanted to see the sketches for the murals which Mr. Charles Rosen is doing for the post office at Beacon, New York. . . .
>
> I have always loved the Catskill Mountains, and at Woodstock they loom very near at hand. In every direction there seemed to be attractive spots to paint. We saw one or two easels up and painters so engrossed that they did not even look at the passing cars.
>
> We found our artist's house quite easily and spent a delightful time in his studio. The map he is painting, which is to go the length of the lobby, is not only lovely in color, but interesting in design.[50]

Two years later Rosen was one of three artists who received commissions to paint murals in the post office of Poughkeepsie, New York, the most ambitious building of the six and the one that received the most attention from the president. This post office cost more than $400,000 to construct—a vast sum in this period—and the cost of the murals "totaled more than $13,000—over four times the normal 1% of the total expense reserved for interior decoration."[51] Rosen's task was to create a view of the city as it was in 1939. His elongated mural shows the Hudson River in the foreground (complete with oarsmen participating in the Poughkeepsie Regatta) as well as two bridges and an extensive view of Poughkeepsie on the hill behind the river. (See pages 41–45 for a more extensive discussion of Rosen's murals.)

The history of art is full of sad stories about artists who gave everything to their work, in the process sacrificing their relationships with friends and family and leaving a trail of bad memories behind them. This was not how Charles Rosen lived his life. By every indication he was a good father and husband, a man who made friends easily and kept them, and a beloved teacher who gave much to the communities where he lived and worked. Woodstock historian Anita Smith said that during the many years he lived in Woodstock, "I doubt if he made a single enemy. He was a man with strong convictions but with a gentle and smiling manner that would disarm the fanatic."[52] The many letters to Rosen from his Bucks County friends suggest that Smith's assessment of his character would also apply to his years in New Hope. While almost no letters have survived *from* Rosen, there are many letters *to* him from both his Woodstock and New Hope artist friends, and these letters are uniformly warm and supportive, full of the flashes of humor that are reserved for the closest of buddies.

Typical of these is a December 15, 1924, note from George Bellows, written to Rosen while he was teaching in Columbus, where Bellows had grown up. Bellows had apparently just received an announcement of an exhibit of Rosen's work in Columbus, a show that Bellows described impishly as a "weed sale":

> Dear Mr. Rosen:
>
> I have the catalogue announcement of your weed sale for Christmas, and note with disappointment that there are no portraits of grasses in the catalogue.

I would treasure a good likeness of Columbus grasses as a reminder of my mis-spent youth. I was commissioned in 1896 to remove the weeds from the front yard display at 65 East Rich Street, which I carried out with characteristic thoroughness. The result was a skinned diamond.

You can see how I feel.

Very truly yours,
Geo Bellows, Esq.[53]

Rosen's grandchildren were still young when he died, but they have fond memories of their grandfather, whose nickname was "Greendaddy" (probably because of the green paint they saw on his hands). He was fond of giving them creative and playful gifts. Once when two of his granddaughters were sick with chicken pox, Rosen sent them a series of seven postcards, one card a day, that depicts a parade of circus animals gradually marching from left to right (fig. 19). The cards are accompanied by a running commentary that includes "I bet that lady's cold!" (referring to a tastefully drawn nude reclining on top of an elephant). With the words "Huh oh!!!" the sixth card shows a somewhat compressed elephant that has bumped into the right edge of the card, and in the last one the entire parade is crammed and jammed together: "Ah! Too bad—the parade is stopped!"[54]

Rosen had a gift for communicating with children, and his empathic and generous personality also extended to his students, as evidenced by a letter from Rosen to the Canadian artist André Bieler, who studied with Rosen in Woodstock. After telling his student first to surround himself with art by the best artists, both historic and contemporary, Rosen said:

Bask in the sunshine of the real great—it establishes standards. Art is not national! It is universal—has no country or time—your chances are now all within yourself and merely need proper development. You can't be greater than you are, but your job is to succeed in being as

f.18
Rosen working on the Beacon mural, 1937.
Courtesy of Katharine Worthington-Taylor

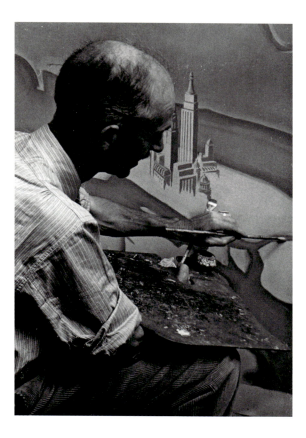

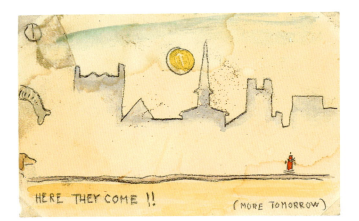
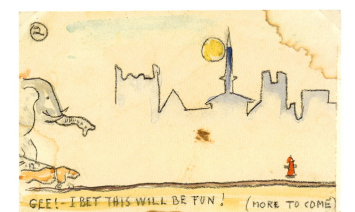
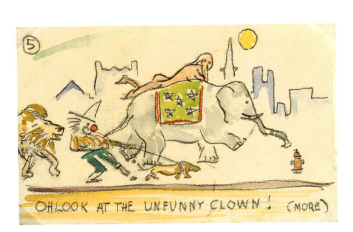
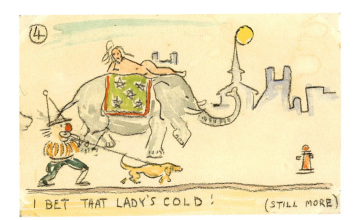
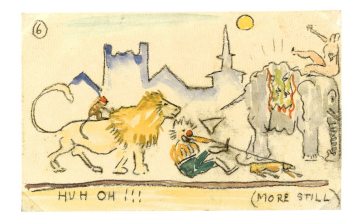
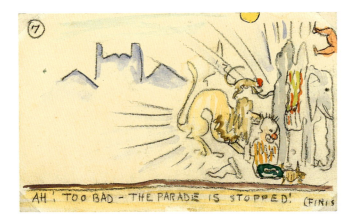

f.19

Set of postcards from Charles Rosen to
two of his grandchildren, ca. mid-1940s.
Courtesy of Virginia Callaway

f.20

Charles Rosen, ca. 1940s, courtesy of
Katharine Worthington-Taylor

*great as you really are. This may be little or much and it is what you stand or fall on—but the
fun of the race is in the running. . . .*

*Search out the things that are important to you. Style will probably take care of itself and some-
day you or somebody may discover that you are an artist. . . . All your life you will find that you
have but one job—to put on the canvas what you want on it. . . . I don't know if this helps or
not—it's definite and also vague. In any case, you have my very best wishes for everything.*[55]

Bieler's biographer believed that this letter was written with deep insight into the young artist's
personality, and that the letter "could well serve today as a guide to any aspiring artist in search of
his identity, as it served for André Bieler."[56]

Rosen's lasting impact on his friends, family, and community was best expressed in the poignant
words written by his friend Eugene Speicher on the day Rosen died:

*Charles Rosen died this morning and the little town of Woodstock is in tears. Deeply loved by
everyone who knew him for his sweetness, understanding and tolerance, greatly appreciated as
an artist, confining himself to life and art in his appreciation of the works of others, especially
the young and little-known artists, he leaves one of the tenderest memories.*

*He will be missed in the village, at the gallery and in the stores and in the homes of his countless
loving friends.*

*Eugene Speicher
Woodstock, June 21, 1950.*[57]

The abbreviation "AAA" refers to the Charles Rosen Papers in the Archives of American Art, Smithsonian Institution. This material was loaned to the AAA by the artist's daughter Katharine Warner in the mid-1970s to be microfilmed; original documents have been lost.

1. From a gallery brochure for a 1955 solo exhibition at Galeria IBEU of the Instituto Brasil-Estados Unidos in Rio de Janeiro, Brazil; AAA.

2. From a group of Rosen's handwritten lecture notes, undated; AAA.

3. It should be noted that, for the purposes of this book, the term "landscape" is meant to be synonymous with Rosen's New Hope paintings, nearly all of which were part of a more conservative tradition. Because his Woodstock-era canvases are almost exclusively associated with modernist ideas, the adjective "modernist" is meant to be synonymous with work done during his Woodstock years.

4. Harry Salpeter, "About Charles Rosen: Spurning Easy Success, He Had the Courage to Build Anew on a More Honest Foundation," *Coronet* 5 (February 1939): 90.

5. The David Rosen family eventually added two more sisters, Maude and Katharine, so he had three siblings. Apparently Lessler's nickname was Lulu, since that is the name remembered by the Rosen grandchildren.

6. From an undated handwritten personal memoir written by Polly Rosen Goff, in the possession of Virginia Callaway, p. 1.

7. Salpeter, "About Charles Rosen," 91.

8. AAA. The letter is undated.

9. AAA.

10. From an oral history interview with Rosen's daughter Polly Rosen Goff conducted on January 15, 1996, by Polly's granddaughter; cassette tape is in the possession of Polly's daughter Virginia Callaway.

11. Student records from the late 1890s at the National Academy of Design were lost, but two of Rosen's certificates of enrollment from the National Academy, dated 1898 and 1899, are in AAA.

12. Salpeter, "About Charles Rosen," 91.

13. A reference to the Ohio art gallery is in Anita M. Smith, *Woodstock History and Hearsay* (Woodstock, N.Y.: Stonecrop, 1959), 83.

14. Information about National Academy of Design entrance requirements was obtained from NAD curator Mark Mitchell.

15. The New York School of Art began its existence as the Chase School of Art, named after the famed American painter William Merritt Chase (1849–1916), who was the school's principal instructor. The school changed its name to the New York School of Art in 1898, but often students still referred to it as "the Chase School." Unfortunately the student records from this school have been lost, so it's impossible to confirm which teachers Rosen studied with; information on his teachers is contained in a chronology written by the artist's daughter Katharine Warner, in AAA. Frank Vincent DuMond (1865–1961) was a well-known Connecticut impressionist painter who taught principally at the Art Students League in New York City, but he also taught at the New York School of Art.

16. Goff interview.

17. The Criterion Theater was part of a huge entertainment complex known as "Hammerstein's Olympia," built on Times Square in the late 1890s by famed theatrical entrepreneur Oscar Hammerstein, grandfather of the renowned lyricist Oscar Hammerstein II. The building took up a full city block and had three theaters as well as a bowling alley, a pool hall, and a Turkish bath. It was torn down in 1935. Information is from William Morrison, *Broadway Theatres: History & Architecture* (Mineola, N.Y.: Dover Publications, 1999), 25–26.

18. Smith, *Woodstock History and Hearsay*, 83.

19. Goff interview. According to Polly, Mildred "came from a distinguished family. Her mother, Mildred Chauvenet Holden, was the daughter of William Chauvenet, who . . . founded the U.S. Naval Academy at Annapolis." Goff memoir, p. 1. Mildred's father, William Holden, must have eventually come to respect his son-in-law, because several years later Holden arranged to have Rosen paint at least three portraits of West Point administrators and teachers that were hung at the academy. Information is from a letter to Rosen in AAA, author unknown.

20. Basic information on Lathrop, Redfield, and the New Hope art colony can be found in *Pennsylvania Impressionism*, ed. Brian H. Peterson (Doylestown, Pa.: James A. Michener Art Museum; Philadelphia: University of Pennsylvania Press, 2002). More detailed studies on the two artists include Constance Kimmerle, *Edward W. Redfield: Just Values and Fine Seeing* (Doylestown, Pa.: James A.

Michener Art Museum; Philadelphia: University of Pennsylvania Press, 2004), and Brian H. Peterson, *Intimate Vistas: The Poetic Landscapes of William L. Lathrop* (Doylestown, Pa.: James A. Michener Art Museum, 1999).

21. From Margaret (Tink) Spencer, unfinished typed draft manuscript of a Robert Spencer biography, ca. 1969, p. 5. Manuscript is in the James A. Michener Art Museum archives.

22. Salpeter, "About Charles Rosen," 92.

23. In an e-mail message of April 26, 2005, the artist's granddaughter Virginia Callaway says, "It has always been my understanding that Mildred's side of the family was pretty well-to-do."

24. Information on sales is contained in letters to Rosen from various institutional officials, in AAA.

25. Letter is in AAA.

26. According to records in the Bucks County Courthouse, Mildred H. Rosen purchased the property from Dr. George Morley Marshall on December 2. 1914. It adjoined the Lathrop property and the Delaware Canal. Dr. Marshall was a childhood friend of Lathrop's; in the late 1890s he had owned the entire Phillips' Mill complex, but he sold a portion of it to Lathrop in 1899. On October 1, 1924, Mildred and Charles Rosen sold this property to Edward M. Pershing. Interestingly, the property was sold subject to a clause stating "that no liquor of any kind shall ever be sold on the above described tract of land and in the event of such sale as aforesaid the above described tract of land to revert to the said Mildred H. Rosen or her heirs." It is not known how Rosen and his wife were able to afford to build this house; possible sources of funds were income from Rosen's paintings and money from Mildred's family. According to an April 26, 2005, e-mail message from Rosen's granddaughter Kit Taylor, "Mildred's sister, Mabel, did live very well and had the fortune/misfortune to outlive three very fine husbands. Mabel may have helped them with the house." When speaking of the second New Hope house, Rosen's daughter Polly said, "My dad must have sold some paintings." Goff memoir, p. 2.

27. Rosen's travel diary is in AAA.

28. More information on Garber can be found in Kathleen A. Foster, *Daniel Garber, 1880–1958* (Philadelphia: Pennsylvania Academy of the Fine Arts, 1980), as well as in the catalogue raisonné by Lance Humphries, *Daniel Garber: Romantic Realist* (New York: Hollis Taggart Galleries, 2006).

29. Letters are in AAA.

30. The first Garber letter is undated; the second letter is dated simply "Dec. 13th." Letters are in AAA.

31. Letter from Lathrop is dated "June 30—1907, Fishers Island." Letter is in AAA.

32. Goff interview.

33. Transcribed from a telephone interview with Rosen's granddaughter Kit Taylor on April 1, 2005.

34. From a brief undated reminiscence by Folinsbee entitled "Charles Rosen, 1878–1950," in AAA. See Appendix 4 for the complete text.

35. Goff interview.

36. This story was told by Katharine's son Peter Warner in an interview on May 13, 2005.

37. Salpeter, "About Charles Rosen," 90–91.

38. Quoted in Ruth Seltzer, "The Philadelphia Scene," *Philadelphia Evening Bulletin*, June 18, 1957.

39. From an April 27, 1931, letter from Spencer to Duncan Phillips. Letter is in the archives of The Phillips Collection, Washington, D.C.

40. From an undated note found on a scrap of paper in Lathrop's studio, in the possession of William L. Bauhan.

41. Goff interview.

42. Information on Rosen's years in Columbus was provided by Elizabeth Hopkin, associate registrar, Columbus Museum of Art, Columbus, Ohio.

43. Goff interview.

44. Information on Rosen's years in San Antonio was provided by Amy Fulkerson, registrar of the Witte Museum, San Antonio; additional information is in John Powers and Deborah Powers, *Texas Painters, Sculptors & Graphic Artists: A Biographical Dictionary of Artists in Texas before 1942* (Austin: Woodmont Books, 2000), 434–35.

45. Rosen and Inglis were married on December 29, 1934, at the Church of the Saviour in West Philadelphia. Marriage certificate is in the possession of Kit Taylor.

Extensive genealogical research has determined that Jean Inglis was the niece of Annie C. Inglis, a young girl who contracted scarlet fever and was confined to a wheelchair; Annie Inglis's premature death on May 4, 1875, was the inspiration for the founding of the Inglis House, a Philadelphia institution that provides "programs and services . . . for people with severe physical disabilities" (from the Inglis Foundation Web site). John Auchinclos Inglis (Jean's father) was the younger brother of Annie C. Inglis, in whose memory Inglis House was established by Annie's parents, William Cowper Inglis and Caroline Keyser Inglis.

46. Transcribed from a telephone interview with Amy Fulkerson, registrar of the Witte Museum, conducted by Birgitta Bond on April 29, 2005.

47. Bernice L. Thomas, *The Stamp of FDR: New Deal Post Offices in the Mid-Hudson Valley* (Fleischmanns, N.Y.: Purple Mountain Press, 2002), p. 15.

48. Thomas, *Stamp of FDR*, 7.

49. Smith, *Woodstock History and Hearsay*, 84.

50. Quoted in Smith, *Woodstock History and Hearsay*, 84. Mrs. Roosevelt wrote the column six days a week between 1935 and 1962, stopping only once, for four days, after her husband died in 1945.

51. Thomas, *Stamp of FDR*, 27.

52. Smith, *Woodstock History and Hearsay*, 84.

53. Letter is in the Amherst College Archives and Special Collections, Amherst, Massachusetts; reprinted by permission of Jean Bellows Booth.

54. Cards are in the possession of Virginia Callaway.

55. Quoted in Frances K. Smith, *André Beiler: An Artist's Life and Times* (Toronto: Merritt Publishing, 1980), 35.

56. Ibid.

57. From a newspaper obituary in the files of the Woodstock Artists Association, Woodstock, New York, newspaper unknown. According to Rosen's daughter Polly, he died "of a prostate operation, with possible heart problems—very unexpected, sad!" Goff memoir, p. 3.

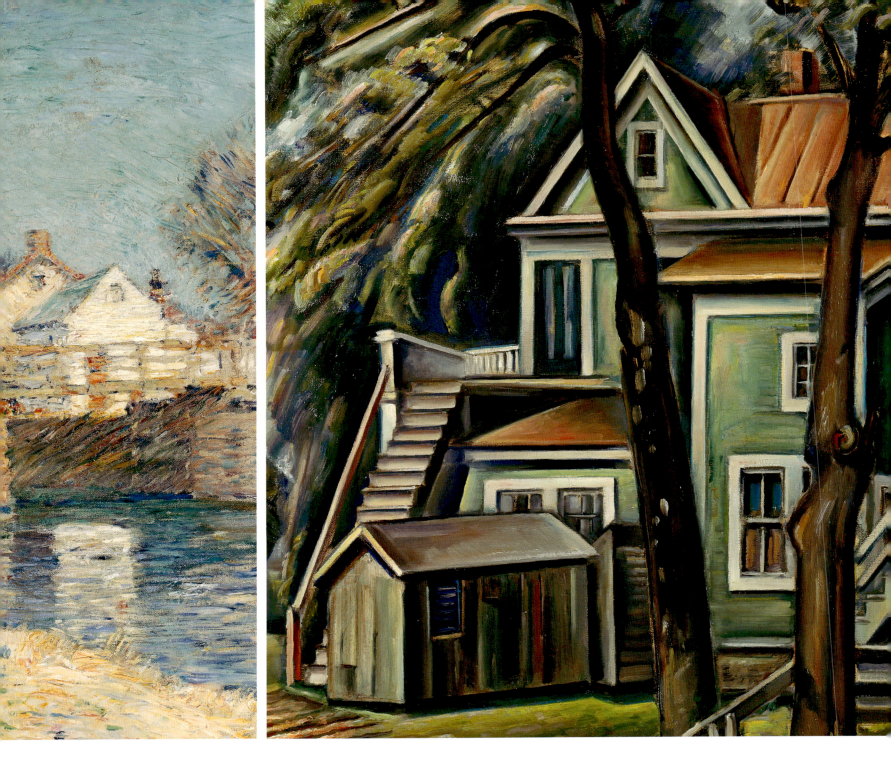

A Tale of Two Colonies:
Charles Rosen's Woodstock Years

TOM WOLF

In 1918 when the artist Charles Rosen embarked on his radical mid-career change from painting poetic impressionist landscapes to painting gritty industrial scenes in a modernist style, his artistic leap was accompanied by a change in environment. He moved from New Hope, Pennsylvania, to Woodstock, New York—from an art colony where the dominant artistic style was rooted in the nineteenth century to one where modernist tendencies were in lively competition with traditional practices.

Rosen settled in New Hope in 1903, when he was twenty-four or twenty-five years old and newly married. Having completed his art studies in New York, he moved to the art colony that had begun in 1898 when two esteemed painters, Edward Redfield and William Lathrop, took up residence there. They were followed by other painters attracted to the beautiful and varied landscape of the area, which was mostly untouched by industrialization. These qualities were shared by the art colony in Woodstock, New York; indeed, a rural, picturesque landscape was common to virtually all the sites that gave birth to art colonies, starting with the Fontainebleau colony at the outskirts of Paris in the mid-nineteenth century. The art colony movement, which began with the Barbizon painters at the Forest of Fontainebleau, came at a time when landscape, ideally painted out of doors, was the most compelling subject for painting. Colonies spread through Europe, and by the end of the nineteenth century many painters in the United States, often with experience in European art colonies, were moving to beautiful, rural, American areas with other kindred spirits.[1]

Woodstock was a different breed of art colony from New Hope in that its roots were in the British Arts and Crafts movement rather than French landscape painting practice. It was not founded by landscape painters searching for a scenic place to practice their art but by a wealthy Englishman who personally knew the men who inspired the Arts and Crafts movement in England, John Ruskin and William Morris. Ralph Radcliffe Whitehead idealistically dedicated his inherited fortune to realizing his mentors' concept of a community of art workers leading fulfilled lives in a beautiful natural setting. He was married to Jane Byrd McCall, an aspiring painter from a prominent Philadelphia family, whom he met in Florence in 1892. Mrs. Whitehead was also a personal acquaintance of Ruskin, and after they moved to the United States in 1892, the couple wanted to create a colony following his ideals. They built an estate in Montecito, adjacent to Santa Barbara, and stayed in California for a decade, fraternizing with wealthy local people who shared their Arts and Crafts ideals.

They were generous to a group of painters who had found their way to the West Coast: Leonard Lester from England, Charles Walter Stetson from Rhode Island, and William Wendt from Germany and Chicago. They were particularly close with the respected landscape painter Birge Harrison, from Pennsylvania, who had lived for some time in the French art colony at Grez-sur-Loing. Harrison would be one of the strands in the braid of relationships that connected Charles Rosen to both New Hope and Woodstock.

After a decade in Montecito, the Whiteheads were frustrated with their arty friends and with their own inability to create an art colony. They put together a team to make their fantasy real, hiring maverick poet Hervey White, as impoverished as Whitehead was wealthy, and artist Bolton Brown. Brown had recently lost his position as the first studio art professor at Stanford University because of his insistence on having nude models pose in front of coeducational figure drawing classes, which offended the widow of the founder of the university.

In 1902 Whitehead asked White and Brown to help with his search for an ideal spot for a colony, and while the former two explored North Carolina, Brown, an experienced mountaineer, hiked through the Catskills. When he came upon the little village of Woodstock, Brown decided his search was over—the area was beautiful, varied, unspoiled, and close enough to New York to take advantage of the city's cultural and business life. He sent a telegram urging his fellow searchers to come to Woodstock. Unfortunately Whitehead was biased against the Catskills, because he was anti-Semitic and feared the area was full of Jews (his prejudice would fade in his later years). But once he saw the perfection of the setting, and the possibility of buying up five farms and taking

f.1
Road leading to White Pines, Byrdcliffe, ca. 1907. Courtesy of Winterthur Library, Joseph Downs Collection of Manuscripts and Printed Ephemera

f.2
Art Building at Byrdcliffe, 2000. Photograph by Tom Wolf

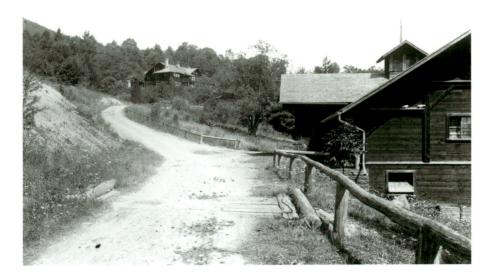

f.3

Birge Harrison (1854–1929)
Woodstock Meadows in Winter, 1909
oil on canvas
46 × 40½ inches
Toledo Museum of Art,
Gift of Cora Baird Lacey, in memory
of Mary A. Dustin, 1912.1266

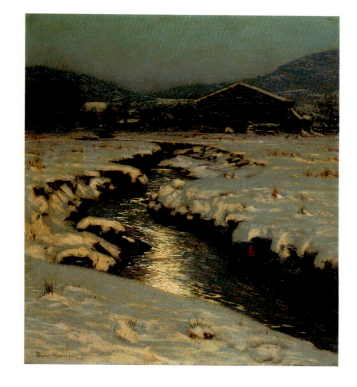

over the side of a mountain, he overcame his aversion and bought the land. Over the next year the team supervised the construction of close to thirty buildings, and then Whitehead began to invite artists, craftsmen, and students to live and work at the colony. He named it "Byrdcliffe" after his wife's middle name (Byrd) and the second syllable of his middle name (Radcliffe) (fig. 1).[2]

In this manner the Byrdcliffe colony was self-consciously created, unlike New Hope, which grew naturally as an art colony from two artists settling there because of their attraction to the area. Also, following the principles of the Arts and Crafts movement, Byrdcliffe was not exclusively for painters. Whitehead was as interested in the crafts as he was in fine art, and he built studios for woodworking, ceramics, weaving, and metalworking. At the outset the major concern of the colony was to make and market Arts and Crafts furniture. In fact, Byrdcliffe was an unusual Arts and Crafts colony because of Whitehead's interest in painting: from the start he intended to have painting taught there by accomplished artists, and he erected a building expressly for that purpose (fig. 2).

The painters who came to Byrdcliffe to teach fit a model of professional American artists current at the time: most of them had spent several years in France and specialized in landscape painting. They included Hermann Dudley Murphy and Leonard Ochtman, the latter active in the art colony at Cos Cob in Connecticut. Most influential among them, however, was Birge Harrison, whom Whitehead brought from California, and who in 1906 left Byrdcliffe to start the Woodstock summer school in landscape painting for the Art Students League (fig. 3). The Art Students League was a liberal school in New York City, which Rosen attended. It granted no degrees and had a flexible admissions policy. Over the years the league's summer school, which featured landscape painter John Carlson as its director after Harrison retired in 1911, drew hundreds of art students to Woodstock. Among them were John Folinsbee and Harry Leith-Ross, both of whom would settle in the New Hope area after studying with Harrison and Carlson in Woodstock.

There were many connections between Pennsylvania and Woodstock. Not only was Mrs. Whitehead from Philadelphia, where her father had served as mayor, but her cousin, Henry Chapman

Mercer, established a renowned Arts and Crafts ceramics manufactory in Bucks County, the Moravian Tile Works.[3] Eva Watson Schütze, the primary photographer at Byrdcliffe, was from Philadelphia, where she studied with Thomas Eakins before joining Alfred Stieglitz in founding the Photo-Secession. Birge Harrison also studied with Eakins at the Pennsylvania Academy. Around 1914, when his niece and former student, Margaret Fulton, married New Hope artist Robert Spencer, Harrison began regularly visiting the colony, and he built a studio for himself there.[4] Spencer was an old friend of Rosen's—they had studied together in New York, along with Rae Sloan Bredin, who had also moved to New Hope after finishing his studies.

Bolton Brown's initial judgment of Woodstock as well situated due to its proximity to New York was borne out as the Art Students League summer school lured many aspiring young artists from the metropolis. There was a fluid interchange between the city and the town; many artists who lived in Woodstock exhibited in New York, and those who could afford it had residences in both. After the famous Armory Show in 1913, which introduced fauvism, cubism, and other avant-garde styles to the American public, artists who commuted between New York and Woodstock were well aware of the modernist challenge to traditional representational art, particularly the young students who were fascinated by the new developments. This created tensions between those who favored the traditional ways and those who were eager to experiment. When Rosen came to Woodstock, there were three generations of American art represented there, starting with the realist landscape painters like John Carlson and other pupils of Birge Harrison. Early in the twentieth century, before the Armory Show, there was already a group of artists in revolt against conservative practice: the Ash Can school, whose members painted subjects of everyday life in the city. They were led by Robert Henri, who, to cite another New Hope connection, was a friend of Edward Redfield's.[5] The most famous artists associated with the Ash Can group were Henri and George Bellows. Henri was in Woodstock in the summer of 1920, and Bellows spent his last years there, from 1920 until his death from appendicitis in 1925 at age forty-three. He built a house there in 1922, close to the house of his good friend, Eugene Speicher, whose solidly constructed, dignified portraits made him one of the leading portraitists in the country.

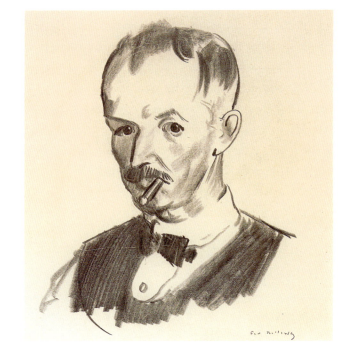

f.4
George Bellows (1882–1925)
Charles Rosen [poker sketch], n.d.
graphite on paper
9⅞ × 8¼ inches
Collection of Katharine Worthington-Taylor

The little road today called Bellows Lane is only about a mile from the busy center of Woodstock, but it seems secluded and serene. Here Bellows's house is next to Speicher's, with Rosen's house a little farther up the path (see fig. 12, page 23). The three were close friends, often driving into the countryside in Bellows's roadster for painting trips. They used members of each other's families as models and relaxed by playing poker together, often with another painter friend, Leon Kroll. The card sessions resulted in what today are called "poker portraits"—quick, spontaneous sketches of one another that despite their rapid execution are usually firmly structured and convey a vivid likeness (fig. 4).[6]

Before the Armory Show, the Ash Can school artists and their friends represented the most radical art in the country. But immediately afterward a new generation came into being. In Woodstock the pioneering modernists were Konrad Cramer, who was familiar with European modernists in his native Germany and friendly with avant-garde art dealer Alfred Stieglitz; Andrew Dasburg, who visited Matisse in Paris; and Henry Lee McFee. Rosen was actually older than any of the artists mentioned here, including his Ash Can school neighbors, but his open-minded, adventuresome spirit led him to work in a modern style that allied him with the avant-gardists, even though socially he was closest with Bellows and Speicher.

Historian Alf Evers has written about Rosen,

> Seldom did a painter make a break with one way of working and embrace another in so thorough a manner as to suggest a total rebirth. . . . Charles Rosen, who became next to McFee the most respected of the Woodstock School, made an about-face in his work which put an almost unbridgeable gulf between his earlier and later work.[7]

Certainly Rosen made a radical change in his painting style around the time he moved to Woodstock, a departure that alienated some of his New Hope friends and that took a clear position in the artistic conflicts of the time. But from today's vantage point his shift seems less extreme than it did at the time he made it. As Brian Peterson has pointed out in his essays in this book, Rosen's impressionist paintings were characterized by a restless variety rather than a unified, clearly defined style. Although he consistently painted harmonious views of natural scenes, he experimented with different types of structure and handling. His friend John Folinsbee wrote that Rosen's *Winter Sunlight*, which earned him the National Academy's Inness Gold Medal in 1916, marked the breaking point, in that Rosen said he would never paint another picture like it.[8] *Winter Sunlight* looks like a late impressionist landscape rather than an early one (pl. 26). It is traditionally impressionist due to its realism, its concern with atmosphere, and the calmness of the scene. But the entire foreground area can read as a flat plane of white as well as a snow-covered piece of riverbank, and its strong diagonal placement recalls the compositions of many Japanese prints, which had a great influence on the avant-garde artists of the generation preceding Rosen's. This is very much a painting of its time, the late nineteenth or early twentieth century, in that elements of abstraction are inexorably making themselves felt despite the painting's apparent realism.

Three paintings that depict water in motion, unfortunately none of them dated, suggest some evolution behind Rosen's sudden change. *Tumbling Brook* (ca. 1916; pl. 32) is a lovely evocation of a secluded bit of nature, with water rendered by the independent strokes of pure color that characterize impressionist painting. But those strokes are large enough to suggest independent planes, and in retrospect they convey a latent will to structure on the part of the artist. *A Rocky Shore* (ca. 1917; pl. 31), with its deep space and luminous sky, is again acceptably conservative. But a detail of the water flowing over rocks in the foreground shows that Rosen treated it

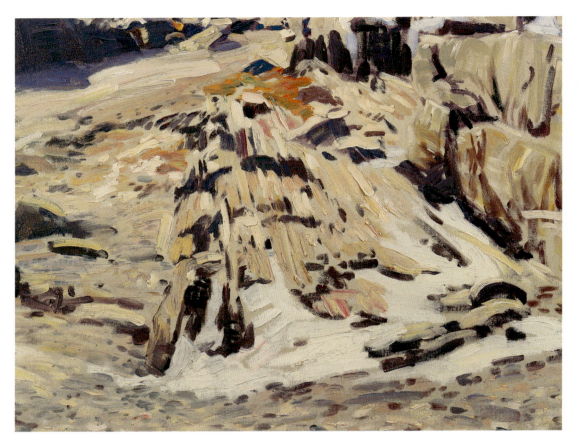

f.5
A Rocky Shore, ca. 1917 [detail, pl. 31]
oil on canvas
32 × 40 inches
Private collection

not as a series of graceful art nouveau curves, as in the earlier *Icebound River* (ca. 1915; pl. 13), but as a bunch of parallel, rectangular strokes, sumptuous in the delicacy and variety of their color, but clearly geometrical (fig. 5). If this passage seems like an intrusion in an otherwise lyrical painting, in his later *Waterfall* those forces have taken over, as Rosen created an energized evocation of the tumult of nature, rather than a quasi-photographic depiction of a slice of it (pl. 66). In this amazing painting he heightened his color and zoomed in on the surging water, representing it with a cascade of planar, geometric strokes and a pearlescent range of hues, dominated by pale blues. This painting is as abstract as his work became, and it suggests that he was looking at the totally abstract paintings that his younger friends, Cramer and Dasburg, had painted in the years after 1913, or even the abstractions of the synchromist painter Morgan Russell, a good friend of Dasburg's.

It is often said that a retrospective exhibition is traumatic for an artist, and Rosen's move to a modernist style was preceded by an exhibition of his impressionist works in 1917 that traveled to five cities and coincided with his being elected a full Academician at the National Academy of Design, the stronghold of artistic conservatism.[9] His change in style was dramatic, and his late paintings are distinctively different from his earlier ones—but the impulses that encouraged his change are suggested, with the benefit of hindsight, in his earlier works. The painter who was his greatest inspiration in his new phase was Paul Cézanne; a framed reproduction of a still life by Cézanne hung in Rosen's Woodstock house. Cézanne had painted in an impressionist style himself before becoming dissatisfied with it because of its lack of firm structure, an evolution Rosen echoed. In addition, in the later teens Rosen's daring younger friends, Dasburg, Cramer, and McFee, had pulled back from the aggressive abstraction they briefly adopted after the Armory Show, and the works of each suggest a personal exploration of the innovations of Cézanne (fig. 6).[10] Still, in

the context of American art, Rosen's move was a radical one, as he boldly followed his sensibility instead of sticking to a commercially successful style.

His drawing *Speicher's House* (1940; fig. 7) salutes the neighborly proximity of his friend in Woodstock. Compared to Bellows's *Landscape, House and Hill* (1922; fig. 8), which may depict one of the three houses on Bellows Lane, it demonstrates how modernist Rosen's style was. Bellows's house is a cubic solid set behind a foreground of grasses, in front of a hill backed by a spacious sky. When Rosen depicted Speicher's house, he rejected this traditional illusionistic space, instead moving the house close to the picture plane and framing it with foliage above. He let his image fade out before it reached the edge of the paper on all sides, and he consistently created geometric forms but refused to close them into discrete shapes. For example, the diagonal of the roof bleeds into the wall below it, so a clear reading in depth is thwarted. This is the open or "transparent" plane of Cézanne, which had a great influence on cubism. It is evident again in the shed at the lower left of Rosen's drawing, which is realistic at the right but fades into the flat paper at the left, so it is both solid and elusive at once.

Speicher's House comes fairly late in Rosen's modernist career, and his drawings are often more experimental than his paintings. Still, his early modernist paintings, like *Village Bridge* (ca. 1919, pl. 38), reveal his new concern for geometry, as in the right angle made by the vertical of the tree at the left intersecting with the horizontal of the bridge. The painting does not display the fragmented forms of the later drawing, but the artist's interest in an intricate play of geometrical forms is clear. The same concerns are evident in *Round House, Kingston, New York* (ca. 1927; pl. 40), with its muscular contrasts of curves versus diagonals, verticals, and horizontals. These are locked into place by the dominant cylindrical tower that rises in the foreground, to be capped by the emphatic horizontals of the shed that closes off the composition at the top. This painting belies critics who claim that in his stylistic transition Rosen sacrificed color for form, because the subtle and varied palette here, from blue grays to green grays to accents of orange and yellow, is as rich as that in his former impressionist works, only here it is harnessed by the strong geometry that holds it firm.

Rosen's dramatic change of style in the late teens was accompanied by new subject matter. No more waterfalls or trees delicately overhanging rivers—now he focused on architecture, which

f.6
Andrew Dasburg (1887–1979)
Landscape, 1920
graphite on paper
12⁷⁄₁₆ × 15½ inches
Whitney Museum of American Art, New York; Gift of Gertrude Vanderbilt Whitney

f.7
Speicher's House, 1940
graphite on paper
11¼ × 15½ inches
Collection of Katharine Worthington-Taylor

provided ready-made geometries for his canvases, as opposed to the irregularities of nature that animated his earlier works. In some works there is an interplay between the two, as in *The Viaduct* from 1926, where the paired arches hark back to the Roman aqueducts of antiquity that have been represented by classicizing painters from Poussin to Corot to Cézanne (fig. 9). Here their stable forms are overlapped by a disorganized tangle of branches that suggests the random, uncontrolled forces of nature beloved by romantic artists. But often in his later works trees and lawns are domesticated and subservient to the buildings that dominate the scenes. The industrial revolution was history; machines and the hard-edged forms they produce are facts of modern life. The architecture that appears in many of Rosen's modernist paintings is markedly utilitarian. Although people are usually absent from these scenes, Rosen's railroad sheds, docks, stone quarries, brickyards, and sawmills are the working places of blue-collar laborers. His affinity with the Ash Can school painters is clear in his choice of architectural subjects: this is where the people in Ash Can paintings would have their jobs if they lived upstate. The paintings move toward modernism in their style while in general they remain true to the proletarian subject matter of Bellows's New York City paintings.

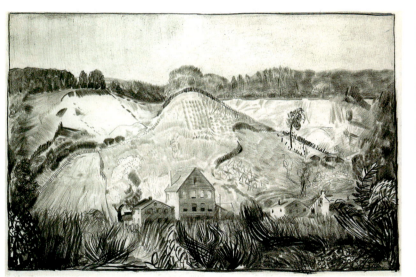

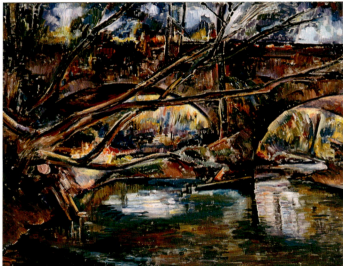

f.8
George Bellows
Landscape, House and Hill, 1922
graphite on paper
11 × 16 inches
Collection—Hahn, Loeser & Parks LLP,
Cleveland, Ohio

f.9
The Viaduct, 1926
oil on canvas
27 × 34 inches
Federal Reserve Board, Washington, D.C.,
Purchased with funds given by the Prince
Charitable Trusts in honor of the twentieth
anniversary of the Fine Arts Program

One of Rosen's favorite subjects was tugboats. He characteristically avoided more glamorous ships, like battleships or ocean liners, to concentrate on the rugged little boats whose function was to tow cargo and large boats. His painting *The Robert A. Snyder* (ca. 1938; fig. 10) is exceptional in his work in that he portrayed a specific boat in the process of its destruction. The *Robert A. Snyder* was a steamship, built in the mid-nineteenth century, that had seen service in the Civil War and had worked up and down the Hudson River for years.[11] In 1931 the boat was retired and docked in Saugerties, a town neighboring Woodstock, where eventually its hull developed a hole and it slowly began to sink. In the painting the listing boat, overcome by the water that surrounds it, is set before a church and some active industrial buildings on the shore. As in many of Rosen's works, man's creations are contrasted with the forces of nature. The closest prototypes can be found in classics of nineteenth-century romantic painting like J. M. W. Turner's *The Fighting Temeraire Tugged to Her Last Berth*, Caspar David Friedrich's *The Polar Sea*, and Frederic Edwin Church's *The Icebergs*, with their threatened or wrecked ships. But, despite the pathos of his subject, Rosen typically shunned the spectacular landscapes that his predecessors favored for a modern, deadpan rendering of his

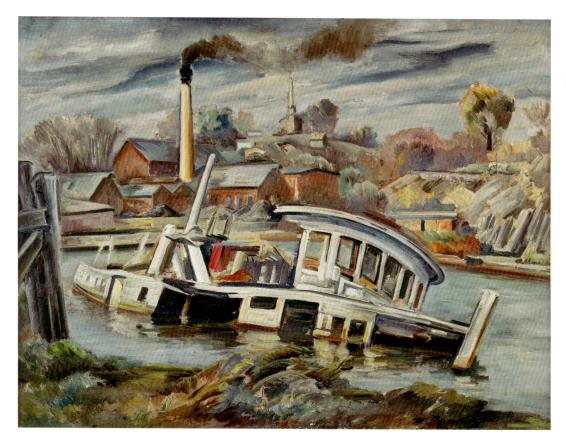

f.10
The Robert A. Snyder, ca. 1938
oil on canvas
32 × 40 inches
Collection of Holly Goff

melancholy theme. Nevertheless, the slowly sinking boat is an image of death, while the church on the shore suggests that physical decline can be accompanied by spiritual transcendence.

Those who wrote about Rosen's subjects paralleled the course of his artistic evolution. Birge Harrison, during Rosen's early phase, felt that "he is equally happy as a painter of the sea, of the wide and snowswept winter landscape, and of the tender moods of early spring and summer."[12] A dozen years later, when she reviewed Rosen's 1928 show at the Rehn Galleries, Helen Appleton Read observed, "He deliberately eschewed the charming, emotional aspects of nature and used the drabbest of subject matter in order that alluring subject matter might not deter him from his purpose." She praised the "sobriety and austerity" of the paintings as "an integral part of the American artistic tradition."[13] When Harry Salpeter profiled the artist for *Coronet* magazine in 1939, he was intolerant of the early works, "stated in the evasive conventions of academic sentimentalism." He wrote of Rosen's prizewinning 1916 painting, "It happens that *Winter Sunlight* is a terrible painting; any one of the comparatively recent pictures reproduced with this article is a masterpiece by contrast."[14] Salpeter felt that Rosen's new style was "honest and sincere," but, perhaps because he was writing for a mass circulation magazine, he reproduced only the most conservative and representational of the artist's paintings, static views of industrial scenes or modest houses that are closer to Edward Hopper (a student of Henri's) than to Cézanne.

During the Depression years of the 1930s, Rosen lived with his wife and two daughters in Woodstock. His career took a new turn when he was selected to paint a series of government-sponsored post office murals—three major ones in Beacon, New York; Palm Beach, Florida; and Poughkeepsie, New York. These paintings gave Rosen a chance to work on a huge scale, in public, employing the more conservative side of his structural, modernist style. Since post office murals around the country were financed by the government, the administrators and the public had a voice in their

41

content and imagery. Consequently most were representational, illustrating historic subjects relevant to the cities that housed them, and very few approached the abstraction of Arshile Gorky's Newark post office mural.[15] In Rosen's case, his Beacon and Poughkeepsie murals were painted under the eye of President Franklin D. Roosevelt. The president grew up in the area where the post offices were built; he not only had a strong interest in the federal mural projects that he spearheaded, but he was a serious student of the history of his native region. He specified that the post offices themselves be built in a style that reflected the colonial architecture of the region, and that all be made of local fieldstone.[16]

Rosen's versatility is again apparent in these ambitious murals, as each of the three has a different format: in Beacon his painting covers the entire interior above the wainscoting; in Palm Beach he painted three panels for one wall; his Poughkeepsie mural is a single, panoramic scene. The Beacon mural, completed in 1937, was in the town where FDR campaigned early in his political career, the hometown of Henry Morgenthau Jr., secretary of the U.S. Treasury, the government agency that commissioned the murals.[17] Morgenthau, his wife, and Eleanor Roosevelt visited Rosen in his Woodstock studio to inspect the Beacon murals as he was working on them.[18]

The artist devised a scheme that filled every wall on the interior of the building with imagery relating to Beacon. He was assisted in executing the paintings by artist Clarence Bolton, today best known for his lithographs of Woodstock landscapes (fig. 11). Two scenes are particularly striking: the forty-foot wall above the clerks' window that features an illustrated map of the Hudson River, and the arched lunette on the east wall that contains a view of Beacon from the river. The map depicts the Hudson as it runs from New York City, with a group of skyscrapers that includes the famous Chrysler Building, to the town of Hudson. Beacon is in the center of the map. The serpentine river is supplemented by illustrations of historic sites along the way. They range from the Revolutionary War, including Washington's headquarters in Newburgh and the Kingston Senate House, to the present, including Vassar College in Poughkeepsie and Franklin Roosevelt's home in Hyde Park. At the beginning, a nineteenth-century clipper ship sails up the river past the home of author Washington Irving in Sunnyside, while farther north a steamboat powers along between West Point and Beacon. The two boats represent a continuity between the historic past and the industrialized present, a theme that Rosen would reprise in other scenes. The map concludes at the right with the Rip Van Winkle Bridge, just completed in 1935, and a sketch of white-bearded Rip

f.11
Rosen and Clarence Bolton at work on Beacon mural, 1937. Courtesy of Katharine Worthington-Taylor

f.12
View of Beacon, Beacon post office mural. Photograph by Ben Caswell

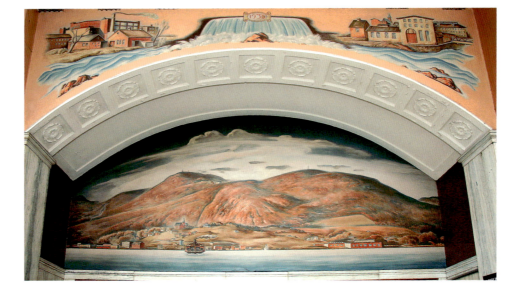

Van Winkle peering down the river toward the home of Washington Irving, the author who created him, whose house begins the cycle. As a whole, the map not only handsomely covers the wall but it illustrates the history of the New York State area north of Manhattan.[19]

In Rosen's expansive view of Beacon seen from the river, the curving hills complement the arched frame of the scene, and a ferry boat chugs across the river toward the shore (fig. 12). The redbrick building to the right of center was the Nabisco box factory. Now it is the Dia art center, showing recent installation pieces by artists well known today, most of them probably unaware that a painted installation by Charles Rosen including maps and local history can be seen a few miles from their works at Dia.[20]

Rosen and his wife moved to Florida for the winter of 1938 in preparation for his next mural, in the post office at Palm Beach, again financed by the Section of Fine Arts of the Treasury Department. Once more he chose a local subject, but this time, unusual for him, his paintings centered on figures. The three-panel scheme was a reaction to the configuration of the wall, as the panels fit between the sculptural brackets that thrust down from the ceiling beams (fig. 13).

For the large central panel Rosen painted scenes from the everyday lives of the Seminole Indians, Native Americans indigenous to Florida, resulting in a sort of exotic Ash Can school rendering of everyday life. He did research in Florida to aid him in accurately depicting the Seminoles, consulting with a local expert and spending time with members of the tribe. His first profession, when he was sixteen years old, was as a photographer, and he used these skills to make photographic studies of the tribespeople, emphasizing their costumes, which he greatly admired (fig. 14). He

f.13
Mock-up of Palm Beach mural, ca. 1938/39. Courtesy of Katharine Worthington-Taylor

f.14
Photographic study of Seminole Indians by Charles Rosen, ca. 1938/39. Courtesy of Charles Rosen Papers, Archives of American Art, Smithsonian Institution

f.15
Pencil study for Palm Beach mural [Seminole woman], ca. 1938/39. Courtesy of Katharine Worthington-Taylor

f.16
View of Palm Beach Post Office mural,
2006. Photograph courtesy of Patty
Wiedman

f.17
Study for Poughkeepsie in 1839 [post office
mural competition], ca. 1939
colored pencil on paper
8½ × 34¾ inches
Collection of Katharine Worthington-Taylor

f.18
Study for Poughkeepsie in 1939 [post office
mural], ca. 1939
gouache and watercolor on paper
9 × 34⅞ inches
Collection of William B. and Sally M. Rhoads

supplemented his photographs with sketches from life (fig. 15). The result was three scenes of life and work among the Native Americans: a man fishing next to a canoe, another plucking a turkey, and, in the center, a cycle-of-life group of a woman grinding grain while an old woman works on a doll and a girl watches. An off-white background vignettes the scenes and makes the ensemble luminous. In the two flanking panels, he depicted palm trees whose uprightness fit gracefully into their vertical formats. In the left panel the palms stand straight against the man-made edge of a lake, while at the right they sway and curve at the shore of the ocean (fig. 16).[21]

In 1939 Rosen won the last of his mural commissions, a panel for the Poughkeepsie post office, which art historian Bernice L. Thomas, in a study of five post offices executed in New York during the presidency of Franklin Roosevelt, calls "the premier post office in the mid-Hudson Valley."[22] It was the largest and most expensive of the five, and Rosen won a competition between eighteen local artists to get the job. The second floor of the interior was already decorated with three large murals by Gerald Foster illustrating the early history of the town. Then it was decided that two oblong murals depicting Poughkeepsie in 1839 and 1939 would be executed by Rosen and another Woodstock artist, Georgina Klitgaard. She painted the earlier scene, based on an 1834 view of the town. This division of labor was fortunate for Rosen, as Klitgaard ran into problems with the president about historical accuracy, and when it came to the ships of the mid-nineteenth century, Roosevelt (the former assistant secretary of the navy) had strong feelings.[23]

Before the committee split the commission between the two artists, Rosen had applied for both parts. In his *Study for Poughkeepsie in 1839*, steamships and sailboats travel the river, and the scene is framed by two trees in the right foreground (fig. 17). In the 1939 version some of the ships have been replaced by the sculls of the Poughkeepsie regatta, an annual event that local authorities wished to have documented in the painting (fig. 18). At the left the Poughkeepsie railroad bridge has been introduced, and at the right the trees have disappeared, with the powerful industrial forms of the Mid-Hudson Bridge taking their place. As art historian William Rhoads has pointed out, the dominating bridge at the right is a special tribute to President Roosevelt, under whose auspices it was completed.[24]

Rosen created a harmonious and powerful composition for his Poughkeepsie view, with three parallel horizontal zones of the river, the town, and the sky, galvanized by the powerful intrusion of the bridges. The post office itself, its pedimented façade topped by a tower, pokes into the sky at the left of center. The artist was able to create a documentary, realistic rendering while

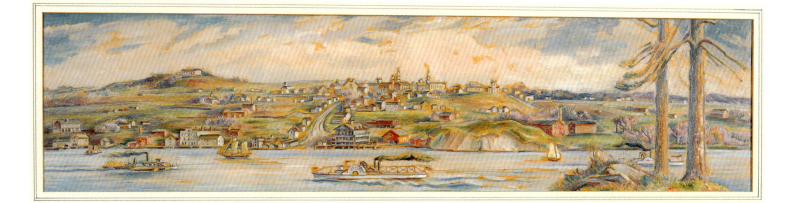

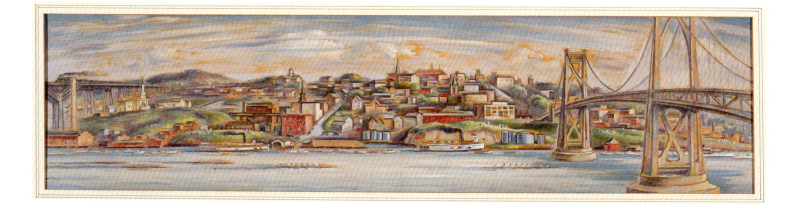

still incorporating his modernist interest in structure. The many cubic buildings, the cylindrical smokestacks, and the conical towers underlined by the horizontal boats of the regatta provide a crisp geometry that Cézanne might have admired.

By the end of World War II, Rosen was sixty-seven years old and had accomplished a great deal, with his much-appreciated impressionist works, his daring modernist paintings, and the large, ambitious murals of the late 1930s. With his adventuresome spirit he was able to push his art in new directions during his last decade, developing a more dynamic version of his modernist works that ended his career with an exciting and affirmative finale. Rosen's *Three Tugs* (ca. early 1930s; pl. 63) provides an example of the realist side of his modernist work. There are no cubist open planes here; the scene of the river and its moored boats is clearly legible. But compared to *Ship Chandler's Row* (fig. 19), painted in 1926 by Robert Spencer, one of Rosen's antimodernist New Hope friends, Rosen's depiction is less atmospheric, more streamlined, and composed with greater insistence on geometry, as in the repeated verticals of the smokestacks of the boats. While handpowered rowboats dominate Spencer's painting, the smoking stack of Rosen's third boat represents modern industry. Rosen often drove to the town of Kingston, south of Woodstock, to sketch the boats in the Rondout Harbor. In a late version of this beloved theme, he exploded the firm composition of his early 1930s *Three Tugs*, opening up the forms and painting them with a sketchy spontaneity that infuses the scene with energy (pl. 81). While the structuring verticals and repeated diagonals are evident, the sky is indicated with a few quick strokes of bright blue against the white ground, and the boats are rapid slabs of color with geometrical strokes overlaid. This is his ecstatic late style, evident in the many still-lifes he executed at the end of his career (fig. 21).[25] By the 1940s many of

f.19
Robert Spencer (1879–1931)
Ship Chandler's Row, 1926
oil on canvas
30 × 36 inches
The Phillips Collection, Washington, D.C.

his artist friends were painting sober, solidly constructed still lifes that were quite handsome but conservative. These include Speicher; Carl Eric Lindin, a mainstay of the Woodstock scene; as well as the formerly avant-garde Henry Lee McFee (fig. 22). Among the other Woodstock modernists, Konrad Cramer had switched from painting to experimental photography, and Andrew Dasburg, after being incapacitated by a long illness, was making abstracted landscape drawings in New Mexico. Rosen's late works, despite the fact that he was a decade older than Dasburg, are comparable in their freeing form from representation while maintaining some fidelity to actual objects (fig. 20).

Immediately after Rosen's death in 1950, Eugene Speicher wrote, "the little town of Woodstock is in tears. Deeply loved by everyone who knew him for his sweetness, understanding and tolerance . . . he leaves one of the tenderest memories."[26] Another newspaper notice claimed, "Charles Rosen, during his lifetime, was considered one of the sweetest, kindest and most sympathetic artists to have ever lived here."[27] This was a man who, when the Klu Klux Klan burned a cross in Woodstock, wrote a letter of protest to be published in a local newspaper.[28] During his lifetime many photographs were published of him. Often he is a serious, dignified artist, sometimes a member of an important art jury. But in several that catch him spontaneously, he is lightheartedly clowning around, dressed in a tutu for a festival at Woodstock's Maverick colony (page 24), or playing at making love to a statue of a half-nude woman (page 172).

In 1939 Rosen wrote out a drawing lesson for his granddaughter, Kit, which articulated many of his practices (Appendix 6). Typically it began with a tolerant, open-minded statement that "It is not *HOW* TO DRAW. It is just *ONE WAY*." Rosen went on to say, "it is not just *outlines* filled in very carefully and neatly with color. The color is allowed to 'spill' over the edges. . . ." He mentioned contrasting types of lines, and concluded, "You might try to make a drawing by putting the color on first—you can make the 'lines' in color as well as in black."[29] This conveys a sense of how Rosen

went about creating his late works: putting down passages of color and relying on his long experience as an artist to spontaneously add a variety of lines and shapes that become flowers in a vase—in a dynamic, energized universe. At the time of his death in 1950, the new generation of abstract expressionists was rising to prominence. Like Rosen, many of these artists had been supported by the government's art projects during the Depression years. Although he was a painter at the end of his career, he still managed to intuitively catch some of their innovative gestural spontaneity in his late works, which express his open-minded and experimental nature, as well as his love of life and of art. As for those of us in his twenty-first-century audience, we are no longer in a position where we feel obliged to accept one style of his painting and reject another. We are free to appreciate all aspects of his rich and varied art.

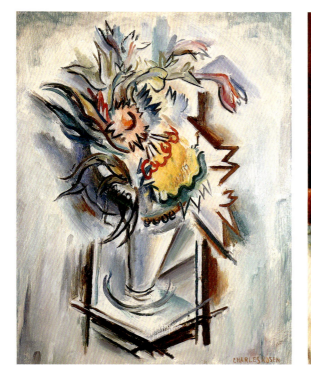

I would like to thank Brian Peterson for inviting me to participate in this project and directing it in an admirable and professional fashion; Birgitta Bond; John Bocchino; Martin Kramer; William Rhoads; Judy Throm of the Archives of American Art; Robert Murphy, president of the Beacon Historical Society; Franklin Riehlman of Riehlman Fine Art; Terry Zigler and Patty Wiedman of the Florida postal service; Ellen Sylvester of the Beacon Post Office; and Kit Taylor, the artist's granddaughter, who was unfailingly generous and helpful. —TW

1. For a survey of the art colony movement, see Michael Jacobs, *The Good & Simple Life: Artist Colonies in Europe and America* (Oxford: Phaidon Press, 1985).

2. The founding and subsequent history of Byrdcliffe are discussed in *Byrdcliffe: An American Arts and Crafts Colony*, ed. Nancy Green (Ithaca, N.Y.: Herbert F. Johnson Museum of Art, 2004).

3. White Pines, the Whiteheads' house at Byrdcliffe, features a fireplace with tiles by Mercer.

4. Andrea F. Husby, *Birge Harrison: Artist, Teacher and Critic* (Ph.D. dissertation, City University of New York, 2003), 130.

5. Constance Kimmerle, "Edward Redfield," in *Pennsylvania Impressionism*, ed. Brian H. Peterson (Doylestown, Pa.: Michener Art Museum; Philadelphia: University of Pennsylvania Press, 2002), 200.

6. For more poker portraits see Marjorie Searl and Ronald Netsky's exhibition catalogue *Leaving for the Country: George Bellows at Woodstock* (Rochester, N.Y.: Memorial Art Gallery, 2003).

7. Alf Evers, *Woodstock: History of an American Town* (Woodstock, N.Y.: Overlook Press, 1987), 524.

8. John Folinsbee, "Charles Rosen, 1878–1950," in the Charles Rosen Papers, Archives of American Art, Smithsonian Institution (hereafter AAA), roll 1119. See Appendix 4 for the complete text.

9. He showed at the Pratt Institute in Brooklyn in November 1916 and then in 1917 at the Art Club of Erie, the Art Institute of Chicago, the Buffalo Fine Arts Academy, and the Hackley Art Gallery in Michigan.

10. The exploration of Cézanne's style after a leap into abstraction by these artists is discussed in my Ph.D. dissertation, *Konrad Cramer: His Art and Its Context* (Institute of Fine Arts, New York University, 1985).

11. For the *Robert A. Snyder*, see Capt. William O. Benson, "The Steamboat Named for Ulster County," 1972, and his "The End of the 'Robert A. Snyder,'" sources not given, AAA, roll 1119, fr. 645 and fr. 431.

12. Harrison, 1916, quoted in Thomas Folk, *Charles Rosen: The Pennsylvania Years (1903–1920)* (Greensburg, Pa.: Westmoreland County Museum of Art, 1983), n.p. Harrison's statement appeared in the introduction to the catalogue of Rosen's one-man show at Pratt Institute in November 1916, AAA, roll 1119, fr. 541.

13. Helen Appleton Read, "Charles Rosen," *Brooklyn Daily Eagle*, March 4, 1928, AAA, roll N736, fr. 209.

14. Harry Salpeter, "About Charles Rosen: Spurning Easy Success, He Had the Courage to Build Anew on a More Honest Foundation," *Coronet* 5 (February 1939): 93.

15. There is a large literature about Depression-era post office murals, with the classic texts being Marlene Park and Gerald E. Markowitz, *Democratic Vistas: Post Offices and Public Art in the New Deal* (Philadelphia: Temple University Press, 1984) and Karal Ann Marling, *Wall-to-Wall America: A Cultural History of Post-Office Murals in the Great Depression* (Minneapolis: University of Minnesota Press, 1982).

16. William Rhoads, "Franklin D. Roosevelt and Dutch Colonial Architecture," *New York History* 54 (October 1978): 430–64; and "The Artistic Patronage of Franklin D. Roosevelt: Art as Historical Record," *Prologue, Journal of the National Archives* 15 (Spring 1983): 421. William Rhoads has been extremely generous in sharing his research with me for this project.

17. Bernice L. Thomas, *The Stamp of FDR: New Deal Post Offices in the Mid-Hudson Valley* (Fleischmanns, N.Y.: Purple Mountain Press, 2002), 11. Thomas's informative publication discusses Rosen's Beacon and Poughkeepsie murals, with reproductions.

18. "Mural Paintings for New Beacon Post Office," *Beacon News*, March 20, 1937. Thank you to Robert Murphy of the Beacon Historical Society for bringing several Beacon publications about the murals to my attention. Eleanor Roosevelt wrote about her visit to Rosen in her syndicated newspaper column, My Day, AAA, roll 1119, frame 442.

19. Some of Rosen's sketches for the Beacon murals were reproduced in Forbes Watson and Edward Bruce's *Art in Federal Buildings,* vol. 1 (Washington, D.C.: D.C. Art in Federal Buildings Inc., 1936). The drawing for the map has virtually no regional monuments represented. A letter to Rosen from artist Olin Dows, chief of the Treasury Relief Art Project, discusses the results of a group review of Rosen's studies for the project and suggests he add "details of interest" including the Roosevelt house in Hyde Park, local churches, and historic houses to the map. The letter is dated February 27, 1936, and also has recommendations concerning color. It can be found in the National Archives, Record Group 121; I am grateful to William Rhoads for bringing it to my attention.

20. Rosen treated the walls opposite the mural, flanking the entrance, in a fairly summary fashion, depicting a map of the state in silhouette with only Beacon indicated, and a similar map of Dutchess County. A third wall features the seals of Dutchess County and of Beacon. Entering the post office, one sees arches to both sides. Rosen painted both with centered waterfalls, their water flowing down the curves of the arches. One scene is labeled 1832 and depicts the Old Power House above the waterfall; the other, labeled 1930, features similar signs of productivity, but with modernized buildings with large glass windows and a steaming smokestack (fig. 12). Beyond the arches, the wall to the west is punctured by a large window. Rosen painted a hill and sky to the left, and at the right the local Methodist church, which actually stands a few hundred yards beyond the post office. Rays of light shine down on it, and Rosen juxtaposed its Gothic spires with a modern telephone pole.

21. A local newspaper writer felt that here Rosen juxtaposed the wild nature of the Everglades with the developed shoreline of Ocean Boulevard, contrasting history with the present, "the primitive Everglades with the modern coastal beauty." Information about Rosen's Palm Beach murals can be found in clippings from Florida newspapers preserved in AAA, reel 1119.

22. Thomas, *Stamp of FDR,* 27.

23. The Poughkeepsie commission and Klitgaard's travails are detailed in Karal Ann Rose Marling, *Federal Patronage and the Woodstock Colony* (Ph.D. dissertation, Bryn Mawr College, 1971), 501–8.

24. Rhoads, "Artistic Patronage of Franklin D. Roosevelt," 16.

25. Elizabeth Ives Bartholet, in a brochure about a retrospective exhibition of Rosen's works from 1964, wrote that he had a heart attack in 1942 and thereafter concentrated on making drawings and pastels—though it seems several small oils exist as well. AAA, roll 1119, fr. 263.

26. Eugene Speicher, quoted in "Charles Rosen, N.A., Noted Artist Dies in Kingston Hospital," source not given, AAA, roll 1119, fr. 489.

27. "Woodstock Gallery Pays Tribute to Charles Rosen," source not given, AAA, roll 1119, fr. 432.

28. Charles Rosen, quoted in Marion Bullard, "Sparks," source not given, AAA, roll 1119, fr. 471. Alf Evers described a Ku Klux Klan cross burning in Woodstock in 1924 and wrote how the Klan "did not win substantial approval in Woodstock and it soon vanished from public sight." Evers, *Woodstock: History of an American Town,* 493.

29. Letter in the collection of Katharine Worthington-Taylor, Woodstock.

BRIAN H. PETERSON

Form Radiating Life:
The Paintings of Charles Rosen

Charles Rosen's grandson, Peter Warner, was in his mid-teens when Rosen died—old enough to be left with some very clear memories. More than fifty years after his grandfather's death, in a lunchtime conversation on the terrace of the Michener Art Museum, Mr. Warner suddenly put down his sandwich and stared into space with an intense look in his eyes. "I remember when I was a kid asking my grandfather why he painted so many tugboats. I've never forgotten his answer: 'Because they have the curve of the bow and the square lines of the cabin.'"[1]

There were many ways that Rosen (fig. 1) could have answered this question. He could have talked about the colorful lore of tugboats, or a happy childhood experience riding in a tugboat, or the way he identified with sturdy tugboats as they pushed giant ships up and down the Hudson River, or how tugboats reminded him of people, with windows like eyes and padded hulls like broad, muscular shoulders (see pl. 63; detail at left). Rosen's response actually feels a bit clinical, given the age of his grandson and the innocence of the question. But the artist in him couldn't help but answer truthfully. Rosen's main love in his Woodstock period was more the lines and shapes inscribed by things than the things themselves. This is not to say that in his Woodstock years he had no interest in the visual universe, or that almost all of his paintings in those years were not grounded in direct observation of the shanties, piers, train yards and, yes, tugboats of the Woodstock area. But Rosen saw the world less as a place full of objects with stories to tell and more as rich source material for pictures that move, that dance with a complex rhythm of line and curve.

It's easy to imagine one of Rosen's daughters, some twenty or thirty years earlier, asking him a similar question: "Daddy, why do you paint so many rivers and trees?" His answer would not have been, "Because of the curve of the river and the straight lines of the tree trunks." He might have talked about how he loved the calm of an icy river as the first rays of morning sun hit the shore, or the way a certain tree seemed to glow and shimmer on a sunny spring afternoon. This is not to say that in his New Hope years he was unaware of the music of visual design—how a tree with its powerful vertical lines could anchor a picture, how a river with its broad curves could sweep gracefully around the anchoring trees. But Rosen's landscapes are primarily about feeling, not form.

So this is the first and most important point that must be made about Rosen's work: the transformation in his paintings was radical, relatively sudden, and downright shocking. Once the change

f.1

Portrait of Charles Rosen, 1937. Photograph by Yasuo Kuniyoshi. Image is courtesy of the Yasuo Kuniyoshi Papers, Archives of American Art, Smithsonian Institution

was made, it was more or less irrevocable. It's perfectly understandable that even sophisticated art lovers would be confused by this, and why, as previously discussed, his New Hope and Woodstock canvases appear to have been made by two different people.

Any attempt to understand Rosen's work has to start with a simple question: what happened? In other words, what forces, either internal or external, drove him to make this profound change in his work? There's another important question that may be related to the first: what are the connections between the New Hope and Woodstock paintings? The differences are obvious—but are there any similarities?

The problem of motivation—why his work changed—touches on the much larger question of how and why change occurs in any artist's work, and even more how artists arrive at any singular way of working. On the one hand, art making is a communal act—it almost always takes place within a community. That community may be local, rooted in connection with a place, like the New Hope and Woodstock art colonies where Rosen lived and worked. Or the community may be much larger and less well defined—of like-minded artists, of artists in general, and even of entire nations and cultures. Rosen, like most creative people, had his eyes and ears open to what was going on around him. Both his New Hope and Woodstock paintings were strongly affected by these external, cultural forces. But he was also an individual, with his own history and character, his own inner life. These external forces influenced him in *particular* ways that grew out of his interests and predilections.

An easy, simplistic way of summing up Rosen's work would be to define him solely in terms of the external rather than internal forces. When he came of age as an artist in the first decade of the twentieth century, landscape painting was the thing to do and the place to be. From its beginnings as an independent art form in seventeenth-century Holland, landscape painting had gradually meandered through England and France, evolving from a lowly, second-class genre to its pinnacle in the late nineteenth and early twentieth centuries when it actually was considered somewhat avant-garde, having largely replaced the grand tradition of narrative and history painting as the dominant way of working. In turning to landscape as a young man, Rosen joined countless other American artists who were strongly influenced by this trend toward landscape in the larger art community.

But Rosen was actually a latecomer to the landscape arena, and in the same decade that he was learning how to do it well (1900–1909), great tidal waves of change were sweeping across Europe. In the visual arts, Pablo Picasso in France and Wassily Kandinsky in Russia were making their first bold ventures into abstraction, challenging assumptions about the relationship between image and reality that had dominated Western art since the early Renaissance. In music, Arnold Schoenberg and his colleagues were steering their compositions into the uncharted waters of atonality, in the process blowing apart an ancient and venerable system of harmony and forever altering the language of music. And in 1905 that obscure Swiss patent clerk named Albert Einstein published his radical new ideas about physics that changed our understanding of the very nature of the universe itself.

It took only a few years for these new ideas to sail across the Atlantic. Historians generally peg the date of these ideas' arrival in the United States as 1913, the year of the famous Armory Show in New York City (fig. 2), when the work of the European modernist painters was introduced to the American audience (which was, to say the least, unreceptive). Many artists were equally unreceptive, and they continued to paint traditional landscapes well into the 1930s, '40s, and '50s and beyond. But other artists were excited by the new ideas and new possibilities, including Charles

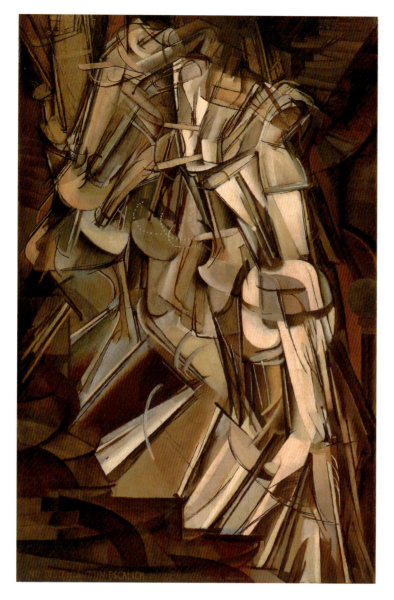

f.2

Marcel Duchamp (1881–1968)
Nude Descending a Staircase (No. 2), 1912
oil on canvas
57⅞ × 35⅛ inches
Philadelphia Museum of Art
The Louise and Walter Arensberg Collection,
1950
Copyright 2006 Artists Rights Society (ARS),
New York/ADAGP, Paris/Succession Marcel
Duchamp
The most famous painting associated with
the 1913 Armory Show, which opened the
door to European modernism in America

Rosen, who first began to think about changing his work only a year or two after the Armory Show and by the early 1920s had completely rejected traditional landscape painting.[2]

So it could be argued that Rosen was a stylistic "camp follower"—a landscape painter when it was in vogue, a modernist when it was in vogue, end of story. This kind of pigeonholing, of course, has little or nothing to do with what motivates the best artists to do what they do. While Rosen may or may not have been the best at what he did, he was certainly very good, and his work had its own story that grew out of his character and abilities: his curious mind, his poetic sensibility, and his instinctive understanding of rhythm and visual "music."

Rosen and Landscape Painting

It's easy for those of us who study artists for a living to assume that a painter makes paintings so that a hundred years later someone will show up who wants to figure them out. Rosen must have had other reasons in mind, because he rarely dated his canvases, and the records that survived him are unreliable.[3] This lack of trustworthy dates wouldn't matter if, in his New Hope years for example, he had quickly grown into one way of making landscapes that he simply cranked out year after year. But the most intriguing characteristic of his landscapes is their lack of stylistic cohesion—that is, the fact that they do not have a singular, unifying set of psychological and technical characteristics. This unusual degree of variety might lead one to conclude that because he was somewhat indecisive as a landscape painter, he shouldn't be taken seriously. But it only takes a few seconds, standing in front of one of his better landscapes, to realize that Rosen was in fact a deeply serious landscape painter with highly developed technical skills and a rare gift for poetry. These paintings invite you to pause and contemplate the mysterious loveliness of the natural world. These paintings are *beautiful*.

It would be fascinating to attempt to track the changes in Rosen's landscapes year by year—to determine conclusively that there were distinct periods when he worked in one style or another. The lack of dependable dates makes this an impossible task. Nevertheless, looking at the roughly decade and a half that he made landscapes, it's possible to divide the work into certain loosely defined categories—categories that may be more reflective of different aspects of his creative personality than a neatly packaged timeline of growth and evolution as an artist.

A few of his earlier paintings are dated, and some of these have a slightly darker, brownish palette and a moody atmosphere that are vaguely reminiscent of the kind of work his New Hope friend and colleague William L. Lathrop was doing in these years. Lathrop was strongly influenced by a style known as tonalism, a movement that was roughly concurrent with impressionism in America but with a distinct identity characterized by a darker, monochromatic palette and an intensely poetic sensibility that emphasized the communication of mood and atmosphere rather than "documenting" the actual appearance of the subject (fig. 3).[4] One could say that,

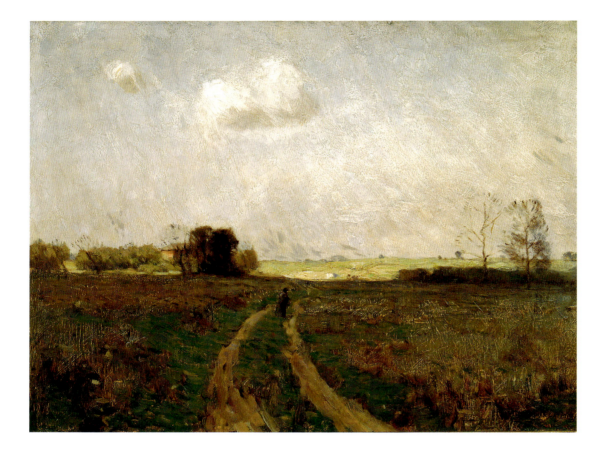

early on, Rosen was very much working in the orbit of Lathrop and the tonalists, but it would be just as accurate simply to say that a poetic sensibility was basic to his character, and that at least in his landscape years, he often cared much more about what a place felt like than what it looked like.

While he soon grew out of the more obvious echoing of Lathrop and the tonalists, Rosen's poetic streak continued as one of the dominant traits in his landscapes and resulted in some of the finest canvases he made in his New Hope years. *Icebound River* (ca. 1915; pl. 13) for example, is a powerfully evocative painting that depicts a moment of transcendental calm at daybreak on the Delaware River. One's eye enters the painting in the lower right corner, moves slowly into the canvas along a delicate, sinuous pathway of moving water between two icy patches, finally arriving at a placid area of blue river that's cradled by a row of dark purplish hills. To the left of the open water, the faint glow of morning sunlight has just struck the shoreline, as the sun slowly rises above the unseen New Jersey hills to the right of the scene. The tranquil atmosphere of this masterful painting arises in part from the simplicity of its composition, the flowing and delicate brushwork (note the sensuous curves of paint in the watery channel on the lower right), and the muted, nearly monochromatic colors that are dominated by soft whites and a multitude of blues from dark to light.

If the only Rosen painting one had seen was *Icebound River* or similar canvases such as *The Delaware Thawing* (1906; pl. 1) and *The Quarry, Winter* (ca. 1910; pl. 9), it would be easy to conclude that he was essentially a gifted painter of moody, evocative landscapes. But paintings such as *The Frozen River* (ca. 1916; pl. 21) and *Floating Ice, Early Morning* (ca. 1915; pl. 23) are in a very different stylistic universe. Instead of darker blues and purples, these canvases are explosions of whiteness—so white that, as the brilliant midday sun reflects off mounds of fresh snow in *The Frozen River*, one almost

f.3
William L. Lathrop (1859–1938)
Untitled [landscape with figure], ca. 1897
oil on canvas
19 × 25 inches
James A. Michener Art Museum
Michener Art Endowment Challenge, Gift of Malcolm and Eleanor Polis

has to resist an urge to squint! Not only is the palette different, but the paint is applied in larger, more rapid strokes, suggesting that the work may have been made at least in part outdoors, or *en plein air* (fig. 4).[5] The composition is more active and chaotic, and the mind-set or basic mood of the painting is radically different from the previously discussed *Icebound River.* Rather than being calm and poetic, *The Frozen River* is full of nervous energy, and it has the classic impressionist obsession with the effects of sunlight on surfaces.

Instead of being under the umbrella of Lathrop, Rosen is now working much more in the orbit of another Bucks County painter, Edward Redfield, who was famous for his brightly colored snow scenes that were painted outdoors, usually in one sitting. Again, what is so remarkable about this is not so much that Rosen worked in a different style, but that he did it so well, and in a manner that was not slavishly imitative of Redfield. *The Frozen River* is a big, bravura canvas, painted with absolute technical confidence, that leaps off the wall from a distance. This painting would hold its own when compared to the work not only of Redfield but of any other American landscape painter of the day.[6]

One might think that this is enough stylistic variation for any painter, but Rosen's restless mind traveled onward. *Hillside* (ca. 1918; pl. 28), for example, is also a brightly colored snow scene, in this case a sunlit hill rather than a tree-covered riverbank. But while the paint application in *The Frozen River* is relatively unbroken, making the piles of snow appear smooth and even, in *Hillside* the brushwork is broken and dappled, almost as if Rosen was influenced by classic French impressionist painters such as Camille Pissarro and Claude Monet (fig. 5). In *Spring Branch* (ca. 1916; pl. 30), the surface is no longer delicately dappled but thick with luscious gobs of multicolored paint laid on with abandon. Rather than displaying a French influence, this canvas is reminiscent of the compositional habits of Japanese printmakers, who loved to linger meditatively on graceful foreground branches, suspended as if in midair, with a river, a mountain, or a village behind them (fig. 6). Another painting (untitled, ca. 1915–18, pl. 29) pushes the thick impasto brushwork of *Spring Branch* even further. This canvas appears to have been made with a palette knife rather than a brush, and the paint is applied with such random energy that it borders on abstraction, as individual branches and trees begin to be absorbed into the greenish-yellow mass of hills and grass in the foreground.

When one absorbs the incredible variety of Rosen's landscapes—and the paintings described above do not even begin to tell the full story—a simple fact becomes clear. Despite the skill and intensity that he brought to his work, despite the professional and financial success he achieved, this was an artist who never grew into his own skin as a landscape painter. Again, it must be said that this creative restlessness does not imply a lack of seriousness or imply that the paintings produced in these years were necessarily inferior to what came later. The most useful metaphor here may be *marriage.* Rosen genuinely fell in love with landscape painting in his early twenties and threw himself into it with all his ability and passion. But he never felt entirely comfortable with this relationship, and by his mid-thirties he began to realize that it was no longer satisfying. By his late thirties he knew that divorce was his only option. The relationship that worked for him as a young man fell apart as he matured. The failure of his first "marriage" was not for lack of trying! At one time or another, he experimented with almost every form of landscape painting then known, and he even made up a version or two. But ultimately nothing fit, and he had to move on.

f.4

Rosen heading outdoors to paint *en plein air*, ca. 1910–15. Photograph courtesy of Katharine Worthington-Taylor

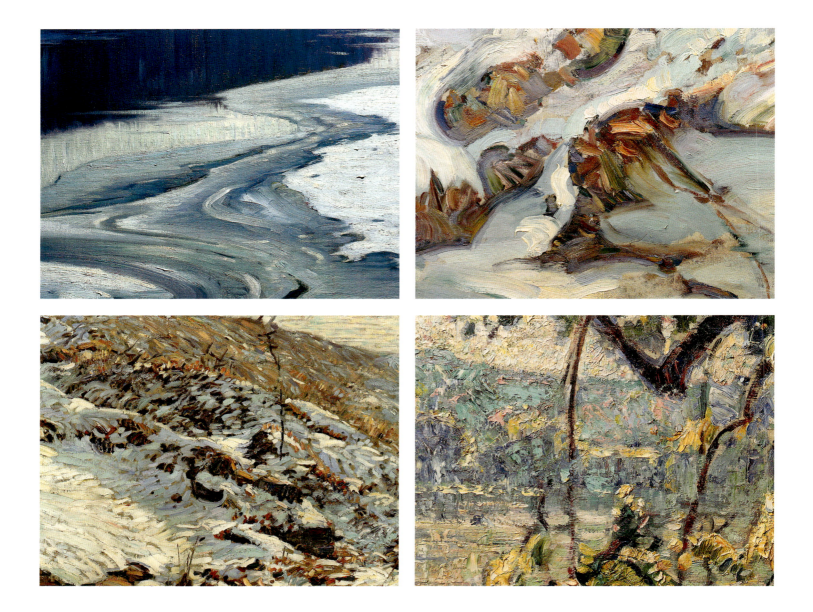

f.5
Four details showing different styles
of brushwork in Rosen's landscapes
(clockwise from top left):
Icebound River
The Frozen River
Spring Branch
Hillside

f.6
Katsushika Hokusai (1760–1849)
Plum-tree and Moon, album plate for
Fuji in Spring, 1803
Color woodblock print, one page from
a book
6⅛ × 8⅝ inches
Martin A. Ryerson Japanese Book Collec-
tion. Reproduction, The Art Institute of
Chicago
A Japanese print with a design concept
similar to certain Rosen landscapes, such
as *Spring Branch* (pl. 30)

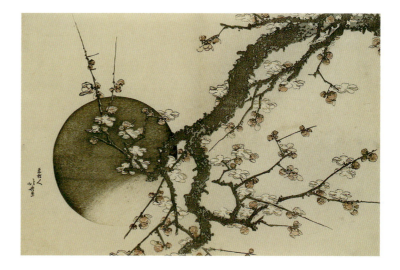

Rosen and the English Modernists

To pursue the marriage metaphor a little further—the end of his first relationship was no doubt hastened because another dance partner had caught his eye. There is no concrete evidence that Rosen actually saw the Armory Show, but in a short posthumous essay on Rosen, his friend and fellow New Hope painter John Folinsbee said that Rosen "had become conscious of the new art from Europe shown in 1913, at the first Armory Exhibition."[7] In the same essay Folinsbee also mentions two English critics whose ideas influenced Rosen's thinking about art for the rest of his life, Roger Fry (1866–1934) and Clive Bell (1881–1964).

Fry and Bell were both associated with the Bloomsbury Group, a famous and highly influential coterie of writers, painters, and intellectuals who lived in the Bloomsbury district of London in the first few decades of the twentieth century. The best-known Bloomsbury writers were novelists E. M. Forster and Virginia Woolf; Woolf actually wrote a biography of Roger Fry, published in 1940 (a year before her death). Fry and Bell were arguably the most important early exponents of modernism in England (fig. 7). Fry organized a 1910 exhibition at the Grafton Gallery in London called *Manet and the Post-Impressionists*, which was the British equivalent of the Armory Show: the first comprehensive survey in England of the work of such artists as Picasso, Matisse, Cézanne, and Gauguin. To counter the intense criticism this show received, Fry published a series of articles that passionately and thoughtfully defended modernist ideas. Similarly, Bell's 1913 book *Art*, which he described in its preface as "a complete theory of visual art,"[8] was one of the earliest and most influential articulations of modernist thinking.

In the transcripts and notes from lectures Rosen delivered on aesthetics and art appreciation, he mentions Fry and Bell prominently and implies that they were the source of some of his own ideas about art. Bell, in particular, was important to Rosen, especially Bell's concept of "significant form." Bell argues that all genuine works of art produce a "peculiar emotion" that he distinguishes from the more commonplace emotions created by "natural beauty" such as butterflies and flowers. Bell calls this the "aesthetic emotion" and asks the question, "What quality is shared by all objects that provoke an aesthetic emotion?"

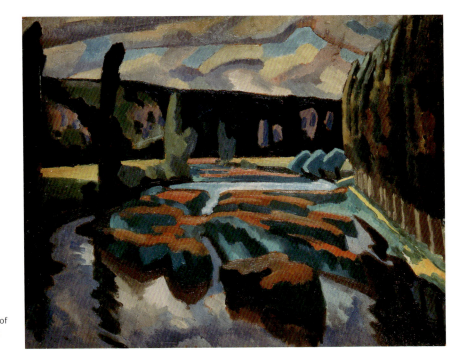

f. 7

Roger Fry (1866–1934)
River with Poplars, ca. 1912
oil on wood
22¼ × 27⅞ inches
Tate Gallery, London/Art Resource, New York
Fry, an English painter and critic, was one of Rosen's principal influences as he created his modernist style.

What quality is common to . . . the windows at Chartres, Mexican sculpture, a Persian bowl, Chinese carpets, Giotto's frescoes at Padua, and the masterpieces of Poussin, Piero Della Francesca, and Cézanne? Only one answer seems possible—significant form. In each, lines and colors combined in a particular way, certain forms and relations of forms, stir our aesthetic emotions. These relations and combinations of lines and colours, these aesthetically moving forms, I call "Significant Form"; and "Significant Form" is the one quality common to all works of visual art.[9]

Roger Fry also distinguishes the aesthetic emotion from everyday emotions, and he attributes the source of the aesthetic emotion particularly to elements of form: "We have separated out the emotions aroused by certain formal relations from the emotions aroused by the events of life."[10] In an essay called "The Artist and Psycho-analysis," which Rosen specifically mentions in one his lectures, Bell says that "the aesthetic emotion is an emotion about form."

In certain people, purely formal relations of certain kinds arouse peculiarly profound emotions, or rather I ought to say the recognition by them of particular kinds of formal relations arouse these emotions. . . . The form of a work of art has a meaning of its own and the contemplation of the form in and for itself gives rise in some people to a special emotion which does not depend upon the association of the form with anything else whatever.[11]

It's fascinating to compare Rosen's lectures with the ideas of Fry and Bell. Rosen, too, speaks of the more commonplace qualities that produce emotional responses to art such as sentiment, drama, and love of nature. But these qualities "are to be found in pictures *of the very lowest order* . . . as well as in the work *of greatest merit*" [emphasis Rosen's].[12] Rosen asks the same question that Bell asks: "What then is this 'indefinable something' that makes one canvas a thing to be treasured by the world for all time, while its absence makes another a thing of absolute insignificance?"[13] The answer, says Rosen, is a quality called "form relationship, or a term that more often comes to my mind in a discussion of this kind—'form music!'"[14] He goes on to mention that Bell's term "significant form" is equivalent to "form music,"[15] and also says:

Form expression is infinite, from the most sublime as in a great temple or cathedral, to the frivolous and gay, as in one of our small townhouses, much too highly ornamented with meaningless towers and "jigsaw" brackets on the front veranda. . . . Forms can radiate energy or suggest frailty. . . . Now when you combine a sense of movement or rhythm with this idea of form, space and color, I feel that you are getting quite close to something of great importance.[16]

These and many other similarities make it clear that Rosen had immersed himself in the ideas of Fry and Bell. These two thinkers, more than any other single influence except perhaps the painter Paul Cézanne (as discussed by Tom Wolf elsewhere in this book), helped to open the door to a new way of making pictures. In his typically unassuming manner, Rosen commented on this transformation in his work by saying, "I think of it as a most happy development for me since it resulted in opening up a completely new and exciting aspect of the whole art problem. It seemed to be more contemporaneous and I found it impossible not to be interested in and influenced by the world in which I suddenly found myself."[17]

It's important to point out that most of Rosen's New Hope friends found it easy to resist being influenced by these ideas.[18] Rosen himself said his decision "had a natural tendency to alienate old friends who had known me mostly as a conservative painter."[19] So the question remains, why

was Rosen so receptive to these ideas when so many others were not? Unfortunately there are no simple answers to this question, except to repeat that he was dissatisfied with landscape painting and knew that something basic to who he was as an individual was not given its voice in the traditional landscape style. He was influenced by modernist concepts, as were many other artists of his day, but simply acknowledging that influence doesn't explain why the seed fell on such fertile ground. Fry and Bell, along with whatever other modernist ideas and paintings he was exposed to, helped him to recognize or "name" an unexplored potential in himself. He knew he needed to grow. Perhaps Rosen would have identified with the wise words of Roger Fry in a 1910 essay about the Grafton Gallery exhibition: "Growth, and not decay, is the real destroyer, and the autumn leaf falls, not because the wind and frost attack it, but because next year's bud has undermined its base."[20]

Rosen's Transformation

While the change in Rosen's work may have made him a wild-eyed revolutionary in the eyes of his New Hope friends, in fact it was not particularly unusual. Many artists in both Europe and America experienced similar stylistic transformations in these years, as modernist ideas created new possibilities for their work. It's very hard for us, after a hundred years of modernism and its countless offspring, to imagine both the excitement and the hatred engendered by such notions as abstract or nonobjective painting, the fragmented and geometrical universe of cubism, or the rarified explorations of color and rhythm in the movement known as synchromism. Rosen's conversion to modernism was not especially remarkable, but the suddenness of the change was. Here one thinks of modernist artists such as Piet Mondrian or Stuart Davis, both of whom, like Rosen, started out as more traditional painters but who left behind a visual record of a gradual evolution.

It's very likely that Rosen, in the mid- to late teens, also had an extensive period of experimentation and exploration. If he did, none of these sketches have survived, though there are a few early modernist pictures made in New Hope that might be considered transitional (pls. 35–38). There appears to be a record of steady production of landscapes up to and including 1918, as well as a few landscapes perhaps made later than 1918. One of the first modernist canvases to survive is *Under the Bridge* (pl. 35); while this painting is somewhat tentative compared to his more mature Woodstock work, it has most of the fingerprints of his modernist style.

The most profound change is also the most obvious: subject matter. One has to look long and hard to find a building of any kind in Rosen's landscapes; there are a few, but the great majority of these paintings are "pure" renditions of the natural world, with little or no evidence of humanity. In the modernist pictures, buildings and other man-made structures not only completely dominate, they appear to be the raison d'être of the work. This is evidenced by the titles: typically the New Hope titles are poetic and evocative—*Opalescent Morning* (ca. 1909; pl. 7) or *The Sun Path* (ca. 1917; pl. 17). Often subject matter is mentioned—*Water Birches* (ca. 1917; pl. 25), *The Frozen River* (pl. 21)—but generically, with no indication of where the birches are or which river is depicted. Woodstock-era titles are almost always derived from the place or thing depicted and are often very specific: *Fireman's Hall* (ca. 1925; pl. 42) or *Round House, Kingston, New York* (ca. 1927; pl. 40). Another major difference between the two periods is color: the landscapes have a greater variety of colors from painting to painting, and often within individual paintings as well. The Woodstock canvases tend toward more muted and monochromatic colors. Instead of creating atmosphere and enhancing feeling, colors in these paintings often are a subset of design, sometimes enhancing connections between elements of a painting through repetition, and sometimes creating tension through contrast.

If one only looks at the titles, it would be easy to conclude that the essence of Rosen's transformation was from a painter of poetry and mood to a painter of place. But the emphasis on place is illusory, or is simply the outer surface or skin of his body of Woodstock work, while the fascination with form is the muscle and bones. It's worth recalling what he told his grandson about why he liked tugboats: the curve of the bow and the square lines of the cabin. Other words and phrases that crop up in his lectures and lecture notes are even more revealing about the ideas and passions that he brought to what he called the "whole art problem."

Rosen's handwritten and often cryptic lecture notes, especially, have a kind of simplicity and intensity in the language. There are many references to music:

Line—form—color—space—music.[21]

In music—space—intervals—rhythm—emotional qualities possessed by form and color.[22]

Aesthetic emotions derived from purely abstract form relations and order—
Ordering of form in space
Rhythmic order . . .
Thrusts—stresses.[23]

The emphasis on a mysterious "life" in a painting is another recurring theme:

Creation of life—independent of imitation.[24]

Creation of a thing that has its own life.[25]

Form that radiates life—effort to achieve this in paint.[26]

To be fair, Rosen's lectures were about art in general, and at least ostensibly not about his own work. But clearly he was seeing art and art history through "Rosen-colored glasses"—glasses that were in part borrowed from Fry and Bell, but with an added emphasis on music and rhythm, as well as this intriguing obsession with the idea of "life." It's as though the goal of the artist, to Rosen, was to make something organic: a living, breathing object that was meant to be experienced, felt, danced with—rather than thought about, analyzed.

Rosen's fascination with form was very much rooted in the modernist revolution, which among other things strove to liberate painting and sculpture from any requirement to "represent" the visual universe, as well as to encourage the exploration of form and design as ends in themselves. But the typical modernist attitude toward form was reductionistic: there was a great striving toward purity and simplicity, and a resulting rejection of the chaos and complexity of nature. Here one thinks of Constantin Brancusi and his elegant, rarified sculptures of birds and human forms, or Mondrian's highly abstracted and geometrical explorations of musical gestures.

An even more interesting comparison with Rosen is Charles Sheeler (1883–1965), the American painter/photographer who was one of the mainstays of the modernist movement known as precisionism. Sheeler and Rosen actually overlapped in Bucks County for about ten years—Sheeler in Doylestown, Rosen in New Hope—and they both painted indigenous Bucks County subject matter in those years. Sheeler painted Bucks County barns (fig. 8) and made many photographs and paintings of the colonial farmhouse that he rented; Rosen of course painted scenes from nature, and in the late teens he made a few modernist pictures of buildings while in New Hope. It's not known if the two men ever met, but Rosen's modernist work has sometimes been compared to Sheeler's, and he even has been thought of as a member of the precisionist camp.[27]

f.8
Charles Sheeler (1883–1965)
Bucks County Barn, 1918
gouache and Conté crayon on paper
16⅛ × 22⅛ inches
Columbus Museum of Art, Ohio
Gift of Ferdinand Howald, 1931
A Sheeler image of a Bucks County barn showing his more simplified and reductionistic approach to painting buildings

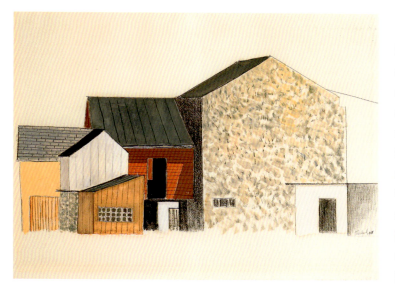

But Sheeler's precisionist renderings of Bucks County barns have only a surface resemblance to Rosen's modernist depictions of buildings and tugboats. Both artists used man-made subject matter, and both were fascinated to the point of obsession with design and form. But the difference between them is summed up in the very word "precisionism," which implies the search for something clean and simple, something precise—i.e., the modernist urge to reduce the subject to its essential elements. While he occasionally dabbled in more simplified designs (for example, *Rondout Dwellings*, pl. 50), Rosen in general would not have been comfortable with this mind-set.[28] Rosen was interested in, as he said, the thrusts and stresses of form. Rather than laying bare the underlying simplicity of the visual universe, he was searching for a kind of organic liveliness—"a thing [painting] that has its own life."[29] Rosen *embraced* complexity—he explored it—he even played with it much like a composer plays with complex counterpoint.

Rosen's true kindred spirit in the modernist pantheon was the Russian painter Wassily Kandinsky (1866–1944), even though Rosen's work for the most part does not obviously resemble Kandinsky's and there is no direct evidence that Rosen knew Kandinsky's paintings (fig. 9). But Kandinsky's work was included in the Armory Show, and he was well-known to American modernist painters, so it's likely that Rosen was aware of both his work and his aesthetic ideas. Especially in his earlier work, Kandinsky was also fascinated with music; he embraced movement and complexity and, like Rosen, strove for that mysterious "liveliness"—the visual equivalent of the old Duke Ellington lyric: "It don't mean a thing if it ain't got that swing!"

There is one other painter who must be dealt with in this brief exploration of Rosen's connections with modernist artists: George Bellows (1882–1925). Rosen and Bellows were close friends—they lived near each other, their children played together, and they even went on painting and sketching excursions together in Woodstock. Given Bellows's fame and his powerful creative voice, it would be reasonable to assume that he had some influence on Rosen's style, especially in the area of visual design.

f.9
Wassily Kandinsky (1866–1944)
Landscape with Rain (*Landschaft mit Regen*), 1913
oil on canvas
27⅝ × 30¾ inches
Solomon R. Guggenheim Museum, New York 45.962, © 2006 Artists Rights Society (ARS), New York/ADAGP, Paris

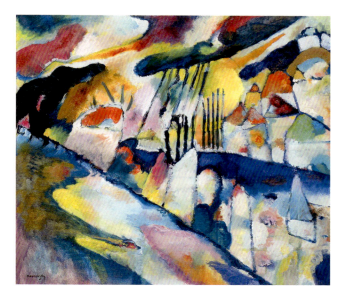

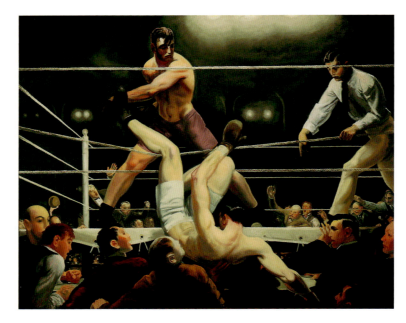

f.10
George Bellows
Dempsey and Firpo, 1924
oil on canvas
51 × 61¼ inches
Photograph copyright © 1998: Whitney
Museum of American Art, New York;
Purchase, with funds from Gertrude
Vanderbilt Whitney
This painting by Rosen's friend Bellows
employs a design system called "dynamic
symmetry"; numerous major and minor
elements are precisely positioned according
to the principles of this system.

Fortunately, Bellows's predilections in this area are well documented.[30] Something about his temperament made him uncomfortable if he was not working within the confines of a system. Whether it was his famous boxing scenes, his landscapes, or even his portraits, Bellows needed to impose an external order on his paintings. At different points in his all-too-brief creative life, Bellows employed at least three different design systems and one color system. He used these systems so religiously that occasionally his figure drawing becomes impossibly contorted, as he carefully positioned arms, legs, and torsos to align with the invisible diagonals and intersections of the given system he was using (fig. 10).

A careful examination of Rosen's Woodstock paintings reveals little evidence of this kind of systematic thinking, at least in the extreme manner that Bellows employed it. One ordering principle that does appear with some regularity is the golden section, a mathematically based proportion in which the four sides of a canvas are sectioned off at an approximate ratio of 0.615 to 1. Rosen sometimes positioned the key events in a painting at major golden section points, or he appears to have aligned various elements with diagonals created by connecting golden section points with corners or other key intersections. Given the intuitive nature of golden section design—it often appears in nature, not to mention in music and architecture—it's possible that Rosen made these design decisions unconsciously.

However, at least one sketch survives in which Rosen has marked off various vertical lines and diagonals that he used as informal guides as he positioned key elements of the painting (fig. 11). In this case it was not the golden section that he used but the rebated square, an idea regularly employed by Renaissance painters (as well as Bellows), in which the length of the shorter sides of a rectangular canvas are marked on the longer sides, creating two implicit squares. For example, if a canvas measures eighteen by twenty-four inches, then an eighteen-inch segment is measured from both ends of the twenty-four-inch sides, making two overlapping squares with eighteen-inch sides. The vertical sides of these two squares are then used to place elements of the picture, as are the diagonals formed by connecting the tops and bottoms of these vertical sides with corners and other significant points.

So Rosen was certainly aware of the rebated square, and probably conscious of the golden section as well. He apparently used these two devices in the early stages of his creative process simply

f.11

A Rosen oil sketch (for a painting called *Round House*) showing the background lines that mark off the rebated squares. Courtesy of Morgan Anderson Consulting

to help him map out the basic location of things—but then "form music" and "creation of life" took over the creative process. In other words, Rosen's general attitude toward the more extreme, systematic mind-set of Bellows would have been no different from his attitude toward the reductionism of Sheeler and the precisionists. To Rosen, this way of thinking would have been too cerebral, too predictable, too confining—and he would have intuitively resisted it. This is not to say that Rosen's way of doing things was better or worse—only that his temperament was different from Sheeler's and Bellows's. While Rosen was by no means anti-intellectual, his creative process was more intuitive than systematic. He placed far more trust in his instinctive grasp of music and rhythm than in any externally imposed system or idea.

Quarry and Crusher

The best way to see how Rosen's mind worked is to examine a single painting in some detail, remembering the ideas and principles that Rosen himself talked about in his lectures: thrusts and stresses; line, interval, and rhythm; and the ordering of form and space. *Quarry and Crusher* (fig. 12, pl. 62) is one of his major Woodstock canvases, probably made in the early to mid-1930s after he had many years to refine his modernist ideas.[31] The painting almost certainly depicts a real place (a preliminary sketch has survived; see fig. 13)—a quarry and rock-crushing operation in the Woodstock area—and it's easy to see why Rosen was fascinated with it. As often happens with man-made structures, there's a strange, anthropomorphic quality to these buildings. One can imagine a child looking at the evenly spaced row of rectangular openings toward the bottom and saying, "It looks like a giant monster with teeth—like a weird beast is chewing up the mountain!" Crisscrossing ladders and wooden supports look vaguely like arms or even tentacles. In other words, there's a psychological layer to this painting—but that's not the main reason Rosen chose to make it.

The problem that interested Rosen with this scene had to do with thrusts and stresses, and in particular, stresses. The place presented him with a highly complex, even chaotic set of forms—forms with a great deal of inherent tension or stress. This stress grew out of the intense visual conflict between the more chaotic, irregular, and unpredictable lines and shapes of the natural world and the geometrical, regular, and more predictable lines and shapes of the man-made world. Figure 14 extracts some of these lines and shapes in an effort to reveal this basic underlying tension in the painting. Note the extreme regularity of the man-made structures—the interlocking and overlapping rectangles, the parallel straight lines, and the profusion of right angles—and the extreme irregularity of the natural forms—the graceful curves of the mountain, the bulky, randomly shaped tree blobs, and the fact that no shape or angle is exactly repeated. This seemingly irreconcilable stress is the problem that Rosen presented himself with in this canvas. Two sets of forms, completely at odds with each other, are jammed together in this rather peculiar scene. The problem was, how to make it work as a painting? How to bring some "rhythmic order" to the scene, and make some "form music"?

Rosen himself provided the beginning of an answer to these questions in one of his lectures: "An artist has the ability to sense the relationship between a few harmoniously associated things—is able to detach them from the natural chaos—and to order them within his creation."[32]

f.12
Quarry and Crusher, ca. early 1930s
oil on canvas
32 × 40 inches
D. Wigmore Fine Art, Inc., New York

f.13
Rosen's pencil sketch for *Quarry and Crusher*, ca. early 1930s. Courtesy of Katharine Worthington-Taylor

Even though this painting started with something Rosen actually saw, the goal was not to show us exactly what the place looked like. His goal was to make some harmony out of the chaos, and he did it, as he said, by "detaching" certain aspects of the scene and by altering various details in ways that enhanced the orderliness of his creation. The simplest and most powerful way he counteracted the inherent *stress* in the painting was through the element of *thrust*—that is, movement. If there was one thing that Rosen disliked in a visual design, it was stasis. This is true of his landscapes, whose designs are almost always grounded in the rhythmic movement or flow of the eye from one place to another in the scene. But in the Woodstock pictures, the movement of the eye around the canvas is arguably the most important aspect of the viewer's experience of the image.

In *Quarry and Crusher*, the underlying movement of the image happens through the interaction of *both* the natural and man-made forms delineated in figure 14. Figure 15 reveals this movement, which is essentially an upward thrust from the bottom of the picture to the top—beginning with the upward pointing vertical and diagonal lines of the rock crusher, then joined by the vaguely upward pointing tree shapes, and finally joined by the upward moving lines inscribed by the left and right sides of the mountain, all of which direct the eye inexorably toward the highest curve of the mountain at the top of the canvas. This sweeping movement, which unites the natural and man-made shapes in a single powerful gesture, goes a long way toward creating that sense of "order within chaos" that Rosen was searching for.

There is an equally powerful but more subtle ordering principle at work in this picture: a profusion of parallel lines that binds together various man-made and natural elements. It's impossible to describe verbally all of these linear connections, but figures 16 and 17 reveal some of them. Note in figure 16, for example, that there are no fewer than six implicit parallel lines created by three diagonal forms in the crusher, two tree trunks, and the left side of the mountain; or five parallel lines in the opposite direction implied by a tiny tree trunk on the left side of the mountain, two diagonal forms on the crusher, and two sloping lines on the right side of the mountain.

The existence of these and many other linear relationships in this painting provides graphic evidence that Rosen practiced what he preached, and very skillfully. He was presented with a highly

chaotic scene, full of inherent "stress." He sensed the presence of these "harmoniously associated things," detached them and carefully manipulated them to produce "order . . . within his creation." The most important underlying principles he used to create this order were 1) *movement*—the uniting of apparently disparate elements in a single powerful thrust, and 2) *repetition*—the binding together of apparently chaotic elements through repetitive devices such as parallel lines. It's important to point out that with this latter principle, the goal is not to eliminate the chaotic or stressful elements, but to create a kind of fluid, dynamic balance between chaos and order.[33]

There is something in the human psyche that resists total chaos but is also uncomfortable with excessive order and predictability. This painting lives in the vast gray area between these two extremes—starting with and embracing the natural chaos of the real world, but seeking out and enhancing the order inherent in the chaos.

Unlike his friend George Bellows, Rosen seemed to enjoy the uncertainty inherent in this way of working. There was no system or formula to fall back on, and the creative process was, in a way, like a highly complex game with no hard-and-fast rules—a game in which one's instincts about what worked were just as important as one's technique and intellect. Having said that, it's also important to point out that in *Quarry and Crusher* Rosen apparently grounded certain basic design decisions on one of Bellows's favorite devices: the golden section. Figure 18 divides the canvas into its eight major golden section points. As it turns out, the single most important place in the picture—the top of the mountain, which is the end point of the thrusting motion described earlier—is positioned at one of the two golden section points on the top edge of the canvas. And the two sets of interlocking parallel lines noted in figure 16 just happen to line up, roughly, with two prominent diagonals that are formed by golden section points and the lower left corner.

As noted previously, it's entirely possible that this apparent use of the golden section was unconscious. Either way, the last thing Rosen would have wanted is for this kind of formal thinking to intrude on the viewer's experience of the picture. All this discussion of thrusts and stresses, parallel lines, and the golden section may seem esoteric. But to Rosen it was not a dry technique—it was a living craft that helped him breathe life into his pictures. Remember, his goal was to create form music. These seemingly arcane devices, as important as they are, were meant to be *felt* rather than analyzed. They were like the harmony and counterpoint of his form music, and Rosen was no more interested in having his viewers think about these things than Beethoven or Brahms would have been in having the average listener be distracted by the details of harmonic progressions or the minutiae of sonata form.

The creative process that produced *Quarry and Crusher* was both highly disciplined in its search for order within chaos and refreshingly "seat of the pants" in its rejection of systems and theories in favor of a more fluid approach to composition. To some degree this same process can be discerned in most if not all of his Woodstock paintings. Each picture usually contains some sort of visual tension or stress: between predictable man-made forms and chaotic natural forms; between active, busy areas and inactive, empty areas; or perhaps simply between curved lines and shapes and straight lines and shapes. The underlying structure of the picture then becomes a kind of elegant game, the goal of which is not to resolve or eliminate the tension, but to create a balance between opposing forces—to "harmonize" the stress—using movement, rhythmic repetition of various kinds, and other techniques.

The elements of this game are the ordinary objects and places that we see around us every day. Despite the sophisticated abstract thinking in the best of these Woodstock pictures, Rosen was not a so-called abstract artist, and he had no interest in the extreme distortions of reality that

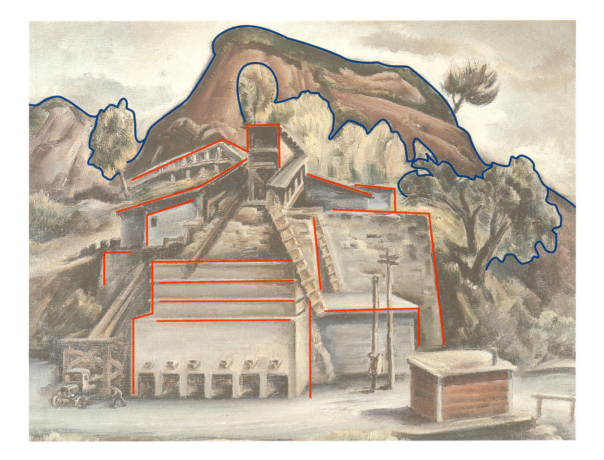

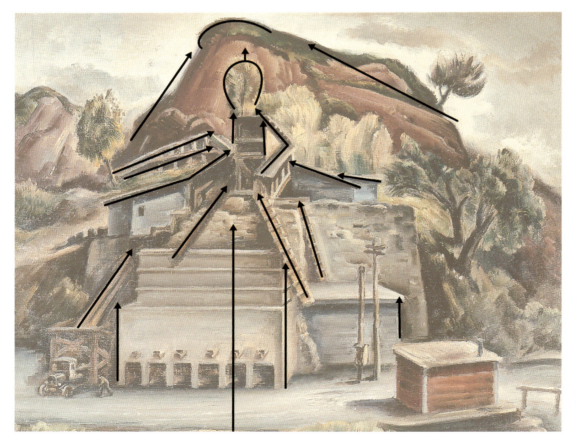

f.14
Quarry and Crusher, with extracted lines showing the inherent "stress" between the more chaotic natural forms and the predictable, geometrical man-made forms

f.15
Quarry and Crusher, with extracted lines showing the movement or "thrust" from bottom to top

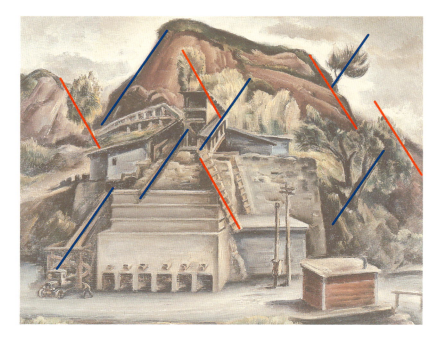

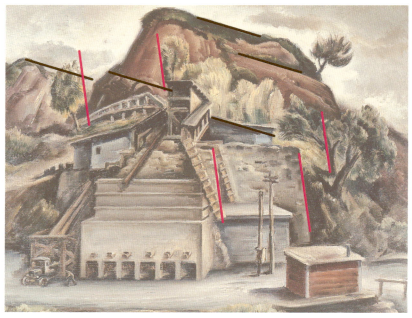

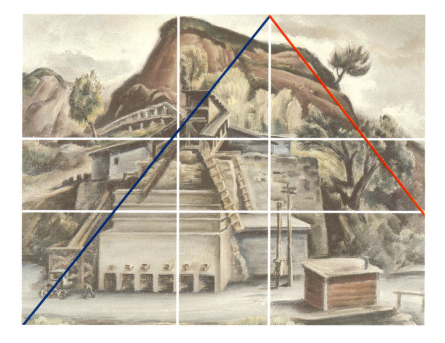

f.16
Quarry and Crusher, with two sets of implied parallel lines

f.17
Quarry and Crusher, with two additional sets of implied parallel lines

f.18
Quarry and Crusher, with golden section points and diagonals; the two diagonals are roughly aligned with the two sets of parallel lines in fig. 16

other modernist artists produced. Rosen *liked* the places he painted, and he grounded his work in the shapes and textures of real things. He didn't want our first reaction to a painting to be, "My, what a clever arrangement of forms!" He wanted first to draw us in to the actual physicality of the place. Then, as we meditate on the image, the underlying rhythms emerge.

"We're surrounded by chimneys, rooftops, windows, and trees," Rosen might have said, "but do we really *see* them?" These objects are also verticals, diagonals, lines, and shapes that both connect with each other and fight with each other. In other words, it's true that a tugboat is the curve of the bow and the square lines of the cabin—but it's still a tugboat! If one can move beyond the literal and begin to imagine a painting as made up of these abstract elements, then it's possible to almost hear Rosen's playful musical mind at work: "Let's see—there's not enough happening in this spot—better throw something else in—but something that connects with that spot over there." Each element has multiple functions in the emerging, complex structure. A chimney is a vertical form that connects with a vertical tree; but it also is a rectangle that echoes a rectangular window; and it also fills up an empty place, becoming a counterweight to another chimney on the other side of the picture.

While the sense of play is obvious in these pictures, simply calling them a game would, in the end, be misleading. Remember, when talking about combining music and rhythm with form, space, and color, Rosen said, "I feel that you are getting quite close to something of great importance."[34] He believed that this creative process produced the aesthetic emotion that Clive Bell described, and Rosen did not see this emotion as disembodied or ethereal. To him, form was a "language of the mind."[35] He spoke of the "coordinated movement" and rhythmical relationships in a painting and said that these qualities "probably mirror man's experience."[36] He even went so far as to say that this "formal order is suspected of simulating . . . the great order of the universe."[37]

In other words, to Rosen form was synonymous with life. It was rooted in the experience of being alive—in the unconscious rhythms of our bodies; in the needs and desires, if not the very language and structure, of our minds. He never explained what he meant by the "great order of the universe," but he clearly felt that as an artist who was devoting his life to exploring "form music," he was participating in something much larger than himself—a universal, even divine, order. Thus what truly interested him was "form that radiates life"—and he devoted himself religiously to the "effort to achieve this in paint." This was the load he wanted to lift in his life. And this was what traditional landscapes, for all their beauty and poetry, did not allow him to do—at least in as focused a manner as the modernist paintings.

New Hope and Woodstock: A Comparison

In fact there is plenty of evidence of form music in the New Hope landscapes, and this may be the most concrete connection between the two bodies of work. The musical sensibility in the landscapes is manifested in a highly developed consciousness of the flow of events in an image. A picture can move in space the way music moves in time: the eye starts and stops, it moves slowly and quickly, it follows linear pathways from one place to another, it jumps from foreground to background and flows gracefully around static resting points. The landscapes are full of this kind of thinking, which shows up in certain compositional habits. In the snow scenes, for example, there may be a central point—a bush or a group of trees—that acts as a kind of anchor to the linear movement of the river. Rosen also loved the idea of placing a large visual barrier in the foreground—a tree or a hanging branch—that creates tension between foreground and background as well as a sense of distance and spaciousness. In general there is a powerful sense of movement and flow in

the landscapes. There are broad expanses of river and vast empty spaces, and often the eye sweeps gently upward into the canvas toward the far-off horizon.

While this musical/formal awareness is present in both the Woodstock and New Hope paintings, in the end one is left with the impression that the two bodies of work are simply different. There is no intellectual sleight of hand, no "grand unified theory" of Rosen that can neatly stitch them together. While there may indeed be some latent elements of abstraction in the later landscapes (as Tom Wolf points out earlier in this book), it is equally true that Rosen tried one thing, eventually realized that it didn't work for him, and moved on to something different. Does this mean that the landscapes were somehow a mistake? No—he poured all the life experience and skill he had into them, and many are beautiful and deeply felt works of art whose emotional power continues to move people more than eighty years after they were made. Were the landscapes the product of his youth and the Woodstock paintings the product of his maturity? Yes. As good as the landscapes are, they tend to be derivative of other styles. It was in Woodstock, not New Hope, that Rosen found his true voice as a man and an artist. There's a sense of freedom in the Woodstock pictures—freedom from the conventions inherent in traditional landscape painting, as well as the freedom of a mature artist who knew who he was, what he wanted to do, and how to do it.

This quality of freedom is evident in the paintings, of course, but perhaps even more in the works on paper where, freed from the technical constraints of oil and canvas, Rosen could let his linear and musical imagination flow. He created an entire body of still lifes, an occasional oil but mostly some form of drawing—and these works often display an elegant use of line, a graceful and lively sense of movement, and a deft and delicate feeling for color. They were made quickly and spontaneously, without the sketching and planning that a large painting required, and without the need for detail and surface. They are quiet and unassuming, but often are magnificent works of art that show a search for a certain kind of simplicity—a refreshing counterweight to the visual complexity of the paintings.

Earlier in this essay the point was made that Rosen resisted the modernist urge toward reductionism—the need to strip the chaos and complexity of the world down to its bare bones. Yet the simplicity of his works on paper suggests that Rosen, too, was intrigued by the question: how much, or how little, does one need in order to make a picture work? It's worth repeating that one of the guiding principles he laid out in his lecture notes was "the creation of a thing that has its own life." To Rosen, the challenge of reductionism was to reduce the world to a kind of mysterious essence, without also reducing the life right out of the image.

With this in mind, it's appropriate to end this essay with an innocuous little untitled drawing made the year before he died (fig. 19). The subject matter is pure Rosen: three tugboats, a building with a chimney billowing smoke, the outline of a pier with some nearby waves, and what looks like a vague hint of some hills in the foreground. The subject is familiar, but the style is abstract: a true modernist gesture. Yet what's remarkable about this picture is not its level of abstraction. Artists like Kandinsky were doing this kind of thing decades earlier, and in fact it's in images like this one that Rosen's kinship with Kandinsky becomes readily apparent. The real accomplishment of this drawing for Rosen is that it reduces the world to its bare bones but still embodies his idea of form music with remarkable skill.

It's possible, up to a point, to talk about how this picture works. There is tension between the prominent straight lines of the boats and the irregular lines in the foreground. There is movement, both diagonal—the intersecting lines of boats and pier—and vertical, caused both by the

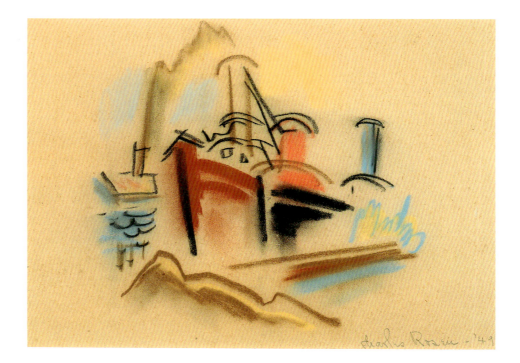

f.19
Untitled [tugboats], 1949
pastel on paper
8 × 10 inches
Collection of Holly Goff

chimneys and by the bows of the boats. And there is the rhythmic, repetitive order so typical of Rosen, created mostly by the three vertical chimneys. This kind of analysis may help to elucidate the inner workings of the design of this picture, but it doesn't explain the strange, spontaneous magic of the image, which is arguably one of the most masterful pictures Rosen ever made.

Why does one jazz group "swing" when another doesn't? Why does the same group swing on one day, but not the next? Certainly skill and facility are important. Experience and constant practice are important, too. But there's an element of mystery in this phenomenon—this "thing that has its own life." Sometimes something clicks, sometimes it doesn't. An artist struggles to find that magic, fails, then suddenly it appears naturally, as if it's the easiest thing in the world. Here one thinks of the composer Joseph Haydn, who got down on his knees every day before settling down at his writing table to work on his latest symphony or string quartet. Making art that *works*, on every level—technical, structural, emotional, spiritual—is a very hard thing to do. Even the greatest artists can occasionally produce pedestrian, uninspired creations and not be entirely sure how it happened—thus Haydn's need to quietly invoke the deity in the hope that he would have a good day!

Certainly Rosen, like all artists, had his difficulties. Ironically, while his Woodstock paintings may be more personal, they are also more inconsistent than the landscapes, and there is indeed a sense of struggle implied by that inconsistency. But he knew he was on to something with the Woodstock work, and he pursued it with skill and total commitment, as far as he could take it. What he was looking for was something that resists analysis—that is felt in the body rather than intellectualized. Again, the musical analogy works best: a song must be sung, and its meaning comes in the singing. This was Rosen's true gift. This was his quiet passion. And this, in the end, is what unites his two radically different bodies of work: the conviction that art, above all else, needs to be alive—alive with feeling, alive with music, alive with an order and rhythm that reflects some larger, more universal order and rhythm.

"Form that radiates life." High-sounding words, even a bit clichéd perhaps. But words that Charles Rosen lived by.

Notes

Among the many handwritten lectures and lecture notes contained in the Charles Rosen Papers of the Archives of American Art, four are quoted in this essay. Simply for the purpose of identification, these documents have been labeled Lectures 1 and 2, and Lecture Notes 1 and 2, and these documents have been reprinted in this book with the same identifying numbers (Appendix 1).

1. Transcribed from a conversation with Peter Warner that took place on May 13, 2005.
2. As noted in the Rosen biography earlier in this book, according to family lore Rosen spent the winter of 1914–15 (not long after the Armory Show) painting the Maine coastline; he went there at least in part because he was troubled about the direction of his work. There is no record of Rosen making a serious traditional landscape after the early 1920s.
3. The only published record of Rosen's work is contained in the small publication simply entitled *Charles Rosen,* which includes a list of more than 200 paintings with titles as well as information about size, medium, owner, and even the location of the scene depicted. Unfortunately there is absolutely no information in this publication that would identify its author, publisher, and date of printing, though it is likely that it was compiled by the Castellane Gallery (one of the commercial galleries that sold Rosen's work after his death) for a 1969 exhibition. Because a typewritten version of this published list has been discovered among the personal papers of the artist's daughter Katharine Warner, it can be stated with some certainty the list was compiled with her direct assistance, though the original material from which she created the list has not survived. A careful examination of this list reveals many internal inconsistencies, as well as numerous contradictions with established titles and dates as revealed both by examination of paintings and comparison with the records of the major juried exhibitions of the day, records that are very reliable. Therefore this published list, while useful, provides at best a general sense of the dates, titles, etc., of Rosen's work. In the Michener publication, dates from the list are used, but always as "circa," unless there is reliable and independent corroboration of a painting's date.
4. Until recently scholarly studies of tonalism, while substantial, have been out of print and difficult to obtain. The two most important early studies were by Wanda Corn, *The Color of Mood: American Tonalism 1880–1910* (San Francisco: DeYoung Memorial Museum, 1972), and William H. Gerdts, *Tonalism: An American Experience* (New York: Grand Central Art Galleries, 1982). But in November 2005, Spanierman Gallery published what will no doubt become the new standard text on the subject: *The Poetic Vision: American Tonalism* (New York: Spanierman Gallery, 2005); this book reprints the original Gerdts essay and also contains many other essays that explore both the nature of tonalism and its cultural context.
5. Plein air painting originated in Europe in the 1840s when oil paint first became available in disposable tubes. The technique was very common among impressionist painters. While there are no surviving journals, interviews, or letters that document the fact that Rosen painted outdoors, the photograph on page 55 firmly establishes that he did it at least once! Close examination of the surfaces of his landscapes suggests that, like many artists, he worked both outdoors and in the studio. Even with his brightly colored snow scenes, he probably did not complete them outdoors as Redfield did, but instead began the works outdoors and finished them in the studio.
6. This is a subjective opinion, of course, but given Rosen's success in the major juried exhibitions (see Appendix 7) as well as the major awards he won (see Appendix 8), clearly his contemporaries also thought his best work compared favorably with that of his colleagues.
7. From an undated and unpaginated essay by Folinsbee in the Charles Rosen Papers, Archives of American Art, Smithsonian Institution (hereafter AAA).
8. Clive Bell, *Art* (New York: Capricorn Books, G. P. Putnam's Sons, 1958), 6.
9. Ibid., 17–18.
10. From the 1914 essay "A New Theory of Art," reprinted in *A Roger Fry Reader,* ed. Christopher Reed (Chicago: University of Chicago Press, 1996), 159.
11. From the 1924 essay "The Artist and Psycho-analysis," reprinted in Reed, *A Roger Fry Reader,* 354–55.

12. Charles Rosen, Lecture 1 (unpaginated), AAA.
13. Ibid.
14. Ibid.
15. Ibid.
16. Rosen, Lecture 2 (unpaginated), AAA.
17. From a typewritten reminiscence, AAA. This document was probably typed by a family member—most likely his second wife, Jean—from a document handwritten by the artist. The typed document has a parenthetical remark at the top: "Charlie wrote this in 1940." This date is incorrect; the document mentions his "teaching assignment" in San Antonio, which occurred in the early 1940s. The most likely date of this document is ca. 1945–50.
18. The one New Hope friend with whom Rosen may have shared an affinity for modernism was the painter Charles Ramsey (1875–1951). According to the Lambertville, New Jersey, art dealer Roy Pedersen (who knew Ramsey's son), the Rosen and Ramsey families were very close. Like Rosen, Ramsey began his career as a landscape painter and began to explore modernist ideas in the teens. While there is no documentation of this relationship, it's certainly possible, if not probable, that the two men shared ideas about modernism in this crucial period of Rosen's development as an artist. Information about the Rosen/Ramsey relationship was obtained in a telephone conversation with Roy Pedersen on July 19, 2005.
19. Typewritten Rosen reminiscence.
20. From the 1910 essay "The Grafton Gallery," reprinted in Reed, *A Roger Fry Reader,* 87.
21. Rosen, Lecture Notes 1 (unpaginated), AAA.
22. Ibid.
23. Rosen, Lecture Notes 2 (unpaginated), AAA.
24. Ibid.
25. Rosen, Lecture Notes 1.
26. Ibid.
27. The highly esteemed author of this book was in fact guilty of this misconception in the essay "The Brush Is Mightier Than the Sword: Art, Politics, and the Horton Collection," in *A Collector's Eye* (Doylestown, Pa.: James A. Michener Art Museum, 1994).
28. Had he lived to see them, one can imagine Rosen especially disliking some of the more extreme forms of modernist reductionism, such as the monochromatic paintings of Ellsworth Kelly or the monumental color fields and "zips" of Barnett Newman.
29. Rosen, Lecture Notes 1.
30. A fascinating discussion of Bellows's systematic thinking can be found in the Michael Quick essay "Technique and Theory: The Evolution of George Bellows' Painting Style," in *The Paintings of George Bellows* (Fort Worth: Amon Carter Museum, 1992). This essay also quotes a November 3, 1922, letter from Bellows to Robert Henri that mentions the painting excursions Bellows made with his Woodstock friends: "Gene [Speicher] and I and Charlie [Rosen], have been going out every day at 8:30 and coming home at dark with landscapes." Rosen, Speicher, and Bellows lived within shouting distance of each other in Woodstock. The Bellows letter is from the Henri Papers, Beinecke Rare Book and Manuscript Library, Yale University.
31. The earliest record of the painting being exhibited is in 1935 at the Carnegie Institute; it was also exhibited in 1936 at the Art Institute of Chicago.
32. Rosen, Lecture 2.
33. Rosen's use of color in this painting, while not discussed at great length, essentially emphasizes the major design elements. The man-made forms of the crusher are a silvery blue, while the mountain is a contrasting brownish red. This red is echoed in the shack in the lower right, and the light blue is echoed in the sky as a few of the tree forms. In general the colors are muted and soft, creating a certain brooding atmosphere that perhaps links up with or enhances the strange, anthropomorphic properties of the man-made forms discussed earlier in the essay.
34. Rosen, Lecture 1.
35. Ibid.
36. Ibid.
37. Ibid.

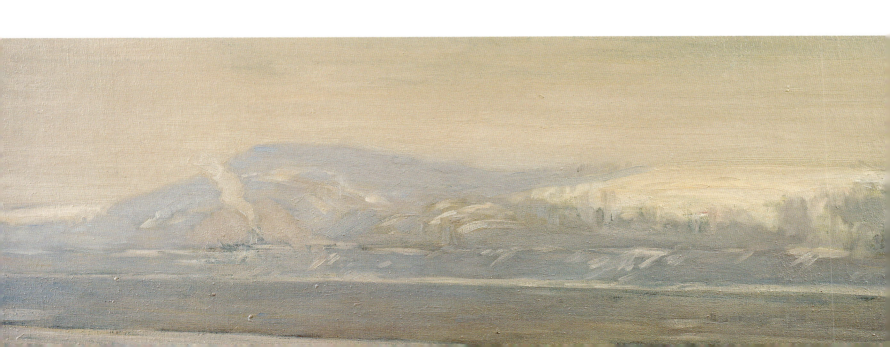

New Hope and Landscape

Many artists begin their careers with a period of experimentation before settling into a recognizable and predictable way of working. But the most intriguing characteristic of Rosen's landscapes is their consistent variety. During the roughly fifteen years that he made landscapes, he worked in several fairly distinct styles. Early on, his paintings tend toward a muted palette and a moody atmosphere that's somewhat similar to the kind of work William L. Lathrop, his friend and colleague in New Hope, Pennsylvania, was doing in these years. Lathrop was strongly influenced by a style known as tonalism, a movement that was roughly concurrent with impressionism in America but with a distinct identity that included darker, monochromatic colors and the desire to communicate the artist's subjective, emotional experience of a place rather than its physical characteristics. It would be accurate to say that Rosen began his career in the orbit of Lathrop and the tonalists, but it would be just as accurate simply to say that he had a poetic sensibility, and that in his landscape years, he often cared much more about what a place *felt* like than what it looked like.

Early Work

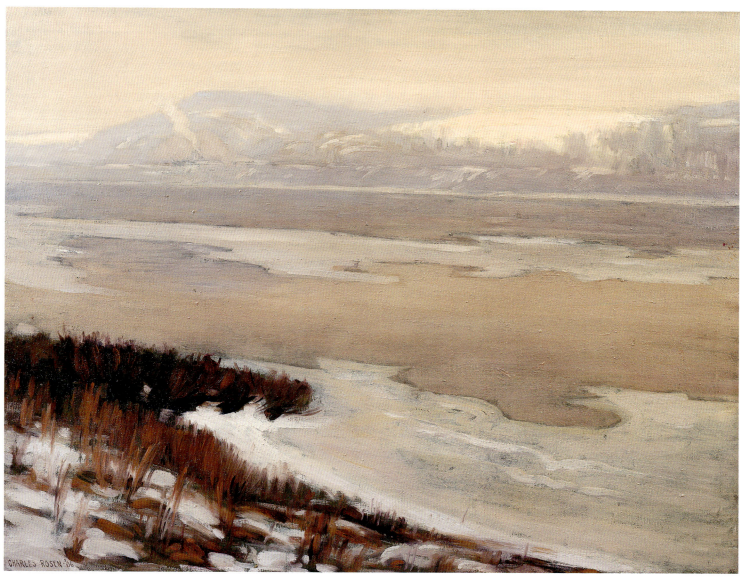

pl. 1

THE DELAWARE THAWING, 1906
oil on canvas
32 × 40 inches
COLLECTION OF GRATZ GALLERY AND CONSERVATION STUDIO

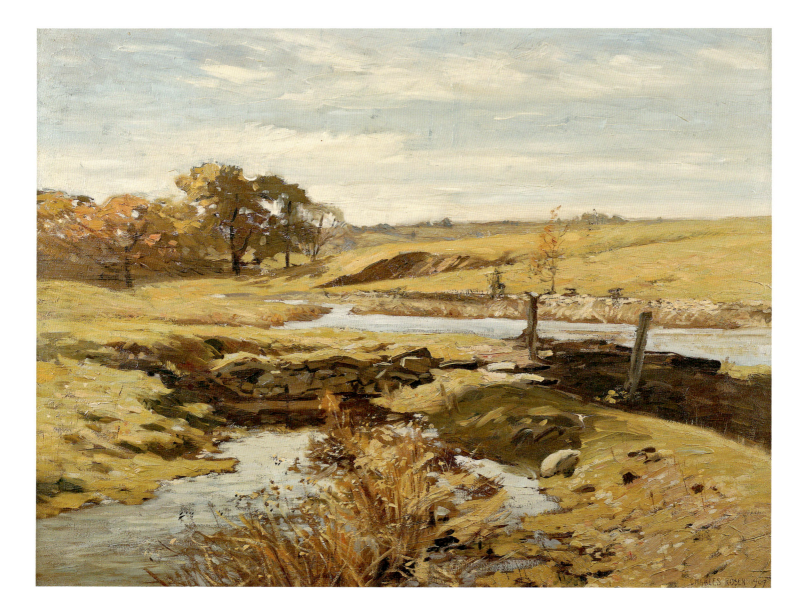

pl.2

MILL RACE, 1907

oil on canvas

32 × 40 inches

COLLECTION OF LOUIS AND CAROL DELLA PENNA

THE MILL POND, 1908
oil on canvas
32 × 40 inches
PAYNE GALLERY OF MORAVIAN COLLEGE

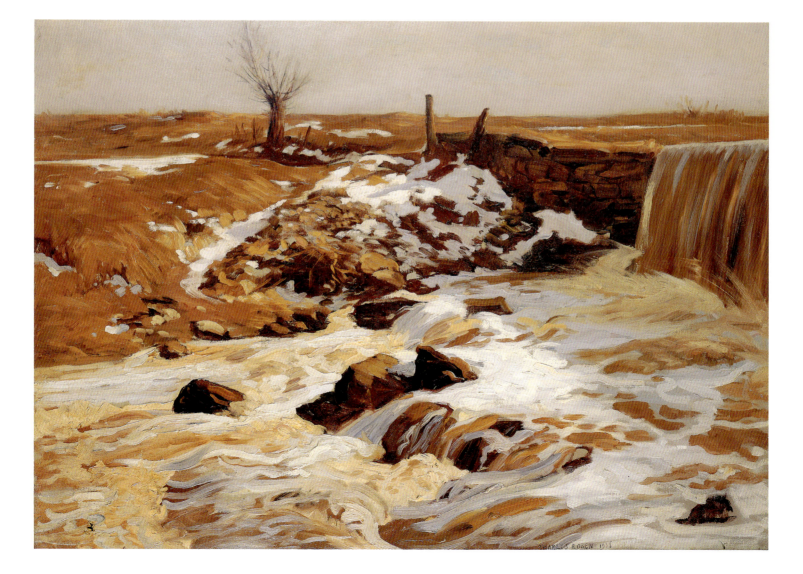

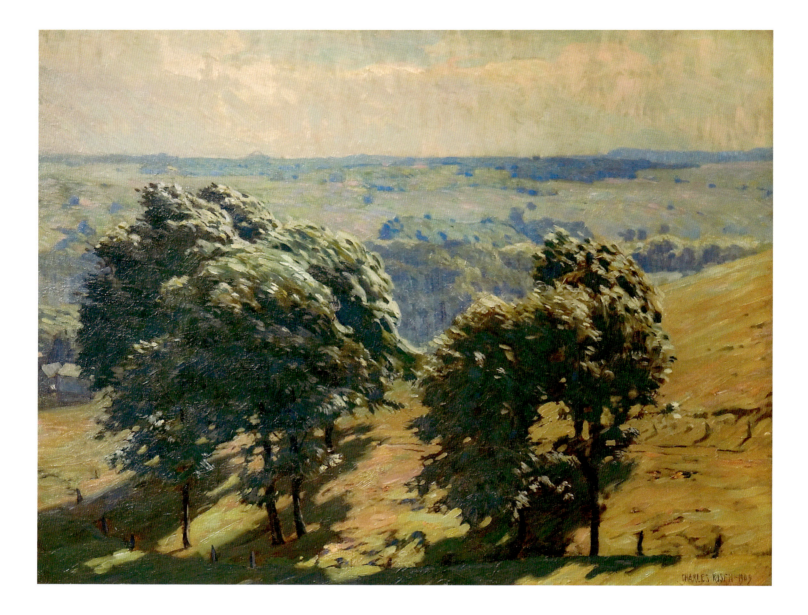

SUMMER BREEZE, 1909

oil on canvas

24 × 36 inches

BILL MEMORIAL LIBRARY, GROTON, CONNECTICUT

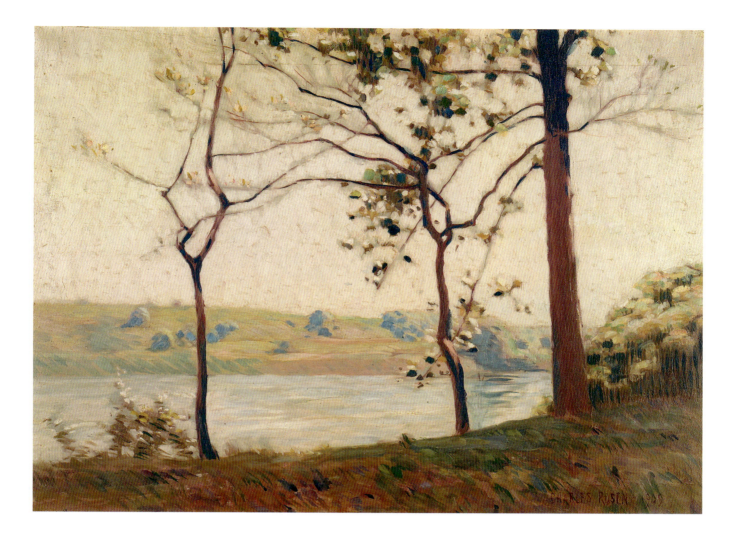

ACROSS THE RIVER, 1909

oil on canvas

18 × 24 inches

READING PUBLIC MUSEUM, READING, PENNSYLVANIA

pl.6

HAYSTACK, CA. 1910
oil on canvas
32 × 40 inches
PRIVATE COLLECTION

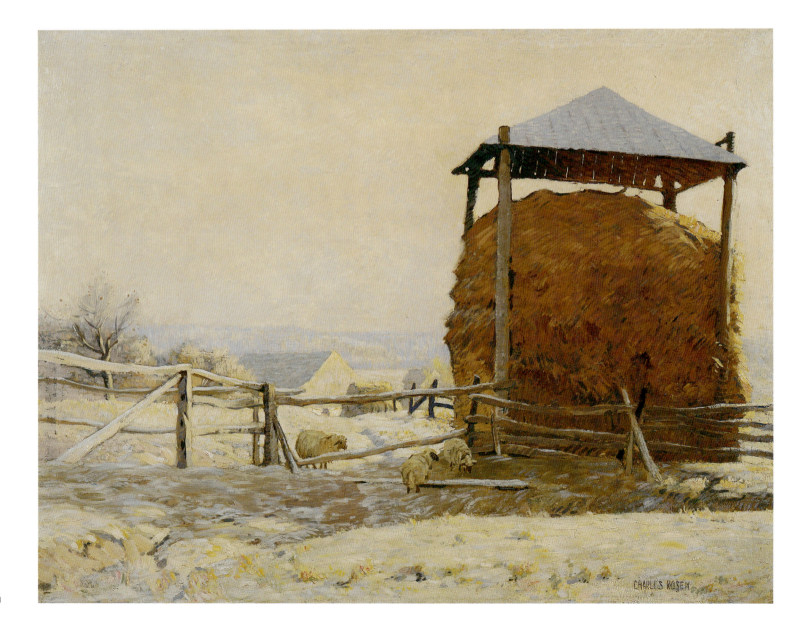

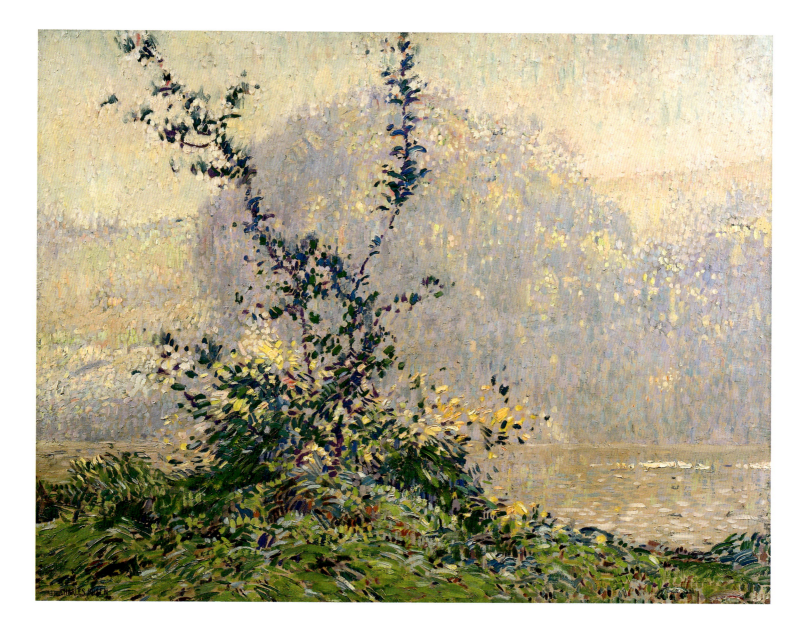

OPALESCENT MORNING, CA. 1909

oil on canvas

32 × 40 inches

JAMES A. MICHENER ART MUSEUM

GIFT OF MARGUERITE AND GERRY LENFEST

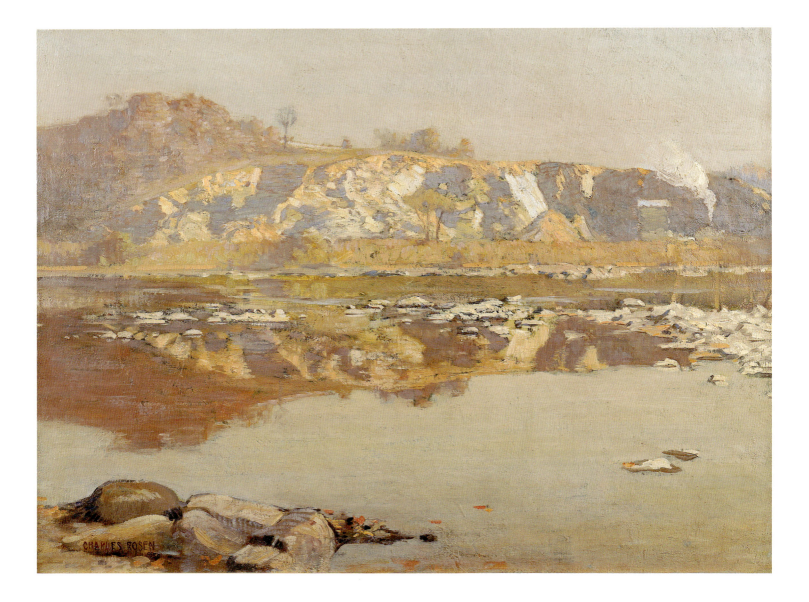

THE QUARRY, 1910
oil on canvas
30 × 40 inches

COLLECTION OF ROBERT AND AMY WELCH

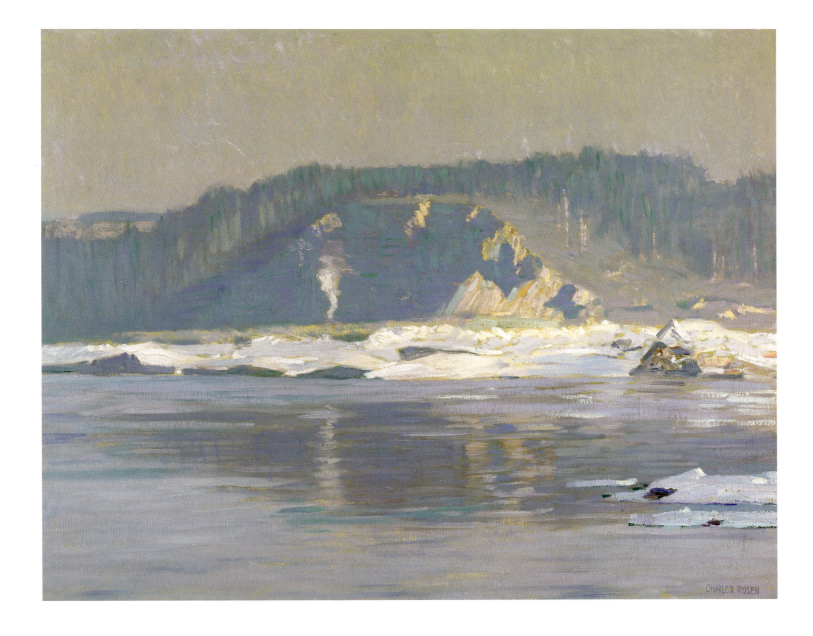

pl.9

THE QUARRY, WINTER, CA. 1910

oil on canvas

32 × 40 inches

COLLECTION OF MARGUERITE AND GERRY LENFEST

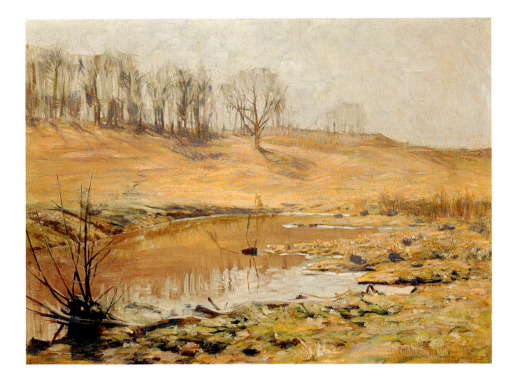

pl. 10

NOVEMBER, N.D.

[ALTERNATE TITLE: *White Sky, Early Spring*]

19⅝ × 25⅝ inches

oil on canvas

COLLECTION OF DR. AND MRS. M. STANLEY KRON

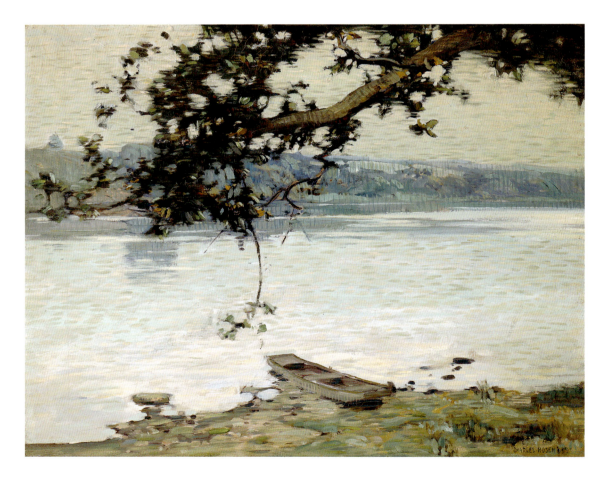

pl. 11

MORNING ON THE DELAWARE, CA. 1912

oil on canvas

32 × 40 inches

PRIVATE COLLECTION

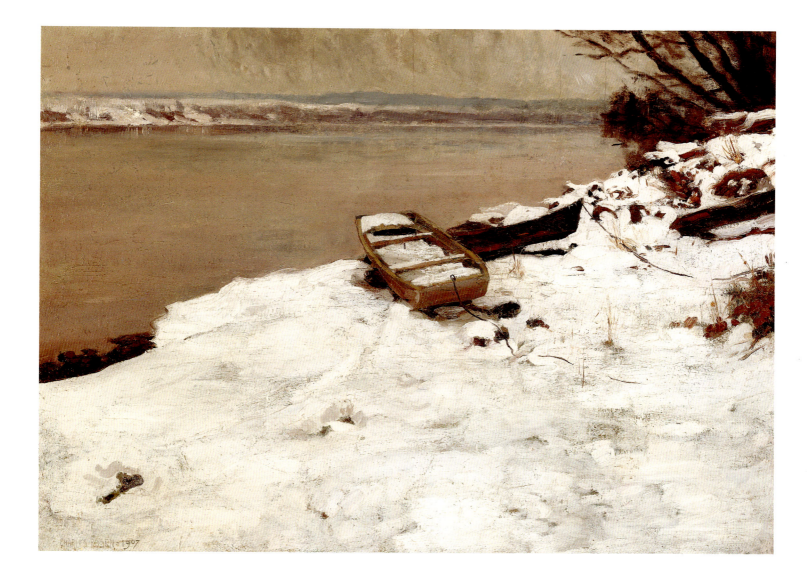

THE BOAT IN WINTER, 1907

[ALTERNATE TITLE: *The Open Boat*]

oil on canvas

29¾ × 40¼ inches

COLLECTION OF THOMAS AND KAREN BUCKLEY

In his early landscapes Rosen was interested in capturing the many and varied moods of nature. While the appearance of his work began to change, this poetic streak continued to dominate his landscapes, resulting in some of the finest canvases he made in his New Hope years. *Icebound River* (pl. 13), for example, is a powerfully evocative work of art that depicts a moment of transcendental calm at daybreak on the Delaware River. One's eye enters the painting in the lower right corner, moves slowly into the canvas along a winding pathway of moving water between two icy patches, and finally arrives at a placid area of blue river that's cradled by a row of dark purplish hills. To the left of the open water, the faint glow of morning sunlight has just struck the shoreline as the sun rises above the unseen New Jersey hills on the right. The tranquil atmosphere of this masterful painting comes in part from the simplicity of its composition, the flowing and delicate brushwork (note the sensuous curves of paint in the watery channel on the lower right), and the muted, nearly monochromatic colors that are dominated by soft whites and a multitude of blues from dark to light.

Icebound River

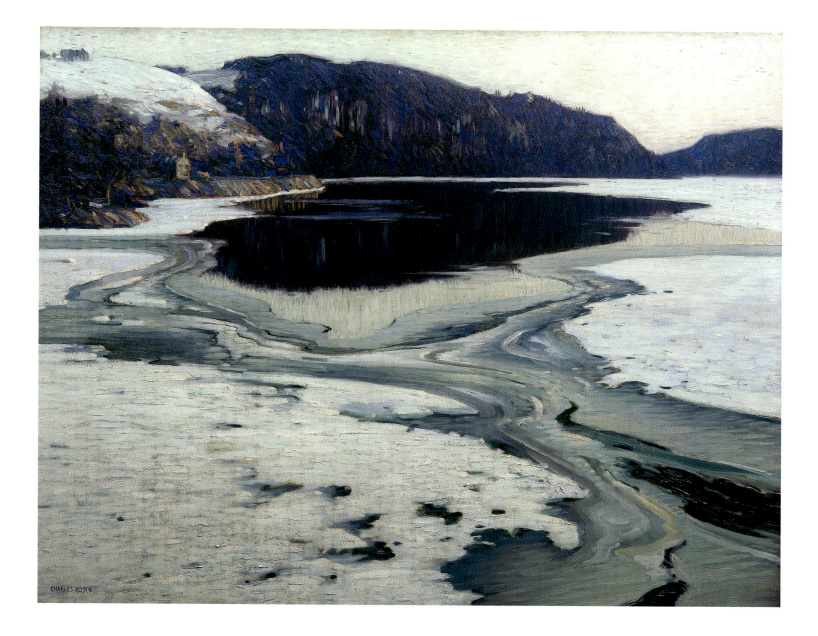

pl. 13

ICEBOUND RIVER, CA. 1915
oil on canvas
54 × 64 inches
COLLECTION OF MARGUERITE AND GERRY LENFEST

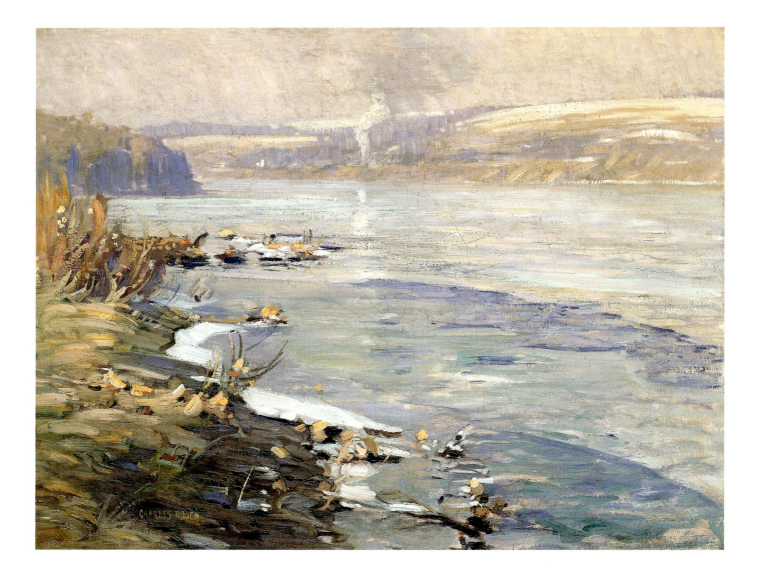

pl. 14

DELAWARE RIVER NEAR NEW HOPE, PENNSYLVANIA, CA. 1910–15

oil on canvas

32 × 40½ inches

COURTESY OF THE BIGGS MUSEUM OF AMERICAN ART

pl.15

WINTER PATTERNS, CA. 1916
oil on canvas
42 × 52 inches
PRIVATE COLLECTION

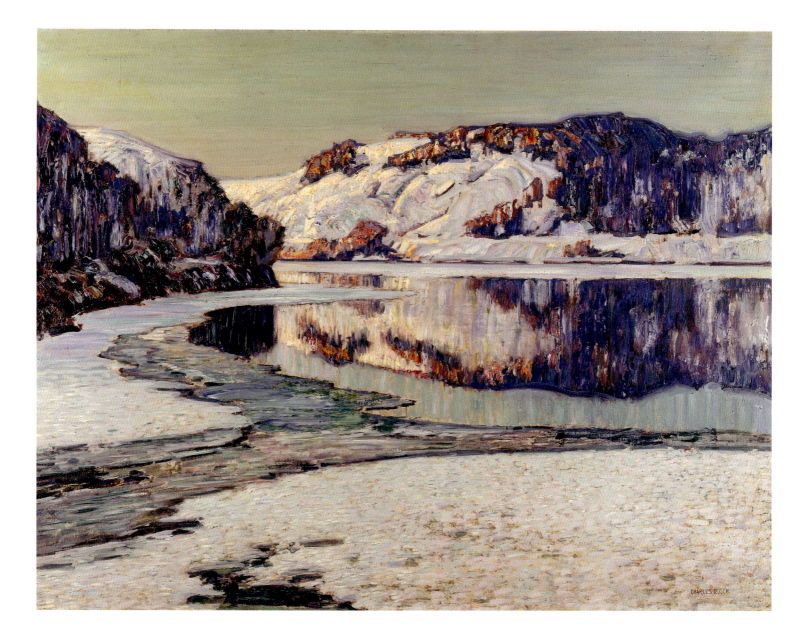

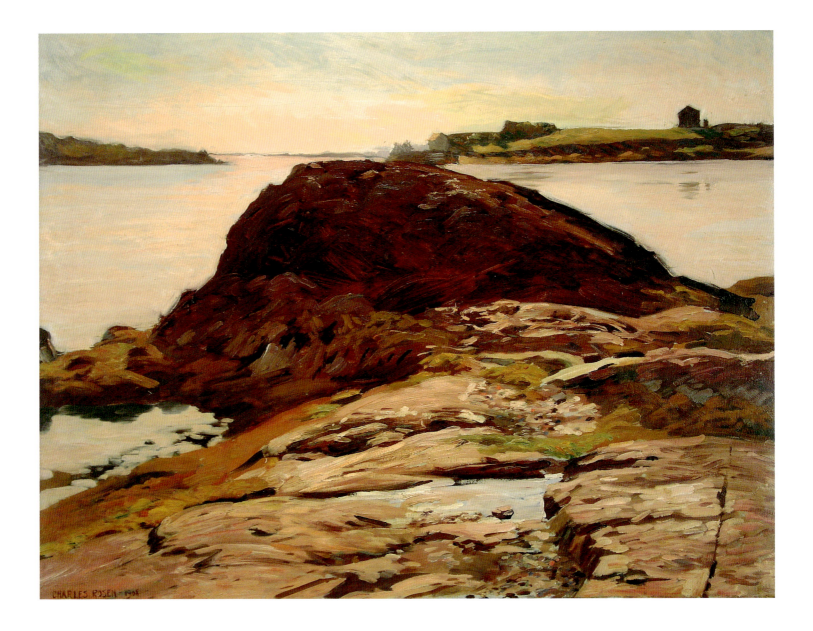

UNTITLED, 1908

[POSSIBLE TITLE: *Rock at North Haven, Maine*]

oil on canvas

32 × 40 inches

MUSEUM OF ART AND ARCHAEOLOGY, UNIVERSITY OF

MISSOURI—COLUMBUS

TRANSFERRED FROM BUSINESS SERVICES, MU

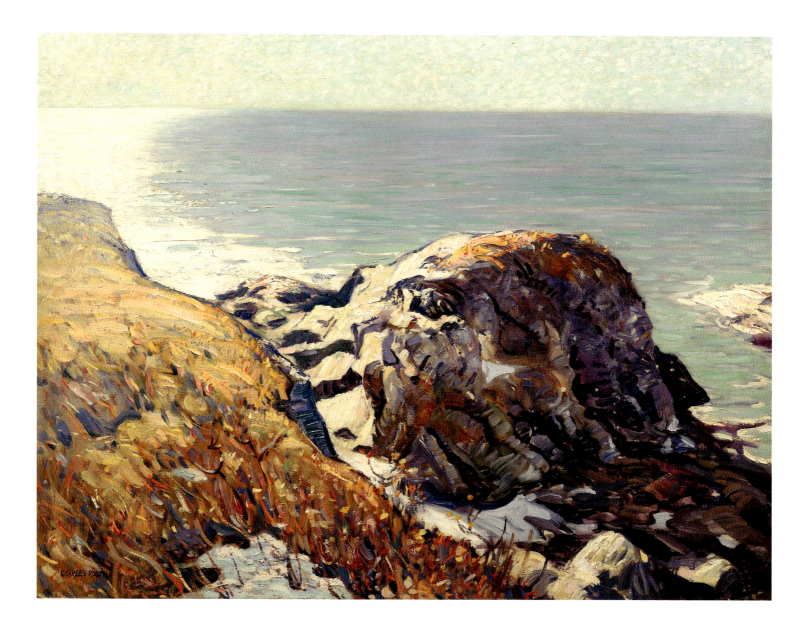

pl.17

THE SUN PATH, CA. 1917
oil on canvas
32 × 40 inches
PRIVATE COLLECTION

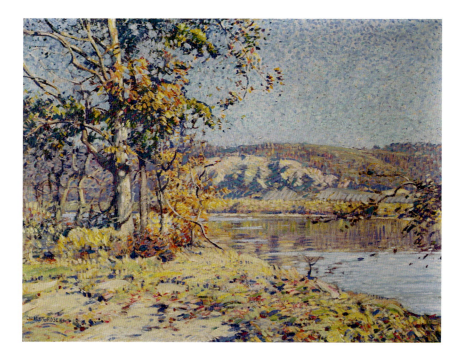

OCTOBER MORNING, 1915

[ALTERNATE TITLE: *Autumn Morning*]

oil on canvas

32 × 40 inches

COLLECTION KENNEDY MUSEUM OF ART, OHIO UNIVERSITY

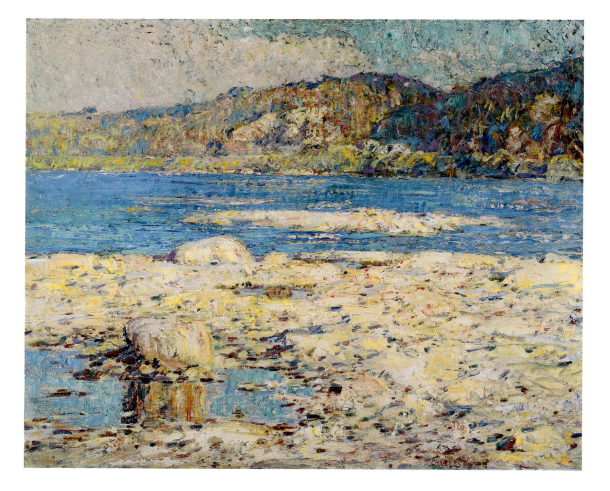

pl. 19

THE BLUE RIVER, CA. 1919

oil on canvas

29¼ × 34⅞ inches

COLUMBUS MUSEUM OF ART, OHIO

GIFT OF JOHN M. ALTMAIER UA.1995

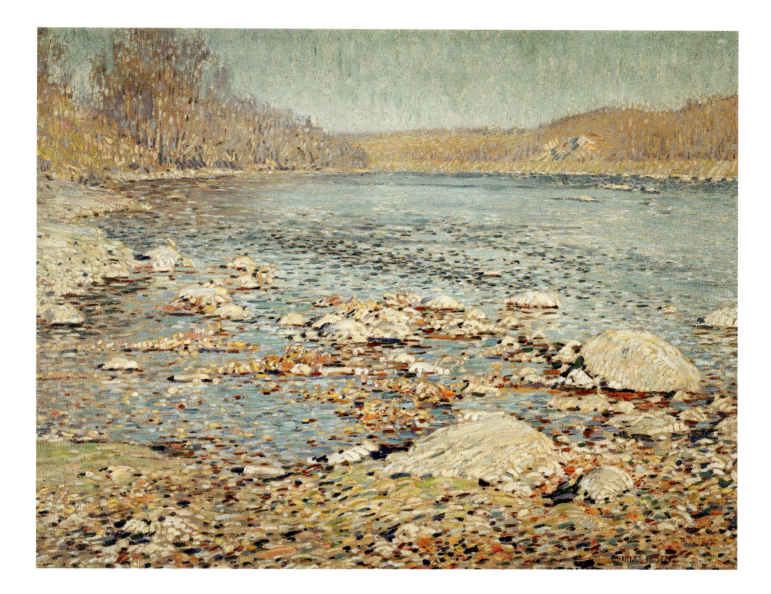

AUTUMN ON THE DELAWARE, CA. 1916

oil on canvas

32 × 40 inches

COLLECTION OF GREGORY DAVID COSTER

If the only Rosen painting you've seen is *Icebound River* (pl. 13), it would be easy to conclude that this artist was a gifted painter of moody, evocative landscapes. But *The Frozen River* (pl. 21) is in a very different stylistic universe. Instead of darker blues and purples, this canvas is an explosion of whiteness—so white that, as the brilliant midday sun reflects off the mounds of fresh snow on the shore of the Delaware River, you almost have to resist an urge to squint! Not only is the palette different, but the paint is applied in larger, more rapid strokes, suggesting that the picture may have been made at least in part outdoors, or *en plein air.* The composition is much more active and complex, and the atmosphere of the painting is radically different from *Icebound River.* Rather than being calm and poetic, *The Frozen River* is full of nervous energy. Impressionist painters often were interested in the varying qualities of light, and this canvas has the classic impressionist obsession with the effects of sunlight on surfaces.

The Frozen River

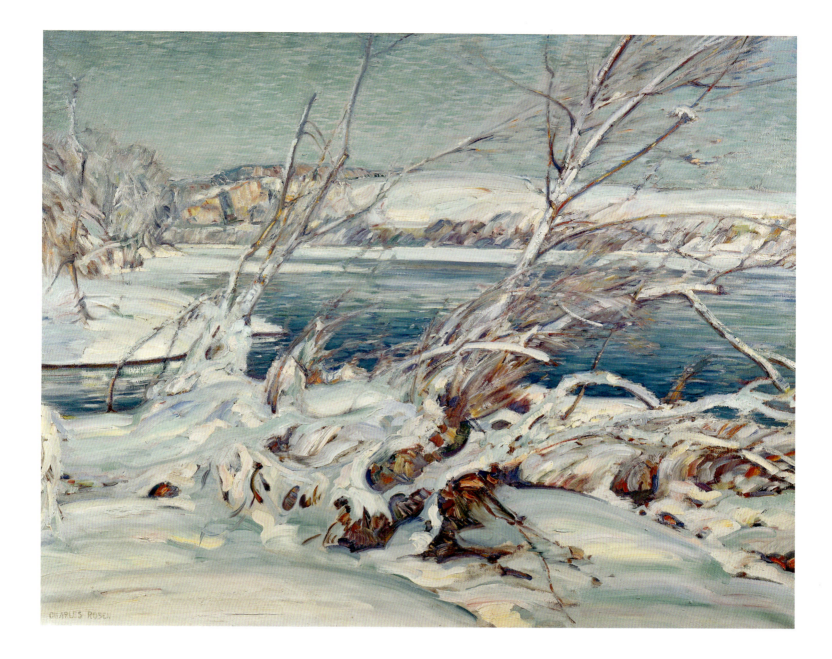

pl.21

THE FROZEN RIVER, CA. 1916

oil on canvas

42 × 52 inches

COLLECTION OF MARGUERITE AND GERRY LENFEST

A WINTER MORNING, CA. 1913

[ALTERNATE TITLE: *The Delaware, Winter Morning*]

oil on canvas

42 × 52 inches

COLLECTION OF MARGUERITE AND GERRY LENFEST

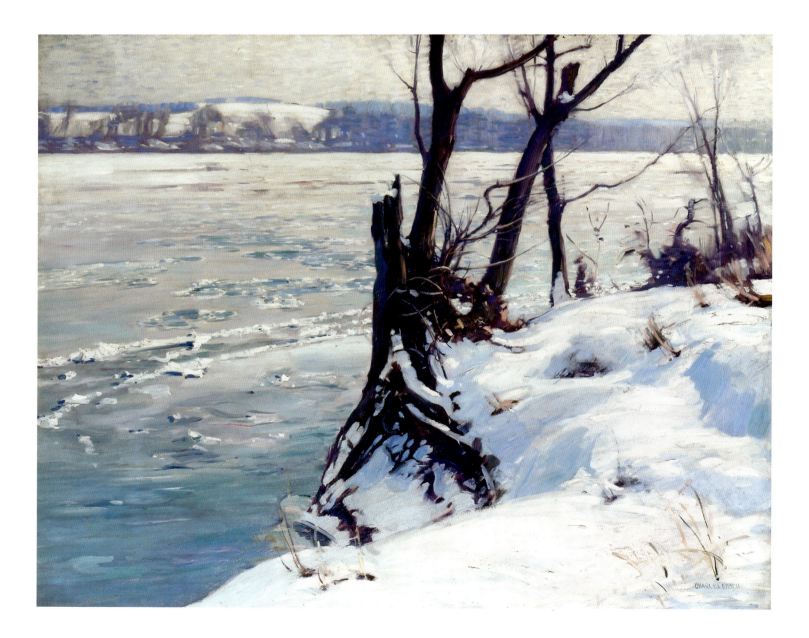

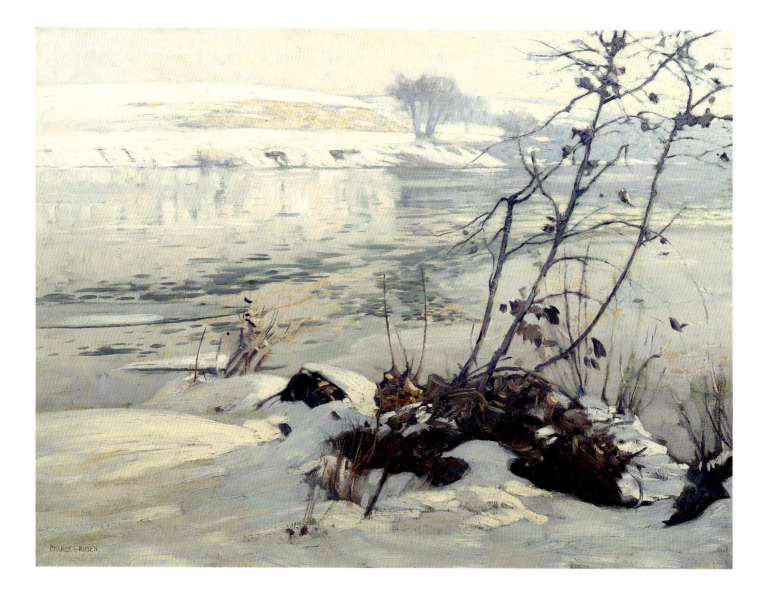

pl.23

FLOATING ICE, EARLY MORNING, CA. 1915

[ALTERNATE TITLE: *Floating Ice, Winter Morning*]

oil on canvas

32 × 40 inches

COLLECTION OF LEE AND BARBARA MAIMON

THE DELAWARE IN WINTER, CA. 1917

oil on canvas

31⅞ × 40 inches

PHILADELPHIA MUSEUM OF ART: THE ALEX SIMPSON, JR., COLLECTION

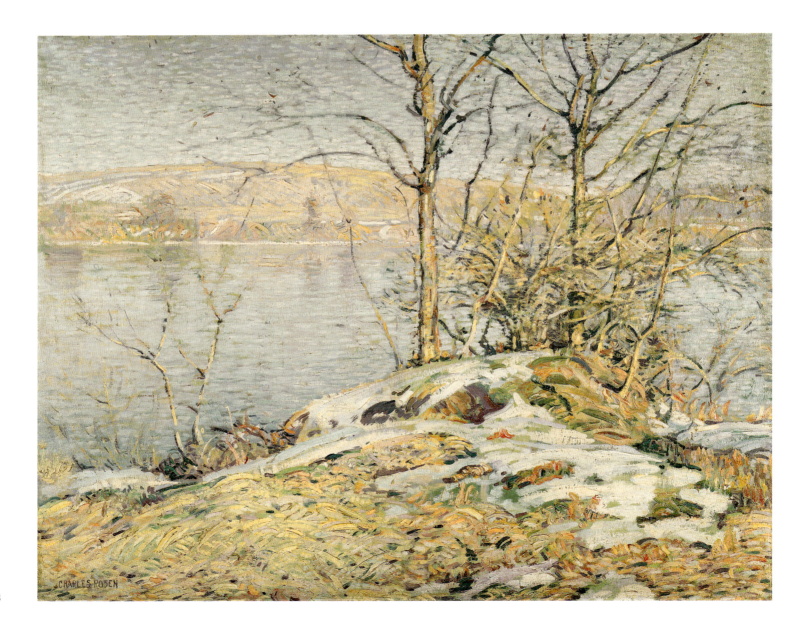

WATER BIRCHES, CA. 1917

oil on canvas

25 × 30 inches

JAMES A. MICHENER ART MUSEUM

GIFT OF MARGUERITE AND GERRY LENFEST

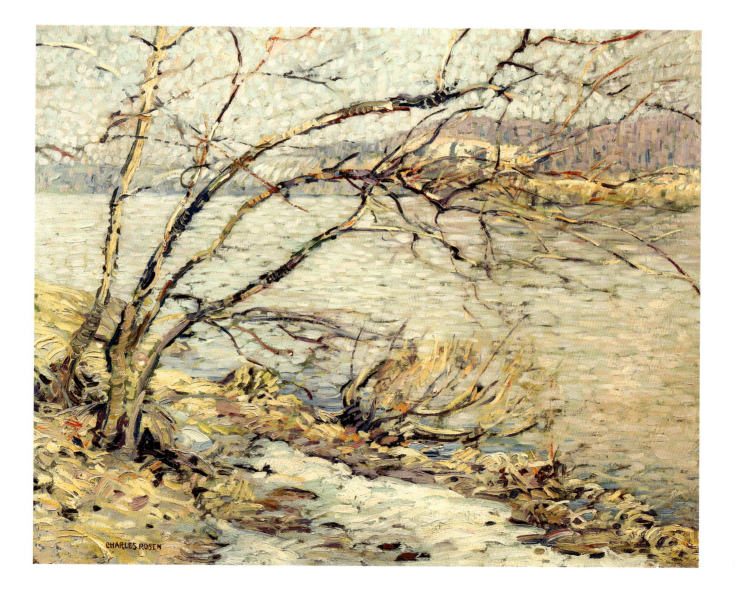

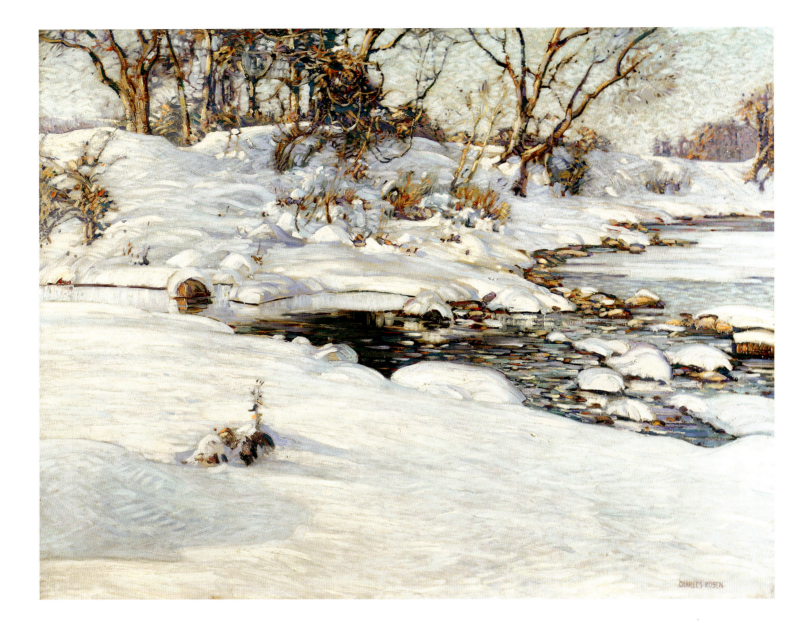

WINTER SUNLIGHT, CA. 1916

oil on canvas

42 × 52 inches

BUTLER INSTITUTE OF AMERICAN ART, YOUNGSTOWN, OHIO

MUSEUM PURCHASE 1920

RIVER IN WINTER, CA. 1918
oil on canvas
32 × 40 inches
PRIVATE COLLECTION

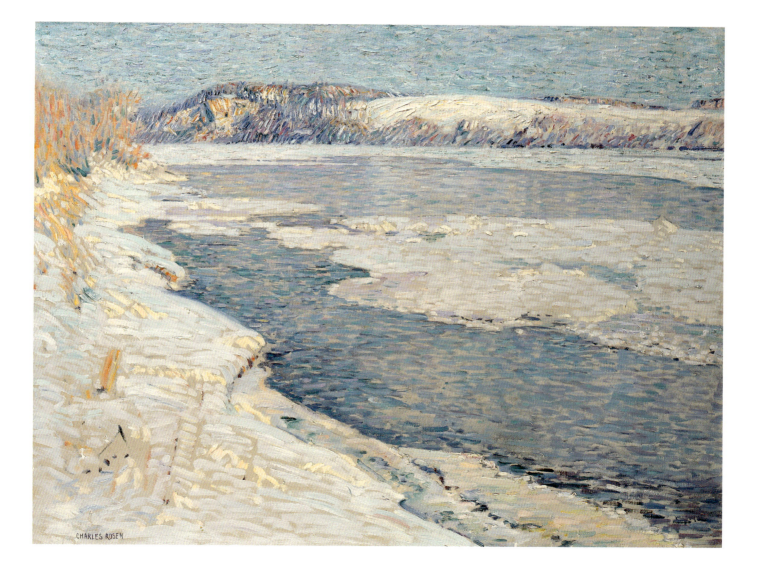

Rosen's restless mind led him to explore even more styles of landscape painting. Like *The Frozen River* (pl. 21), *Hillside* (pl. 28) is a brightly colored snow scene, in this case a sunlit hill rather than a tree-covered river-bank. But while the paint application in *The Frozen River* is relatively unbroken, making the piles of snow appear smooth and even, in *Hillside* the brushwork is broken and dappled, almost as if Rosen was influenced by classic French impressionist painters such as Claude Monet. In *Spring Branch* (pl. 30), the surface is no longer delicately dappled but thick with luscious gobs of multi-colored paint laid on with abandon. Rather than display-ing a French influence, this canvas is reminiscent of the compositional habits of Japanese printmakers, who loved to linger meditatively on graceful foreground branches, suspended as if in mid-air, with a river, a mountain, or a village behind them. When you begin to absorb the incredible variety of Rosen's landscapes, a simple fact becomes clear: this was an artist who never grew into his own skin as a landscape painter. At one time or another, he experimented with almost every form of landscape that was then available. But ultimately nothing fit, and he had to move on.

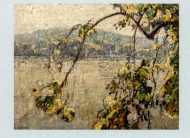

A Variety of Styles

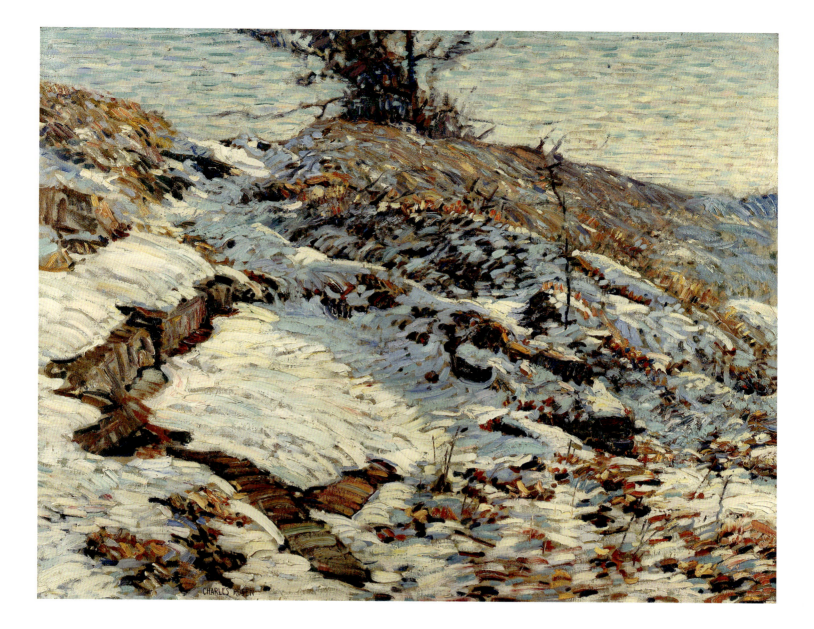

HILLSIDE, CA. 1918

oil on canvas

32 × 40 inches

COLLECTION OF LOUIS AND CAROL DELLA PENNA

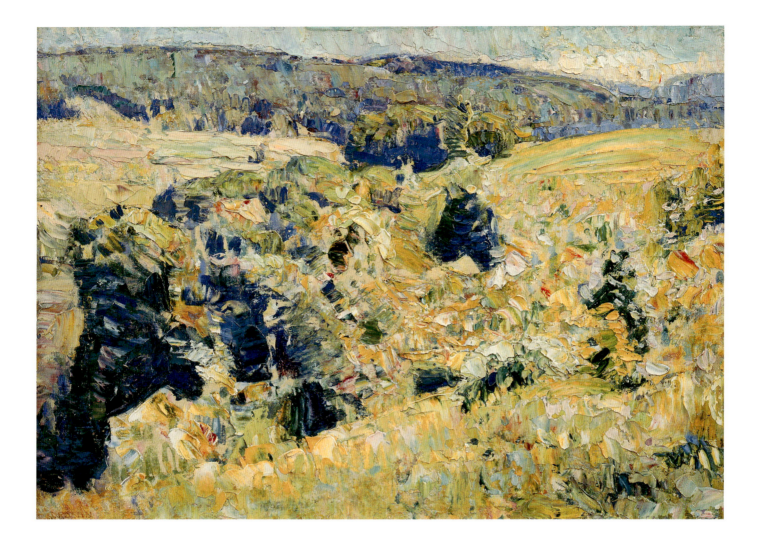

UNTITLED, CA. 1915–18
oil on canvas
9¾ × 13⅞ inches
PRIVATE COLLECTION

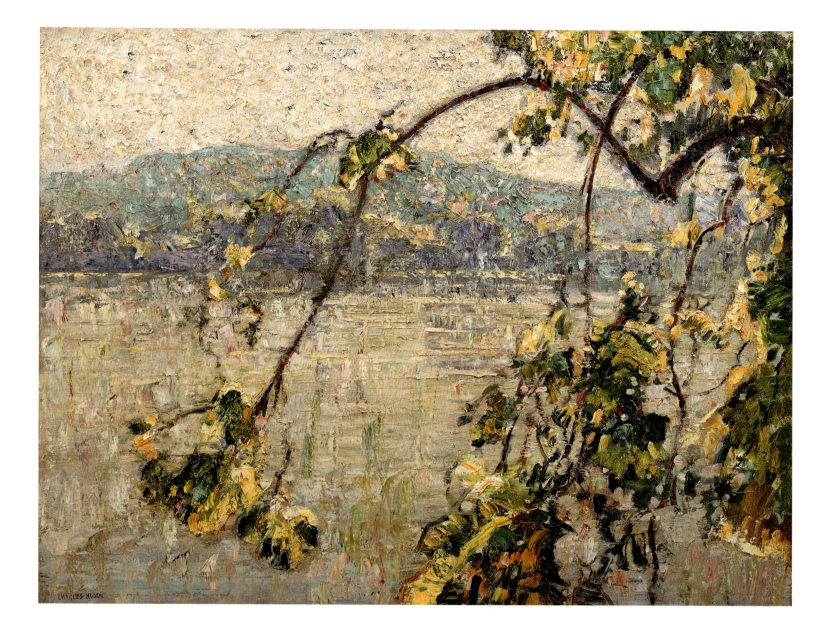

SPRING BRANCH, CA. 1916

[ALTERNATE TITLE: *The Hanging Branch*]

oil on canvas

32 × 40 inches

PRIVATE COLLECTION

A ROCKY SHORE, CA. 1917
oil on canvas
32 × 40 inches
PRIVATE COLLECTION

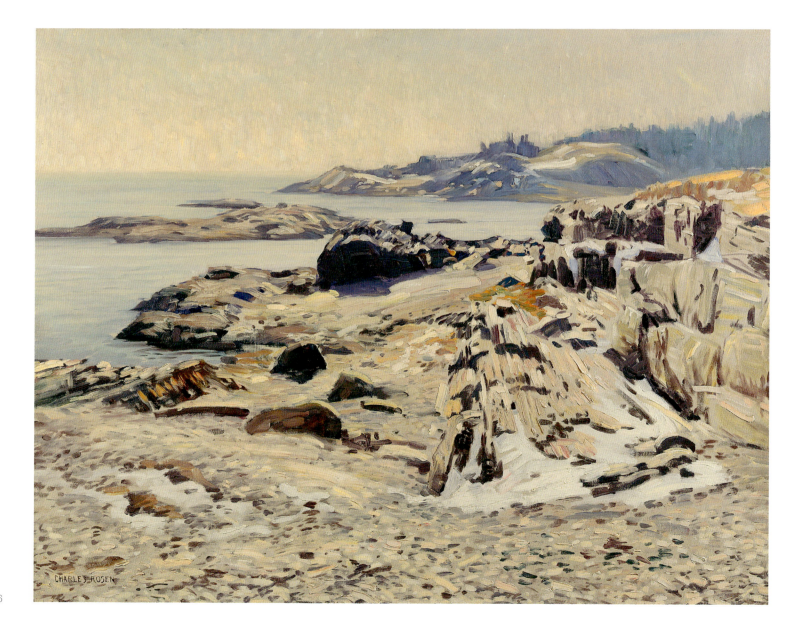

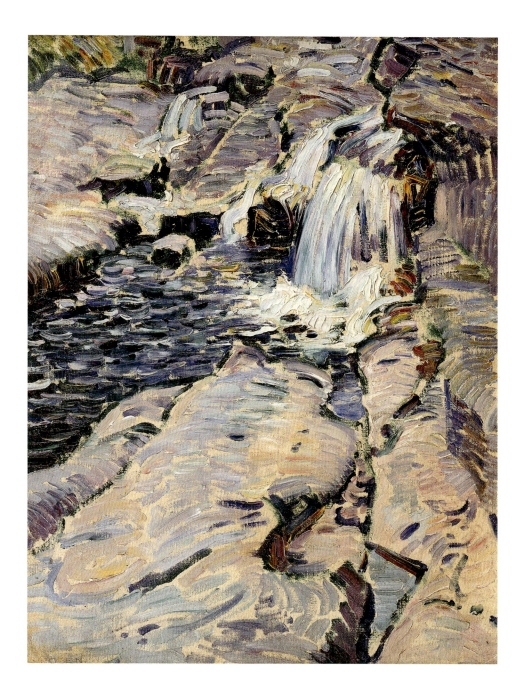

pl.32

TUMBLING BROOK, CA. 1916

oil on board

15½ × 11¼ inches

PRIVATE COLLECTION

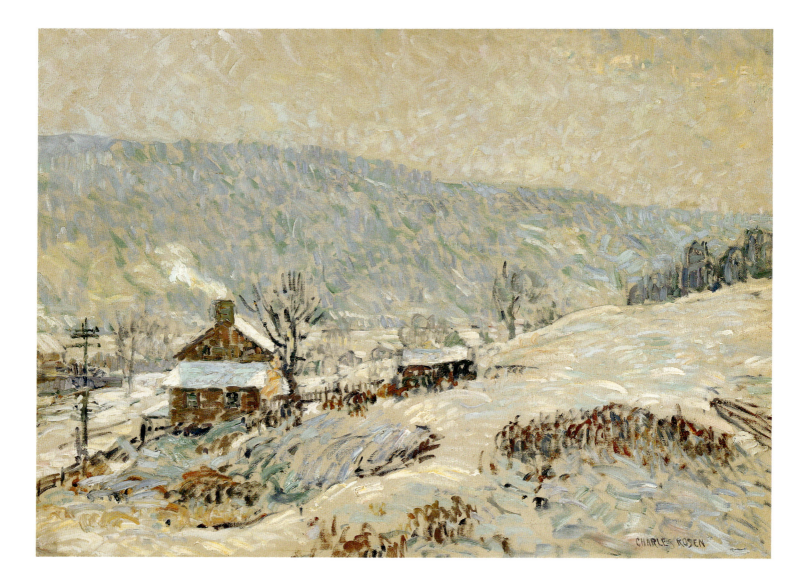

pl.33

WINTER MORNING, CA. 1913
oil on canvas
24 × 32 inches

PRIVATE COLLECTION

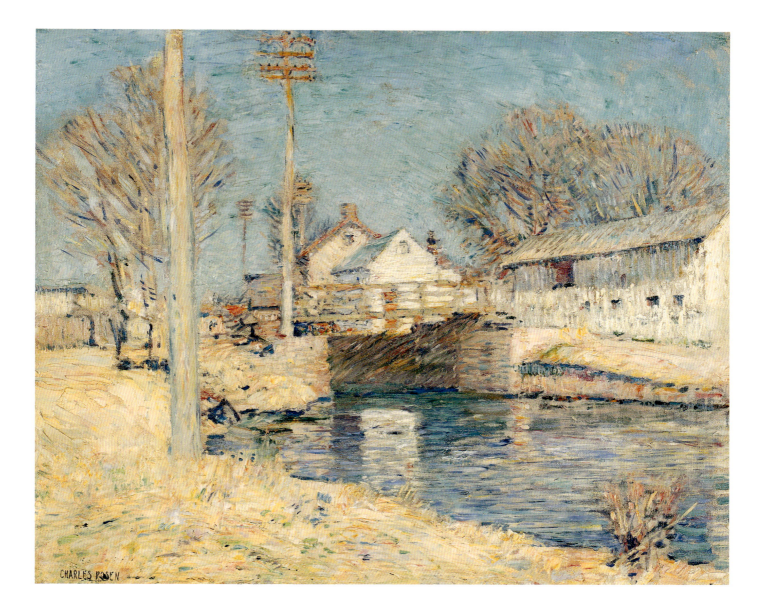

pl. 34

CANAL LOCKS, SPRING, CA. 1916–18

oil on canvas

25 × 30 inches

PRIVATE COLLECTION

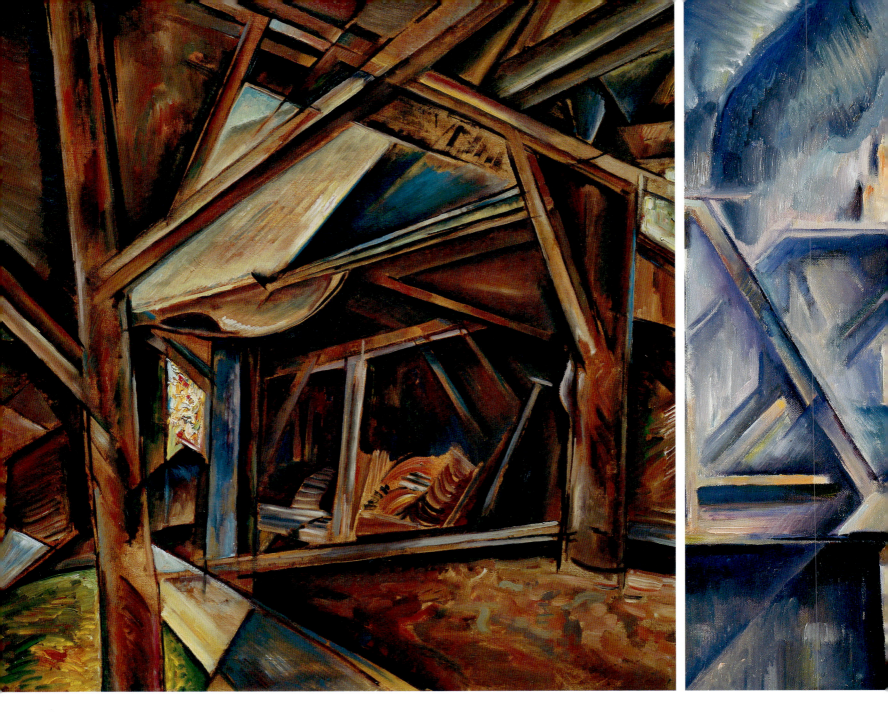

Woodstock and Modernism

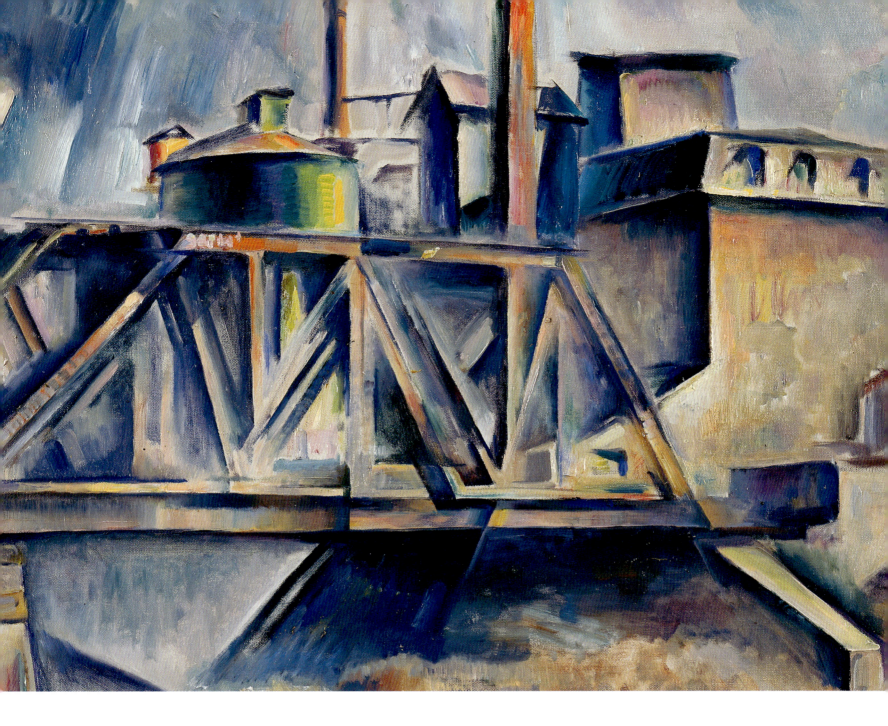

In his late thirties Rosen's work underwent a radical transformation. Instead of pastoral scenes of rivers and trees, he began to paint houses, boats, and other man-made structures in a manner that emphasized form and design rather than visual poetry. The initial paintings in this style were made in and around New Hope (pls. 35–38), but he soon moved to Woodstock, New York, where he joined an art colony that was more receptive to these ideas than the more conservative group in Bucks County. One of the first such canvases to survive is *Under the Bridge* (ca. 1918; pl. 35); this painting has most of the fingerprints of his new way of working: man-made subject matter, muted colors, and a complex visual design that hovers between order and chaos. While the change in his work may have made him a wild-eyed revolutionary in the eyes of his New Hope friends, to Rosen it was a natural outgrowth of his exploratory urge. As he said, "I think of it as a most happy development for me since it resulted in opening up a completely new and exciting aspect of the whole art problem."

A Sudden Transformation

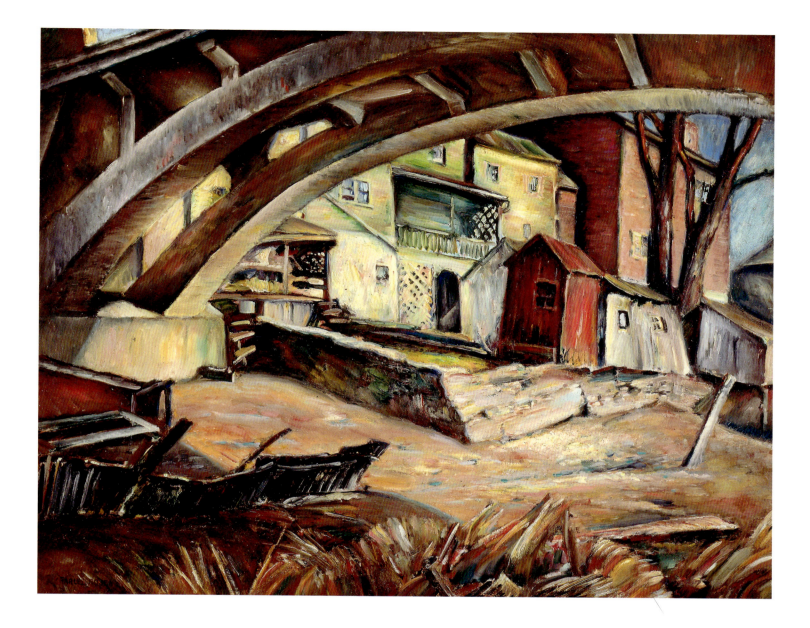

pl. 35

UNDER THE BRIDGE, CA. 1918

oil on canvas

32 × 40 inches

COLLECTION OF MARGUERITE AND GERRY LENFEST

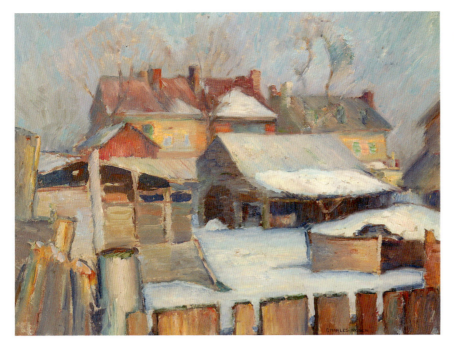

pl.36

UNTITLED, CA. 1918–20
oil on canvas
12 × 15 inches
COLLECTION OF THE HORTULUS FARM FOUNDATION MUSEUM

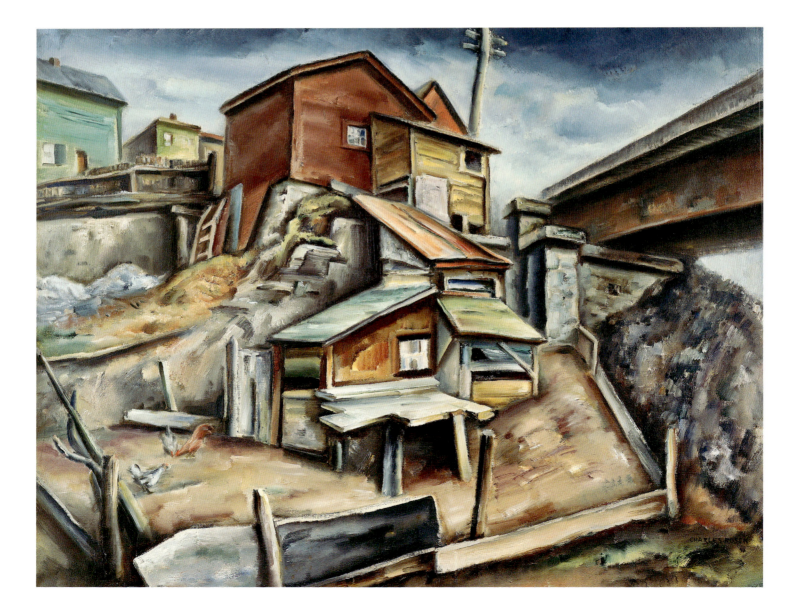

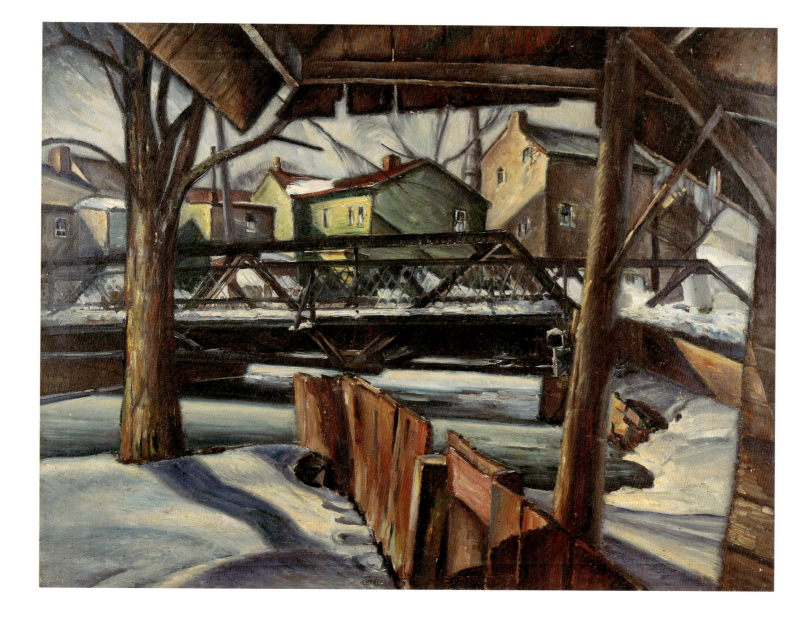

pl.37

CLIFF DWELLINGS, CA. 1918–20

oil on canvas

32 × 40 inches

COLLECTION OF ALFRED DEBEAU

pl.38

VILLAGE BRIDGE, CA. 1919

oil on canvas

32 × 40 inches

COLLECTION OF HOLLY GOFF

Rosen's stylistic transformation did not occur in a vacuum. As his friend and fellow painter John Folinsbee said, Rosen "had become conscious of the new art from Europe." In the first two decades of the twentieth century, great tidal waves of change were sweeping across the art world in both Europe and America. Painters Pablo Picasso in France and Wassily Kandinsky in Russia were making their first bold ventures into abstraction, challenging assumptions about the relationship between image and reality that had dominated Western art since the early Renaissance. It's very hard for us, after a hundred years of modernism and its countless offshoots, to imagine both the excitement and the hatred created by such notions as abstract or "nonobjective" painting, the fragmented and geometrical universe of cubism, or the rarified explorations of color and rhythm in the movement known as synchromism. While Rosen did not embrace these more radical forms of modernism, his emphasis on form and design over more traditional notions of realism and beauty placed him firmly in the modernist camp. He also occasionally made paintings that were directly influenced by certain modernist movements; for example, note the complex geometry of *Side Wheel in the Rondout* (pl. 39) and *Sawmill Interior* (pl. 51) or the abstract qualities of *Mountain Stream* (pl. 69).

Rosen and Modernism

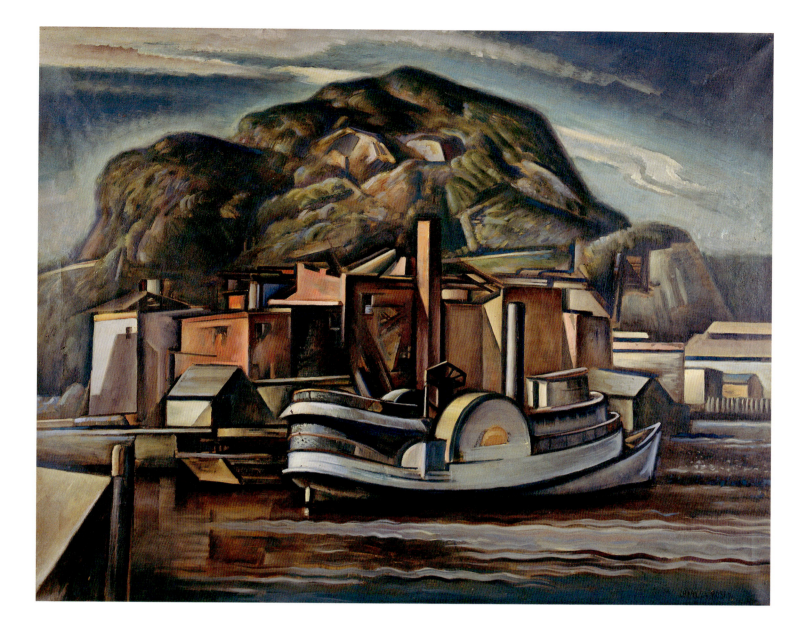

SIDE WHEEL IN THE RONDOUT, CA. LATE 1930S
oil on canvas
32 × 40 inches
PRIVATE COLLECTION

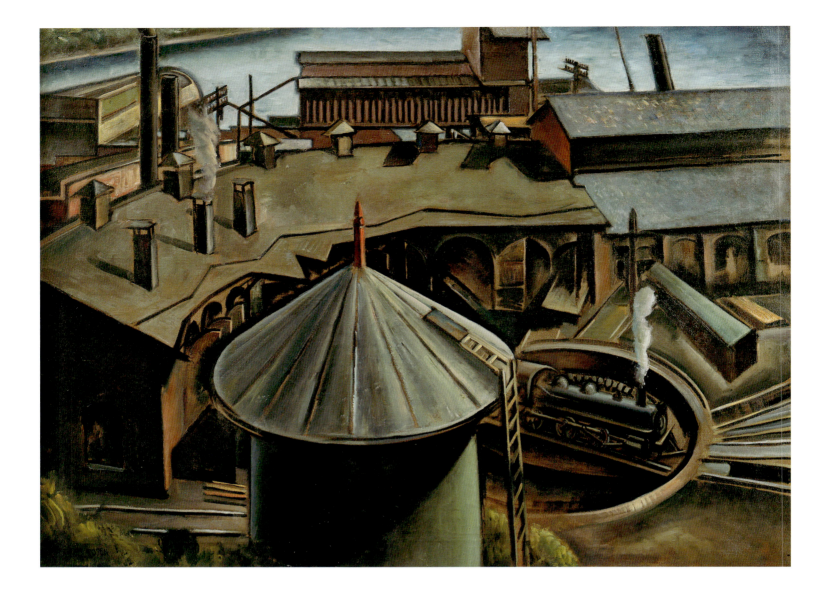

pl. 40

ROUND HOUSE, KINGSTON, NEW YORK, CA. 1927

oil on canvas

32 × 40 inches

JAMES A. MICHENER ART MUSEUM

GIFT OF THE JOHN P. HORTON ESTATE

CAR SHOPS, 1932
oil on canvas
20 × 40 inches
WHITNEY MUSEUM OF AMERICAN ART, NEW YORK; PURCHASE

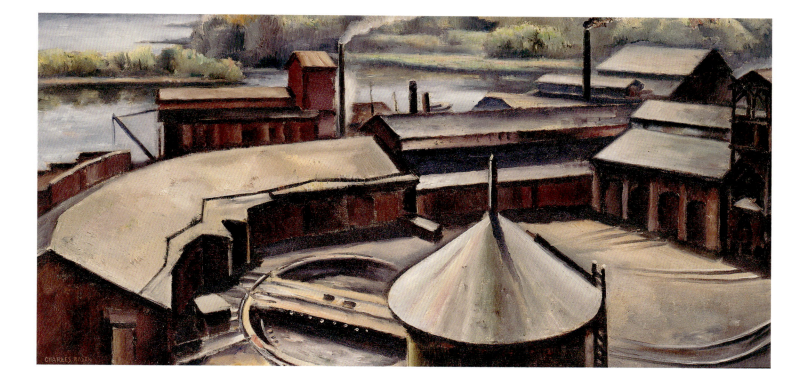

pl.42

FIREMAN'S HALL, CA. 1925
oil on canvas
32 × 40 inches
WOODSTOCK ARTISTS ASSOCIATION
PERMANENT COLLECTION, GIFT OF
JEAN ROSEN

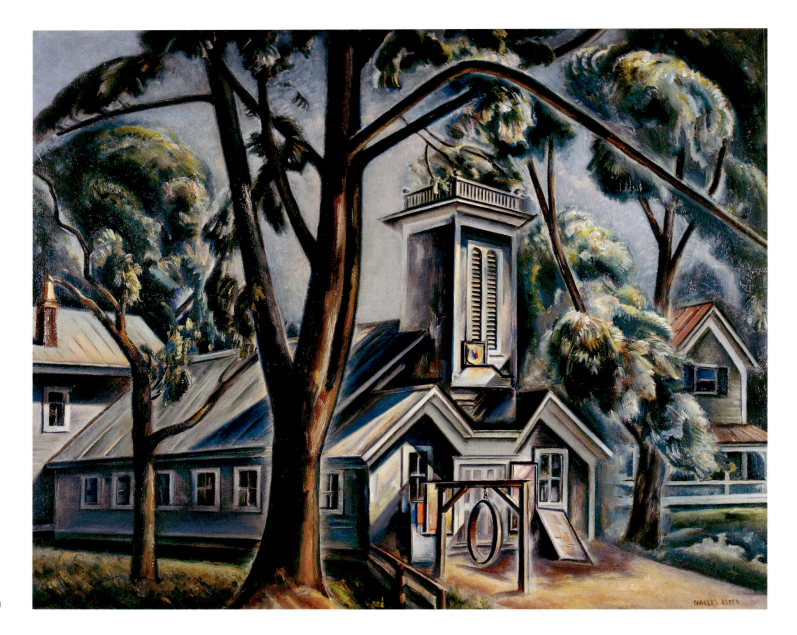

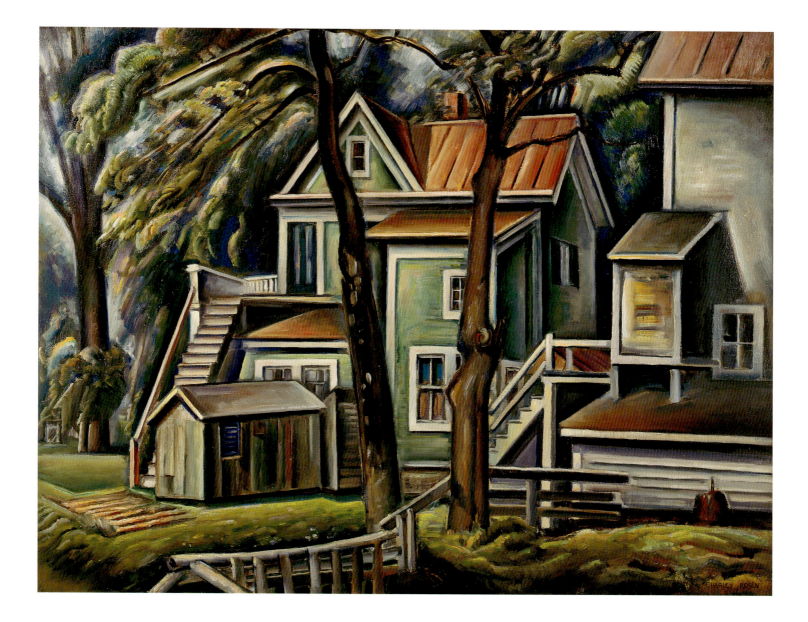

THE VILLAGE, 1935
oil on canvas
32½ × 40 inches
COLLECTION OF SARA AND HYMAN KAHN

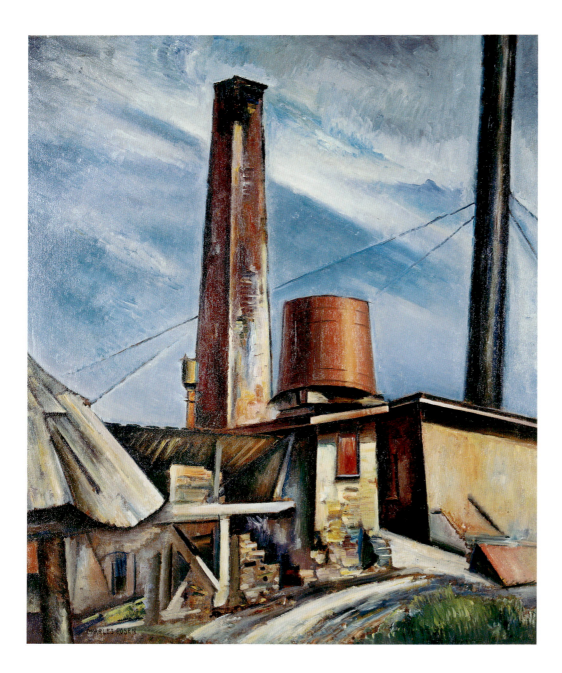

pl. 44

BRICK YARD, CA. 1931

oil on canvas

30 × 24 inches

COURTESY OF MORGAN ANDERSON CONSULTING

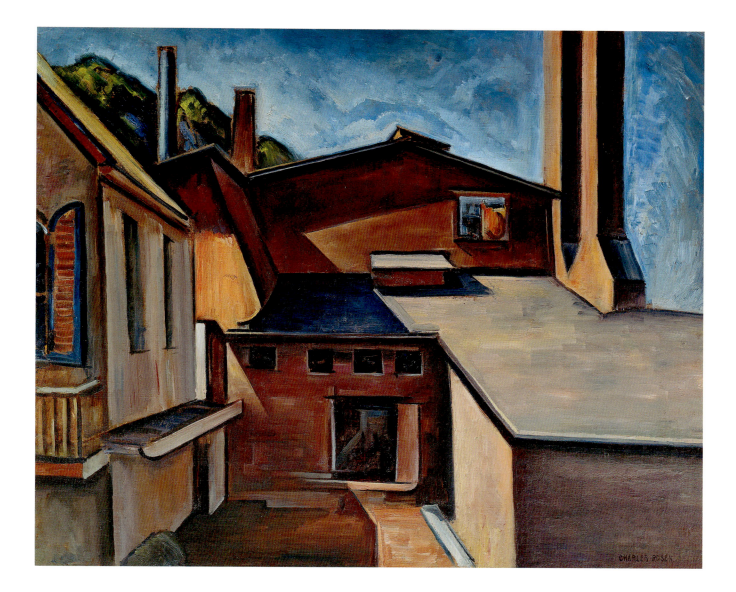

BRICKYARD BUILDINGS, N.D.

oil on canvas

25 × 30 inches

COLLECTION OF MR. AND MRS. ROBERT W. VAUGHAN

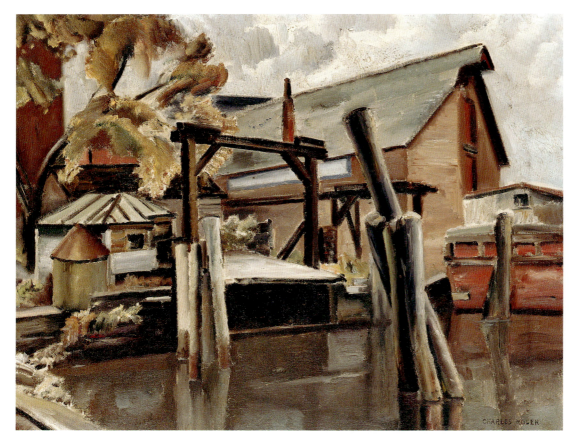

OLD FERRY SLIP, 1931
oil on canvas
24 × 30 inches
WHITNEY MUSEUM OF AMERICAN ART,
NEW YORK; PURCHASE

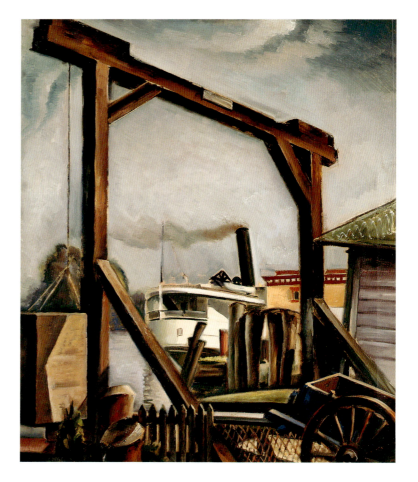

pl.47

STEAMBOAT LANDING, CA. 1929
oil on canvas
30 × 24 inches
COLLECTION OF JIM'S OF LAMBERTVILLE,
LAMBERTVILLE, NEW JERSEY

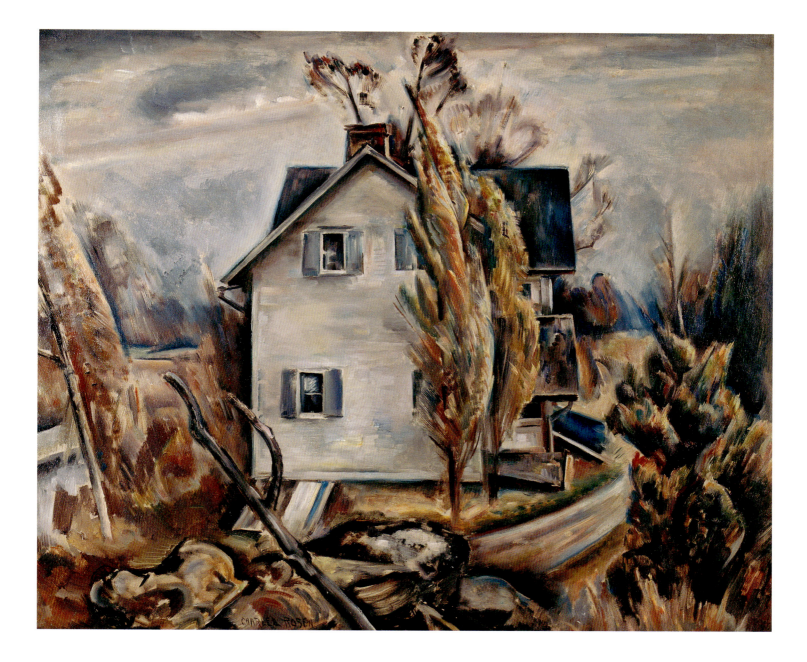

NEIL IVES' HOUSE, N.D.

oil on canvas

25 × 30 inches

COURTESY OF MORGAN ANDERSON CONSULTING

BLACKSMITH SHOP, CA. 1930
oil on canvas
32 × 40 inches
COLLECTION OF KATHARINE WORTHINGTON-TAYLOR

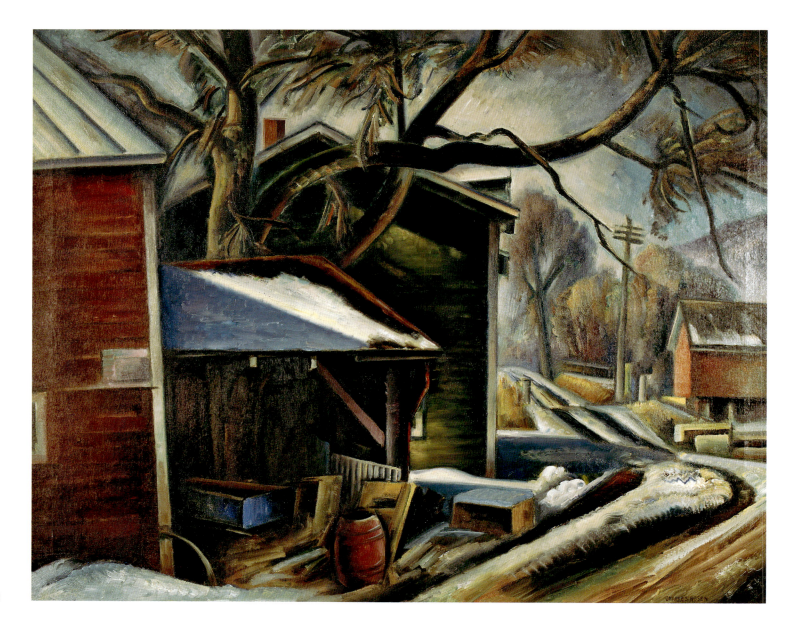

RONDOUT DWELLINGS, N.D.

oil on canvas

20 × 32 inches

COLLECTION OF HOLLY GOFF

Rosen's fascination with form was rooted in the modernist revolution. But many modernist artists were looking for a kind of purity and simplicity in their work, and consequently they rejected the natural chaos and complexity of the visual universe. Rosen was interested in, as he said, the "thrusts and stresses" of form. While he was not an active musician, he often drew on musical analogies to explain his approach to form. He was searching for a quality he called "form relationship, or a term that more often comes to mind in a discussion of this kind—form music!" On the surface his Woodstock work appears to be more or less realistic depictions of actual places. But what really interested him was *movement:* the underlying visual rhythms created by the interplay of line and curve. His paintings are full of chimneys, rooftops, windows, and trees—but these objects are also verticals, diagonals, lines, and shapes that both connect with each other and fight with each other. "When you combine a sense of movement or rhythm with this idea of form, space and color," he said, "I feel that you are getting quite close to something of great importance."

Rosen and Music

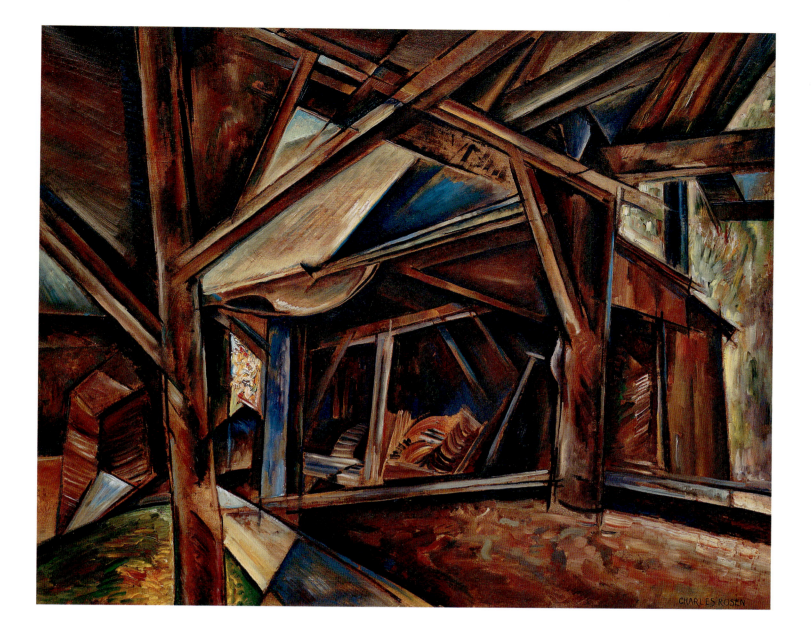

SAWMILL INTERIOR, CA. 1935

oil on canvas

25 × 30 inches

COLLECTION OF MAGGIE J. TYNDORF

STONE CRUSHER, CA. 1930

oil on canvas

40 × 32 inches

LOCATION UNKNOWN—IMAGE COURTESY OF KATHARINE WORTHINGTON-TAYLOR

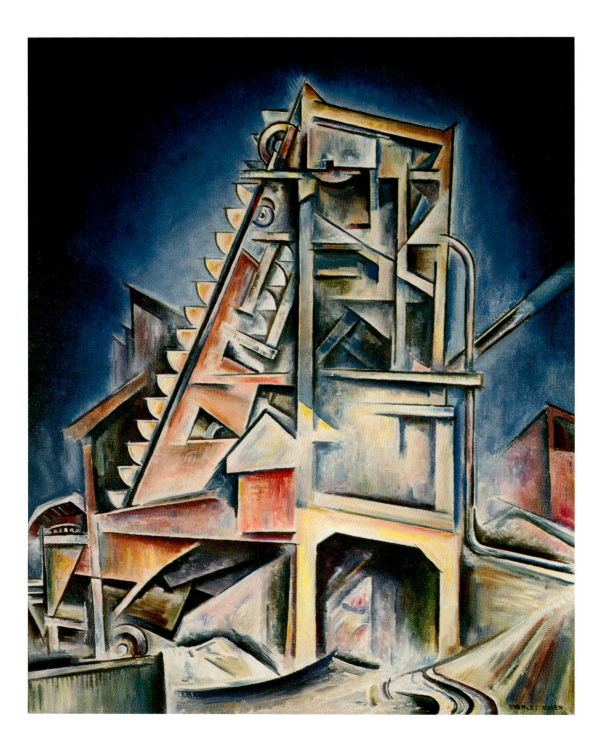

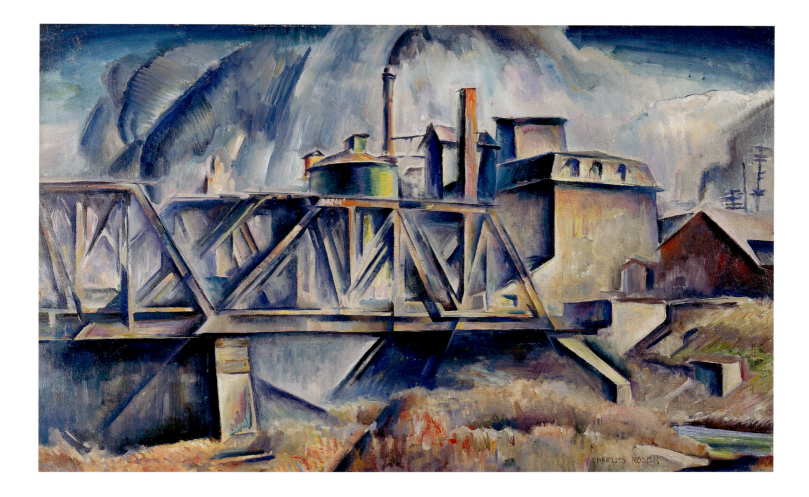

pl.53

RAILROAD BRIDGE, 1925

oil on canvas

20 × 32 inches

COLLECTION OF BARBARA AND DAVID STOLLER

pl.54

MILL AND STREAM, CA. 1939

oil on canvas

20 × 32 inches

COLLECTION OF VIRGINIA CALLAWAY

UNTITLED, N.D.

oil on canvas

24 × 30 inches

COLLECTION OF VIRGINIA CALLAWAY

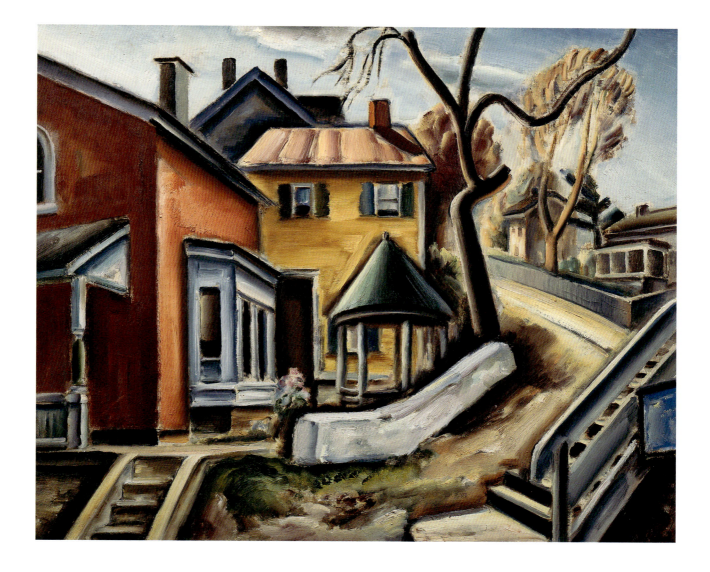

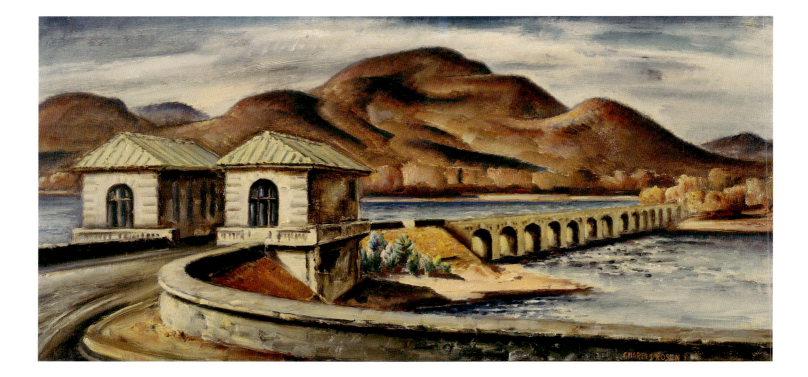

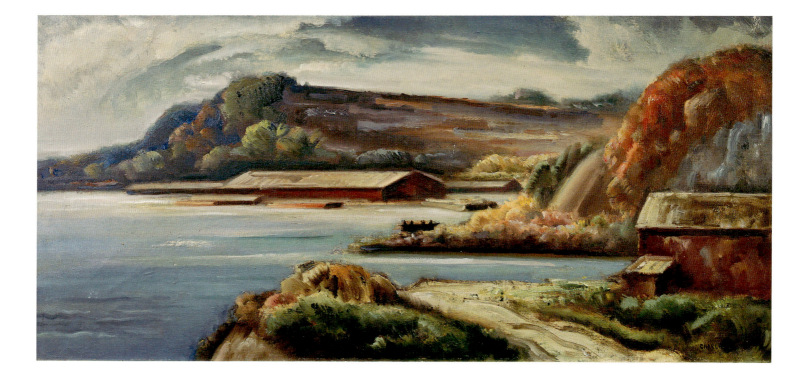

pl.56

ASHOKAN RESERVOIR, CA. 1934

oil on canvas

20 × 40 inches

SMITHSONIAN AMERICAN ART MUSEUM

TRANSFER FROM THE U.S. DEPARTMENT OF LABOR

pl.57

BRIGHAM YARDS, 1940

oil on canvas

20 × 40 inches

COLLECTION OF JUSTIN AND EMILY JONES

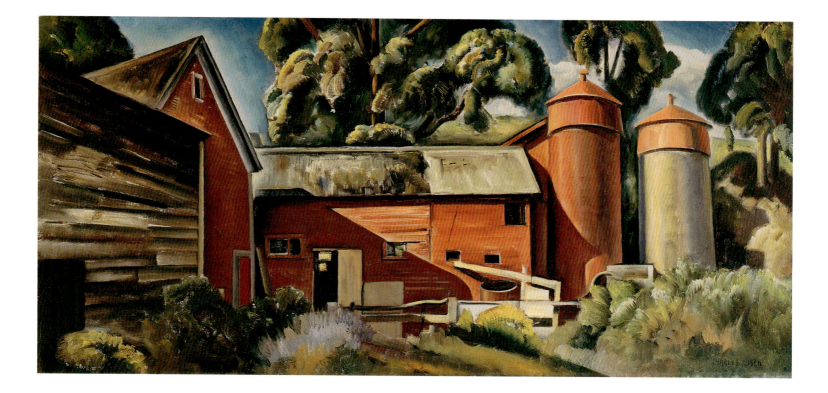

BARNS AND SILOS, N.D.

oil on canvas

19½ × 39½ inches

HOOD MUSEUM OF ART, DARTMOUTH COLLEGE, HANOVER, NEW HAMPSHIRE

GIFT OF THOMAS C. COLT, JR., CLASS OF 1926

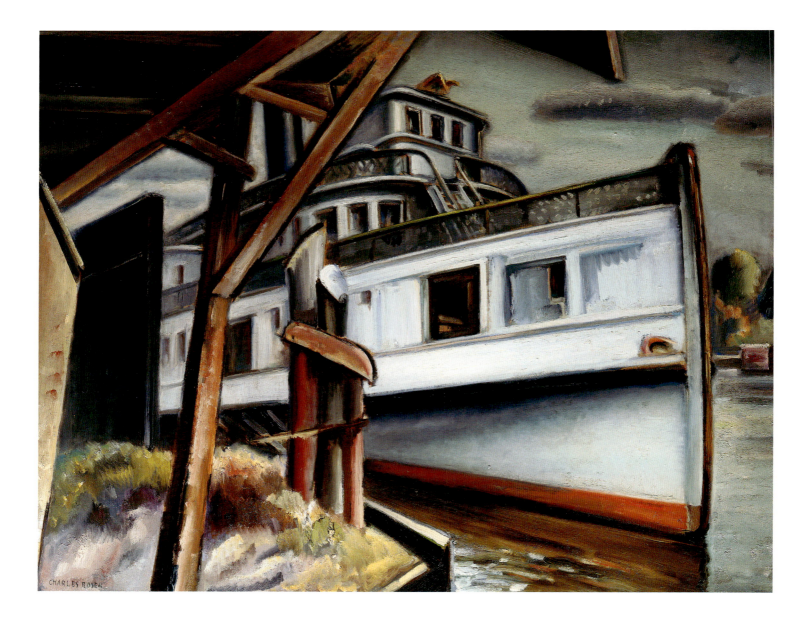

RIVERBOAT, HUDSON RIVER, 1939

oil on canvas

32 × 40 inches

D. WIGMORE FINE ART, INC., NEW YORK

pl.60

TUGBOAT RONDOUT,
CA. LATE 1930S
oil on canvas
32 × 40 inches
COURTESY OF MORGAN ANDERSON
CONSULTING

pl.61

OLD RIVER BOAT, CA. LATE 1930S
oil on canvas
32 × 40 inches
COLLECTION OF LOUIS AND CAROL DELLA PENNA

Quarry and Crusher (pl. 62) depicts a real place—a quarry and rock-crushing operation in the Woodstock area—but documenting what the place looked like was not the main reason Rosen chose to make this painting. What interested him was the intense visual conflict between the more chaotic, irregular, and unpredictable lines and shapes of the natural world and the geometrical, regular, and more predictable lines and shapes of the man-made world. The problem was how to bring some "rhythmic order" to the scene and make some "form music." The simplest and most powerful way he counteracted the inherent *stress* in the painting was through the element of *thrust,* that is, movement: an upward thrust beginning with the vertical and diagonal lines of the rock crusher, then joined by the vaguely upward pointing tree shapes, and finished off by the upward moving lines inscribed by the left and right sides of the mountain, all of which direct the eye toward the highest curve of the mountain at the top of the canvas. An equally powerful but more subtle ordering principle involves the binding together of apparently chaotic elements through repetitive devices such as parallel lines, which are created by such things as tree trunks, diagonal forms in the rock crusher, and the sloping sides of the mountain.

Quarry and Crusher

pl.62

QUARRY AND CRUSHER, CA. EARLY 1930S

oil on canvas

32 × 40 inches

D. WIGMORE FINE ART, INC.

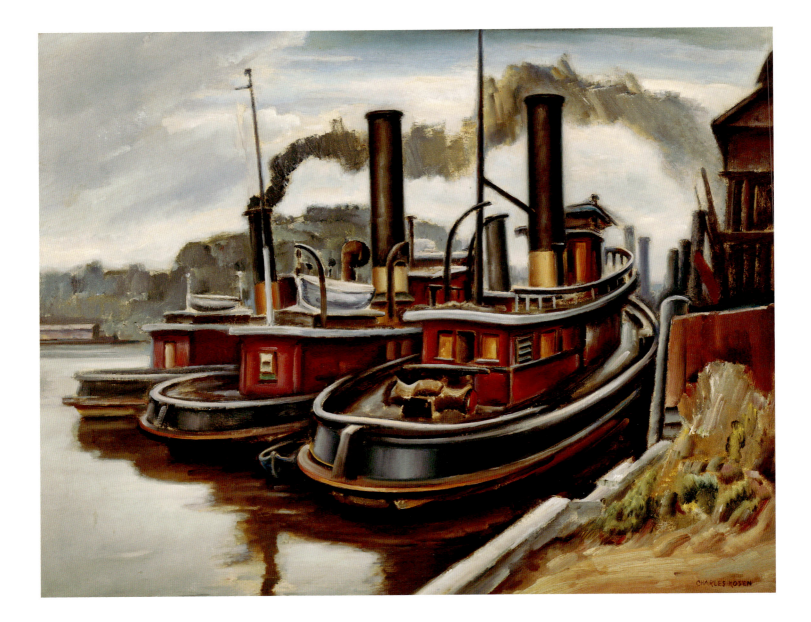

THREE TUGS, CA. EARLY 1930S

oil on canvas

32 × 40 inches

COLLECTION OF JIM'S OF LAMBERTVILLE,

LAMBERTVILLE, NEW JERSEY

pl.64

TUGS, CA. EARLY 1930S

oil on canvas

32 × 40 inches

COLLECTION OF MR. AND MRS. PERCY WARNER

pl.65

SKETCH OF RIVER BOAT, N.D.

oil on canvas

19½ × 40 inches

COLLECTION OF VIRGINIA CALLAWAY

141

WATERFALL, N.D.

oil on canvas

16 × 12 inches

COLLECTION OF KATHARINE WORTHINGTON-TAYLOR

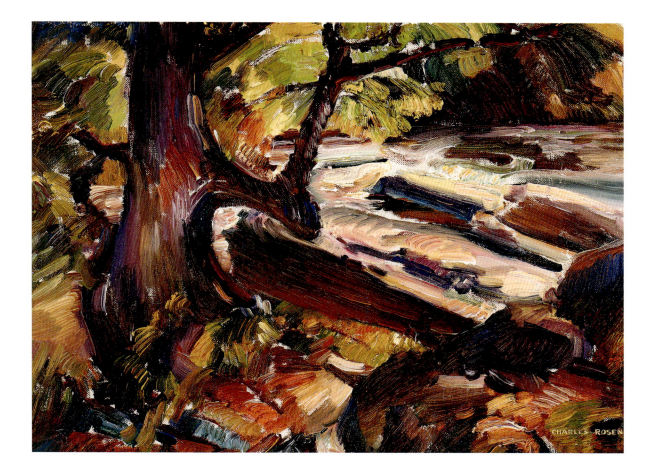

STREAM, N.D.

oil on board

12 × 16 inches

PRIVATE COLLECTION, COURTESY OF

DAVID DAVID GALLERY, PHILADELPHIA

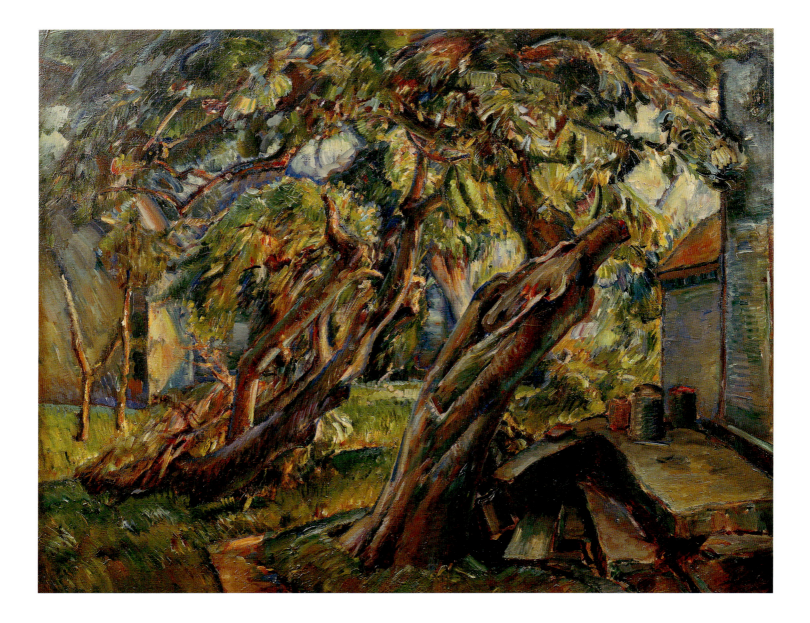

pl.68

APPLE ORCHARD, N.D.

oil on canvas

32 × 40 inches

COLLECTION OF VIRGINIA CALLAWAY

MOUNTAIN STREAM, CA. 1945

oil on canvas

32 × 40 inches

COLLECTION OF VIRGINIA CALLAWAY

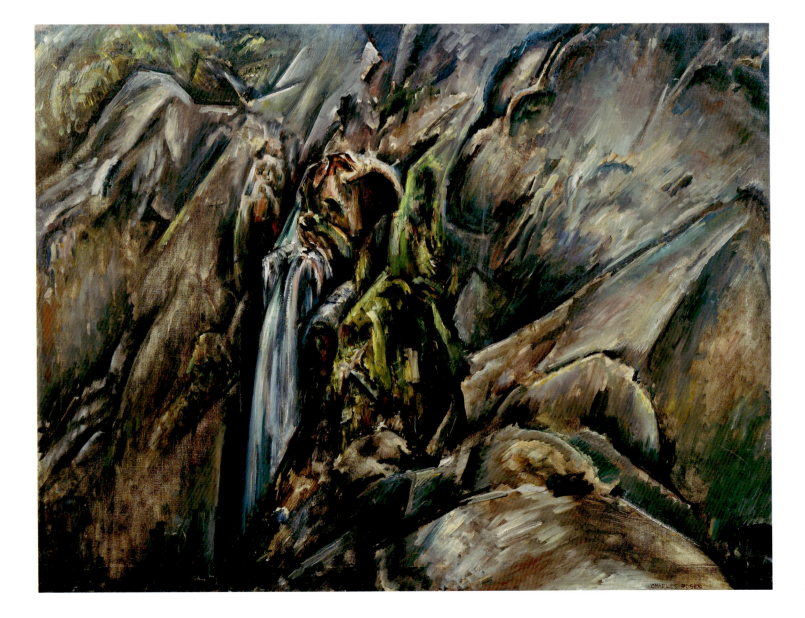

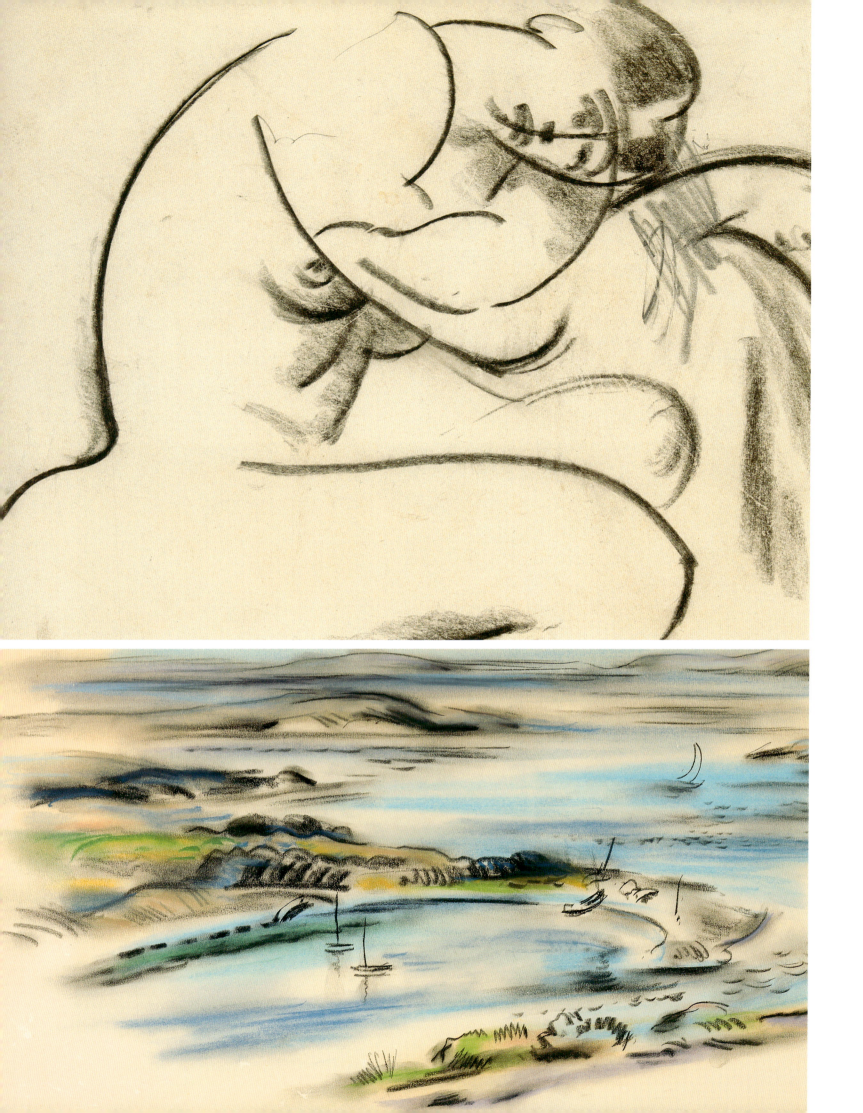

Works on Paper

While Rosen is known for his large-scale paintings, he also created many works on paper, especially figure studies and still lifes. Along with his Woodstock friends George Bellows and Eugene Speicher, he loved to make what are known as "poker sketches": small drawings, mostly portraits, made during quiet moments in the legendary poker games played by these painters. Rosen's still lifes often display an elegant use of line, a graceful and lively sense of movement, and a deft and delicate feeling for color. They are quiet and unassuming, but they often are magnificent works of art that show a search for simplicity in his work that is in contrast to the visual complexity of his paintings. In the last year or two of his life he also experimented with semiabstract drawings that tend to reduce the visual universe to very simple lines and shapes (pls. 80, 81). What's interesting about these pictures is not their level of abstraction (other modernist artists were doing this kind of thing decades earlier), but the fact that these images trim the world down to its bare bones while still embodying Rosen's idea of "form music" with remarkable skill.

Form Music

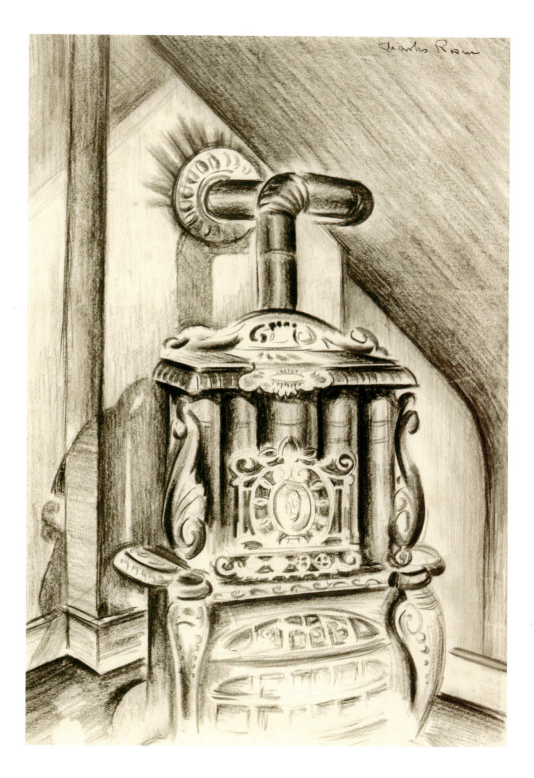

pl.70

OLD FAITHFUL, CA. 1923

Conté crayon on paper

18 × 12 inches

COURTESY OF MORGAN ANDERSON CONSULTING

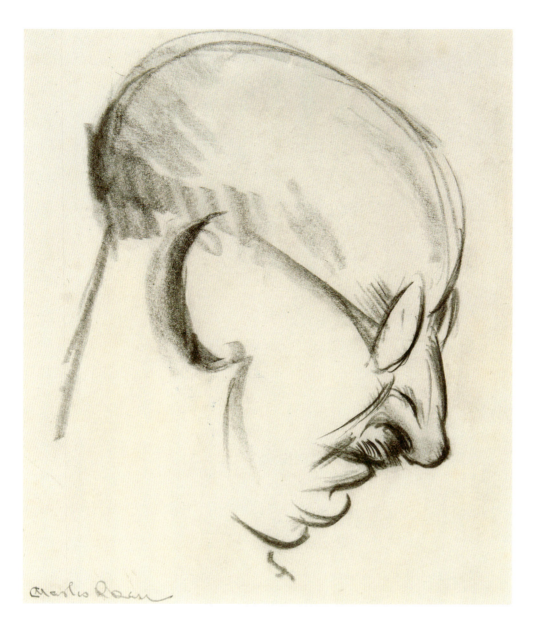

pl.71

GEORGE BELLOWS [POKER SKETCH], N.D.

charcoal with graphite on paper

7 × 5⅞ inches

COLLECTION OF KATHARINE WORTHINGTON-TAYLOR

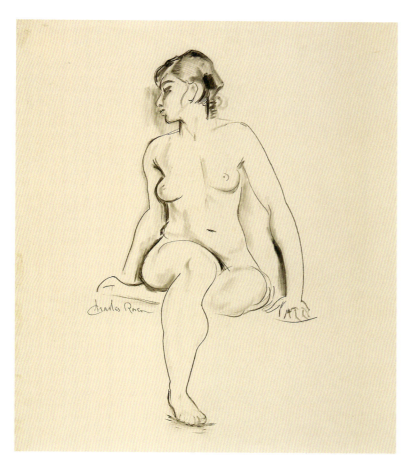

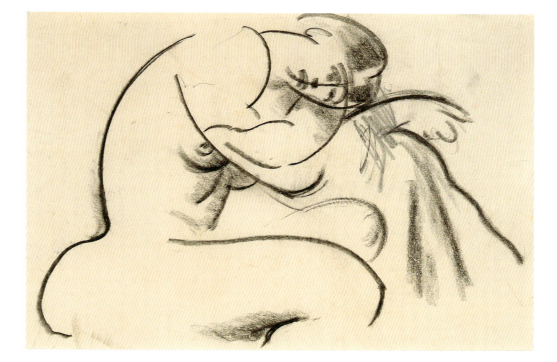

pl. 72

UNTITLED [NUDE], N.D.

charcoal with graphite on paper

13½ × 8½ inches

COURTESY OF MORGAN ANDERSON CONSULTING

pl. 73

ATTRIBUTED TO CHARLES ROSEN

UNTITLED [NUDE], N.D.

Conté crayon on paper

7¾ × 11 inches

COURTESY OF MORGAN ANDERSON CONSULTING

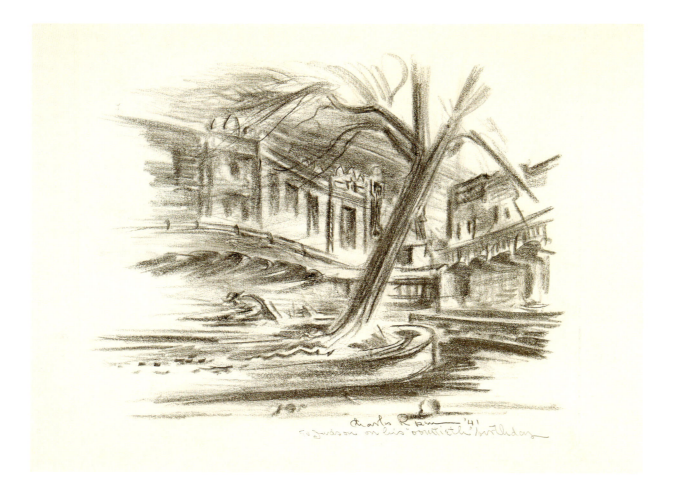

pl.74

UNTITLED [CITY SCENE], 1941
[INSCRIBED "TO JUDSON ON HIS 'OOMTIETH' BIRTHDAY"]
graphite on paper
8½ × 10 inches

COURTESY OF MORGAN ANDERSON CONSULTING

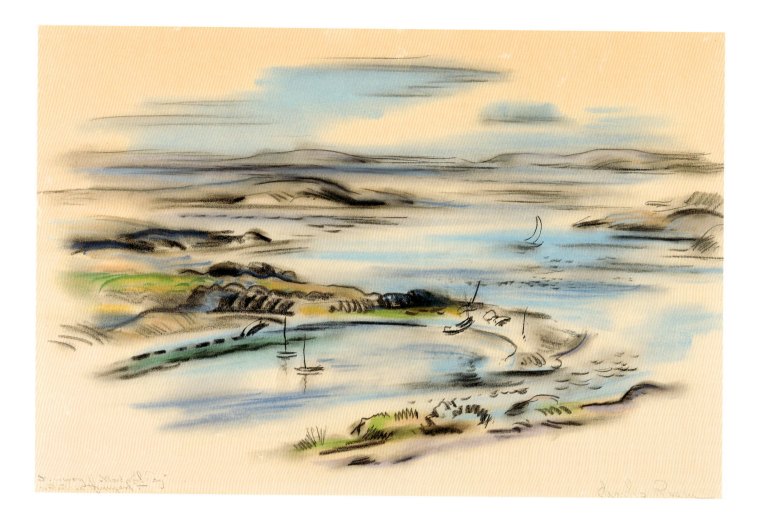

"IN MEMORY OF A WONDERFUL DAY
ON MARTHA'S VINEYARD," CA. EARLY 1940S

pastel on paper

13 × 19 inches

COLLECTION OF HOLLY GOFF

UNTITLED [STILL LIFE], 1949
pastel on paper
16 × 12 inches
COURTESY OF MORGAN ANDERSON CONSULTING

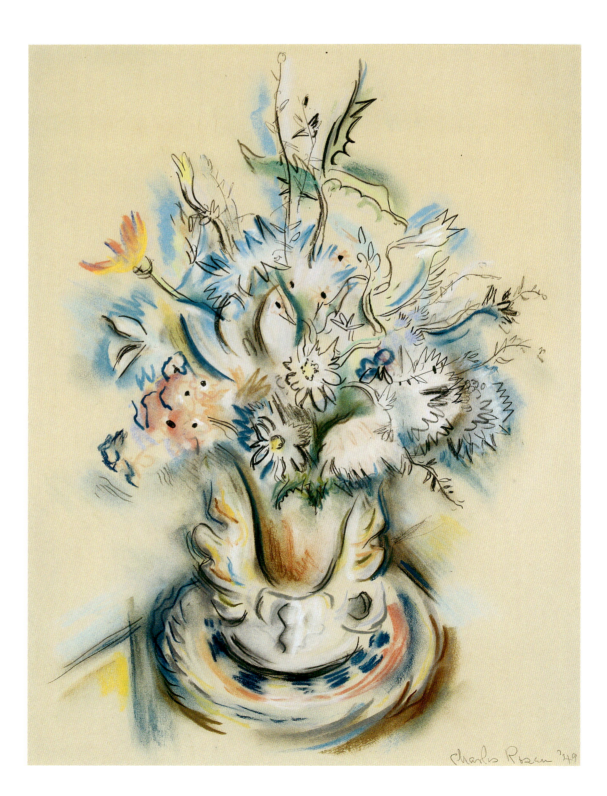

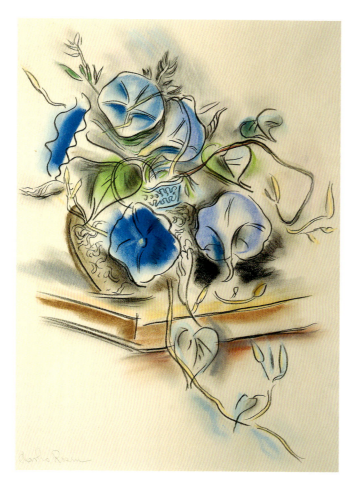

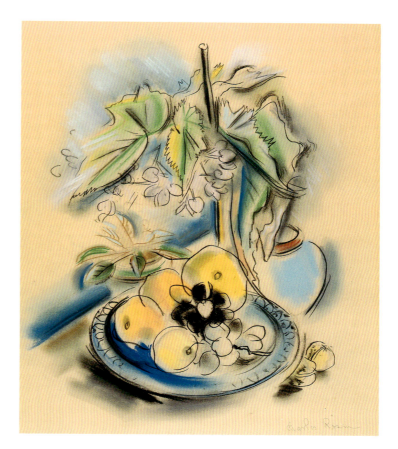

UNTITLED [STILL LIFE], CA. LATE 1940S
pastel on paper
14 × 10 inches
COLLECTION OF TOM AND LINDA TOMPKINS

UNTITLED [STILL LIFE], 1949
pastel on paper
17 × 14 inches
COLLECTION OF HOLLY GOFF

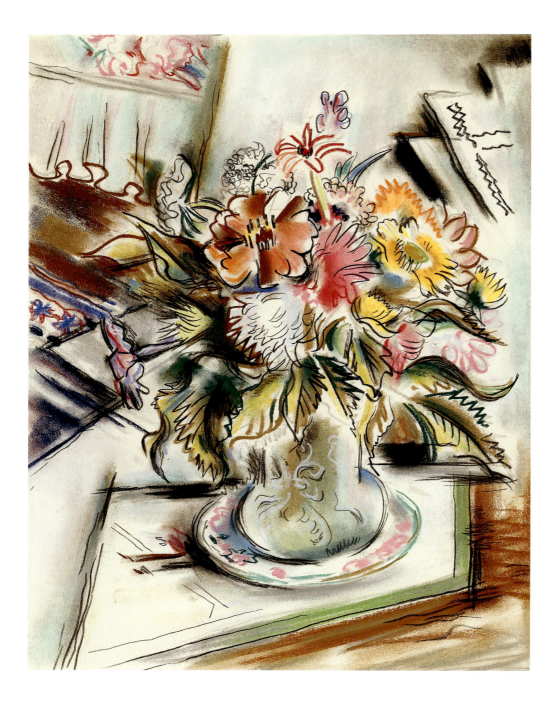

pl. 79

UNTITLED [STILL LIFE], CA. LATE 1940S

pastel on paper

16 × 12½ inches

PRIVATE COLLECTION, COURTESY OF DAVID DAVID GALLERY, PHILADELPHIA

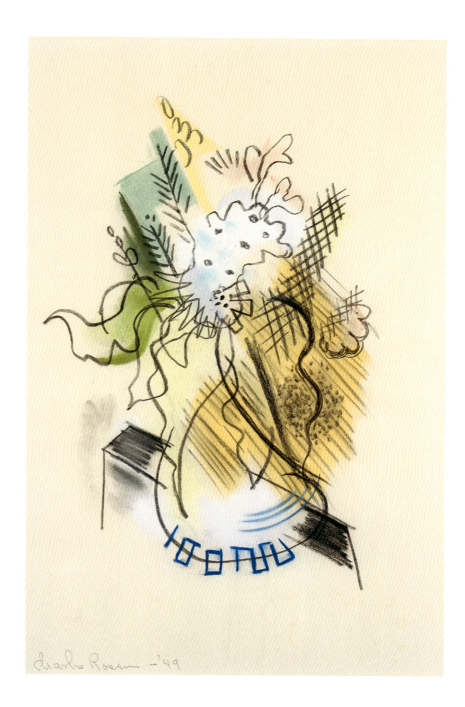

pl.80

UNTITLED [STILL LIFE], 1949
pastel on paper
15½ × 10 inches
COLLECTION OF KATHARINE WORTHINGTON-TAYLOR

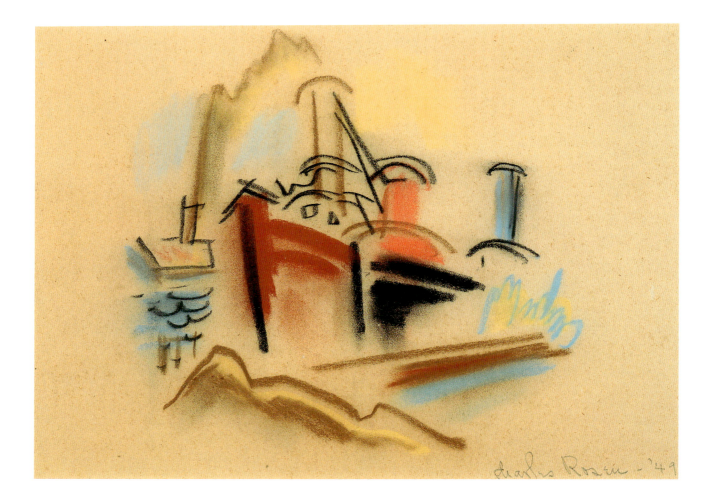

pl.81

UNTITLED [TUGBOATS], 1949
pastel on paper
8 × 10 inches
COLLECTION OF HOLLY GOFF

Rosen was also a teacher, and in his lectures he often emphasized the need for a work of art to have a mysterious quality that he called "life." He thought of the creative process as the "creation of a thing that has its own life," and talked about "form that radiates life" and the "effort to achieve this in paint." He even went so far as to say that this "formal order is suspected of simulating . . . the great order of the universe." In other words, form, to Rosen, was not a dry, cerebral phenomenon—it was rooted in the experience of being alive: in the unconscious rhythms of our bodies; in the needs and desires, if not the very language and structure, of our minds. He never explained what he meant by the "great order of the universe," but he clearly felt that as an artist who was devoting his life to exploring "form music," he was participating in something much larger than himself— a universal, even divine, order. While his Woodstock and New Hope paintings are radically different, this idea may be the most important unifying factor between the two bodies of work: the conviction that art, above all else, needs to be alive—alive with feeling, alive with music, alive with an order and rhythm that reflects some larger, more universal order and rhythm.

Form Radiating Life

Chronology

From the Charles Rosen Papers, Archives of American Art, Smithsonian Institution. Compiled by Katharine Rosen Warner, ca. 1975; edited and expanded by Birgitta H. Bond

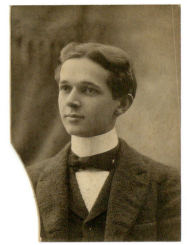

1878	Born April 28 in Westmoreland County, Pennsylvania.
ca. 1894	Opens photography studio in West Newton, Pennsylvania.
ca. 1896	Moves to Salem, Ohio, to work in a friend's gallery and studio.
ca. 1898– 1900	Studies at the school of the National Academy of Design in New York City under Francis C. Jones and Edgar Ward and at the New York School of Art under William Merritt Chase and Frank Vincent DuMond. Works as an usher at the Criterion Theater, New York.
1903	Marries Mildred Holden and moves to New Hope, Bucks County, Pennsylvania, where they reside for seventeen years. They have two daughters Katharine (b. 1905) and Mary (b. 1910—called "Polly").
1906	The Minneapolis Institute of Arts acquires and displays the painting *Washed-out Bottomland*. The painting remains in the possession of the institute until 1955, when it is sold.
1906	Participates in group show at the Society of American Artists, New York.
1908	Serves as a juror at the Art Institute of Chicago.
1909–10	Travels to Europe in November 1909; spends the winter in Italy, principally in Florence.
1910	Receives Third Hallgarten Prize from the National Academy of Design.
1912	Elected an associate member of the National Academy of Design. Wins First Hallgarten Prize from the National Academy of Design.
1914	Spends a winter painting the coast of Maine. Wins the Shaw Purchase Prize from the Salmagundi Club and is made a life member; receives honorable mention from the Carnegie Institute, Pittsburgh.
1915	Wins a silver medal at the Panama-Pacific International Exposition, San Francisco. Three paintings are included in the exposition: *The Delaware: Winter Morning; Floating Ice, Early Morning; Winter Morning: Maine Coast.* The National Arts Club makes him a life member.
1916	Wins the Inness Gold Medal and the Altman Prize of $1,000 from the National Academy of Design. Receives one-man show at the Maine Society of Art, Portland; featured in "Exhibition of 26 Paintings by Charles Rosen," at the Art Gallery, Pratt Institute, Brooklyn. Participates in group exhibitions: "Paintings by the New Hope Group of Painters," Memorial Art Gallery, Rochester, New York; "New Hope Group Show," Cincinnati Museum; "New Hope Group Show," Butler Institute of American Art, Youngstown, Ohio.
1917	Elected a National Academician of the National Academy of Design. Serves as juror at the Art Institute of Chicago. Receives solo exhibitions: "An Exhibition of Paintings by Charles Rosen, A.N.A.," Albright Art Gallery, Buffalo; one-man show, Corcoran Gallery of Art, Washington, D.C.; "Charles Rosen Exhibition," Ferargil Galleries, New York; "Paintings by Charles Rosen," Art Institute of Chicago; "Exhibition of Twenty-seven Paintings by Charles Rosen," Art Club of Erie, Erie, Pennsylvania. Participates in group exhibitions: "Paintings by the New Hope Group," Detroit Institute of Art; "New Hope Group Show," Arlington Galleries, New York; "New Hope Group Show," Cleveland Museum of Art; "Paintings by the New Hope Group," Milwaukee Art Institute.
1918	Begins teaching at the Art Students League summer school, Woodstock, New York. Participates in "New Hope Group Show," Baltimore Charcoal Club; "New Hope Group Show," Albright Art Gallery.

Charles Rosen, ca. mid-1890s. Courtesy of Charles Rosen Papers, Archives of American Art, Smithsonian Institution

1919	Exhibits in "An Exhibition of Paintings by Charles Rosen, N.A.," Ferargil Galleries; "New Hope Group Show," Bresler Gallery, Milwaukee; "Group Exhibition of Oil Paintings by Myron Barlow, Randall Davey, Charles Rosen, John Wenger, Hayley Lever, John Folinsbee," Memorial Art Gallery; "New Hope Group Show," Rosenbach Gallery, Philadelphia.
1919–20	Exhibits at the Luxembourg Gallery, Paris, France.
1919–21	Serves as the director of the Art Students League summer school, Woodstock.
1920	Moves permanently to Woodstock with his family.
1922	With Henry Lee McFee and Andrew Dasburg, conducts a painting school for several seasons, in Woodstock, known as the Woodstock School of Painting.
1922	Participates in the annual exhibition at the Detroit Institute of Arts; among the exhibiting artists are Edward Redfield, Robert Spencer, Van Deering Perrine, Walter Schofield, Robert Henri, Daniel Garber, and J. Alden Weir.
1924–27	Serves as a faculty member at the Columbus Art School; in 1927 he is head of the painting and drawing department.
1925	Wins First Prize from the Columbus Art League.
1926	Awarded the Jennie Sesnan Gold Medal from the Pennsylvania Academy of the Fine Arts, Philadelphia; receives a one-man show at the Pratt Institute; participates in the "New Hope Group Show" at the Albright-Knox Art Gallery.
1928	Receives one-man shows at the Ferargil Galleries and the Rehn Galleries, New York.
1929	Participates in a group show at the Whitney Studio Galleries, New York.
1931	Receives a one-man show at the Rehn Galleries.
1932	Mildred Holden Rosen dies of ovarian cancer. Participates in a group show at Rehn Galleries.
1934	Marries Jean Inglis.
1935	Serves as instructor at the Woodstock School of Painting with Konrad Cramer, Henry Mattson, and Yasui Kuniyoshi; Judson Smith, director.
1937	Receives a commission to paint a mural for the post office in Beacon, New York.
1938	Receives a commission to paint a mural for the post office in Palm Beach, Florida.
1938–39	Moves to Florida with Jean during the winter of 1938–39 to work on the post office mural.
1939	Receives a commission to paint a mural for the post office in Poughkeepsie, New York. Participates in "Hudson Valley Painter Group Show," Yonkers Museum of Arts and Science, Yonkers, New York.
1940–41	Serves as director of the Witte Museum School of Art, San Antonio.
1940	Receives solo exhibitions: Witte Museum; "Oils and Drawings by Charles Rosen," Department of Art of the College of Fine Arts, University of Texas.
1943	Included in "Painting in the United States," Carnegie Institute.
1950	Dies June 21 due to complications from prostate surgery.
1951	"Charles Rosen: Memorial Exhibition" held at Woodstock Artists Association, Woodstock.
1955	"Charles Rosen" shown at Galeria IBEU: Instituto Brasil-Estados Unidos, Rio de Janeiro, Brazil.
1983	"Charles Rosen: The Pennsylvania Years (1903–1920)" held at Westmoreland County Museum of Art, Greensburg, Pennsylvania; Morris Museum of Arts and Sciences, Morristown, New Jersey; and Woodmere Art Gallery, Philadelphia.
2006–07	"Form Radiating Life: The Paintings of Charles Rosen" held at the James A. Michener Art Museum, New Hope, Pennsylvania, and the Samuel Dorsky Museum of Art, State University of New York at New Paltz.

Appendix 1

Charles Rosen: Transcribed Lectures and Lecture Notes: Lecture 1 (on Art Appreciation),
Lecture 2 (on Art Appreciation), Lecture on Monet, Lecture Notes 1, Lecture Notes 2
From the Charles Rosen Papers, Archives of American Art, Smithsonian Institution.
Transcribed by Birgitta H. Bond

Rosen did not begin his teaching career until his early forties, and one of his principal motivations for becoming a teacher was economic: it was a steady source of income in a period of his life when, due to his conversion to the modernist aesthetic, he couldn't count on selling paintings to feed his family. Nevertheless he was a dedicated and passionate teacher. His grandchildren believe that teaching was as important as painting to Rosen, and this conviction is borne out by an examination of his lectures and lecture notes, which provide a fascinating glimpse of the values and ideas that motivated both his life and work.

These handwritten, undated documents are ostensibly about general issues in art and art appreciation, but in fact they are about Charles Rosen. More than any surviving source (except his paintings, of course), they reveal who he was and what he was thinking. They contain his ideas about modernism, about the history of landscape painting, about form and design, and most importantly about what made a painting successful and even "great." They show Rosen to be an educated, well-read artist who had thought long and hard about art and art history. The lecture notes, especially, have a simplicity and force in the language; though often cryptic, they are full of references to music and movement, and they read as basic primers on the concepts and experiences that were the foundation of his work.

For the most part it is unclear exactly where and when he delivered these lectures; they could have been written either in the mid-1920s or early 1940s, when he was teaching in Columbus, Ohio, and San Antonio, Texas, respectively. They make no pretense of being masterpieces of art criticism; they were made by a working teacher who simply needed to organize his thoughts. They were clearly meant to be spoken, not read, as Rosen made no effort to check basic facts such as the spellings of artists' names. As a disciplined craftsman he would no doubt have been embarrassed had the lectures been reprinted verbatim; they are presented here as he wrote them, but with minimal editing and fact-checking to make them more suitable for publication.

—BHP

Charles Rosen, ca. early 1940s. Courtesy of
Charles Rosen Papers, Archives of American
Art, Smithsonian Institution

Charles Rosen on Art Appreciation (Lecture 1)

As a preface to a consideration of the pictures now hanging in the gallery, I want to touch lightly upon the question of art appreciation—calling to your attention a number of things with which you are probably familiar and venturing to point out one phase of art appreciation that may be a little new to some of you—although it is common knowledge among artists and critics, at least among those with whom I happen to associate. All art, as you know, makes its appeal to you through some emotional channel—and as I said, I think you are quite familiar with most of the qualities that produce these almost universal responses—a list which would include: Sentiment; Association; Recognition; Subject Matter; Drama; Prettiness; Love of Nature.

Now *Sentiment* would embrace a number of related subheadings: *Sympathy* (a Mother's Love—a theme as old as time; also poetry in landscape).

Association: Under this heading would come reminiscences of the "old farm"—the "old swimming hole"—childhood recollections—etc.

Recognition: Pleasure derived from merely finding that a picture looks like something you know.

Subject Matter: Includes illustrative painting of a storytelling character that pleases because of the story told (The Dr. again).

Drama: A moving quality at its best, and a cheap theatrical one at its worst—stirring natural phenomena—theatrical sunsets and violent storms—obvious facial expression; related, perhaps, to storytelling.

Prettiness: Embraces all trivial rendering of trivially pretty color or form.

Under *Love of Nature:* You will find a large group of subdivisions—natural grandeur (Grand Canyon)—beautiful scenery (Hudson)—trees—babbling brooks—falling leaves—the seasons—and innumerable others.

NOW—what I wish particularly to call to your attention is this. I hope I can make myself *perfectly clear. All* these various qualities I have just mentioned, and which have an undeniable effect on your emotions, are to be found in pictures *of the very lowest order* (chronometers, calendars, illustrations, etc.) as well as in the work *of greatest merit.* THEREFORE—I think it may be said, with *definite assurance,* that these qualities in themselves *do not, because of their presence in a canvas,* make it *a great work of art.* Superficially a poor painting and a great masterpiece resemble each other.

WHAT THEN is this "indefinable something" that makes one canvas a thing to be treasured by the world for all time, while its *absence* makes another a thing of absolute insignificance?

We are now coming to *the heart* of the matter, and also getting into "*deeper water.*" I run the risk of not making myself perfectly clear, for many much more competent than I have talked and written along this line, with indifferent success.

This *MYSTERIOUS SOMETHING* is easily sensed, by the knowing, but rather difficult to define. You will readily see how difficult it is to express in words the pleasure derived from the fragrance of a rose—and this may enable you to understand, somewhat, the difficulties of my problem. I hope to be able to convince you fully of the presence of this "*artistic overtone,*" and of its great importance, even though I fail in explaining its structure. At this point an example or two might be of help to us (Rembrandt's old woman compared with any old woman; Michelangelo; Botticelli).

Now for the sake of clarity and [indecipherable] let us call this quality "form relationship," or a term that more often comes to my mind in a discussion of this kind—"form music." (music: ordered noise—rhythm—interval etc.) This thought may be a little strange and novel to some of you, though someone, a long time ago, spoke of architecture as FROZEN MUSIC (Clive Bell in his book *Art*—speaks of it as significant form). If you analyze your own sensations at all you will discover readily that you all, easily and frequently, respond emotionally to "form" and "form relations" (Roger Fry and psychoanalysis, wish fulfillment and capacity to respond to form [indecipherable]).

This response is an aesthetic emotional form, not of sentiment, drama, nature, or any other quality in the above mentioned groups—but of an infinite reaction to form and color [indecipherable] abstract sense. This [indecipherable] of abstraction in a work of art in no way denies *representation*—it accompanies it but dominates it. This "formal order" is suspected of simulating, in a greater or lesser degree, the great order of the universe—a form of imitation infinitely superior to copying trivial appearances of natural facts. Its origin is considered to be rooted in the dim distant history of mankind.

A nearness to, or a remoteness from, achieving this universal order is considered to be a measure of quality in art. Coordinated movements—rhythmical relationships in painting etc. probably mirror man's experience. Man's capacity for pleasurable satisfaction before a canvas that is perfectly adjusted rhythmically, is supposed to be directly traceable to his own unconscious efforts, against resistance to a state of equilibrium.

This idea of rhythmic equilibrium used in diaries or slow motion movies [indecipherable].

I wonder how many of you have ever thought of "form" as a *language of the mind*. Beauty can be said to exist *only in the mind* of man, and is imposed on nature. (When you look at nature you see your own reflection.) This Beauty is brought into being through a set of "form relations"—which are determined by the personality of the artist—(Different reaction by different artists to same things).

The artist has only line, form, color, and space at his disposal with which to convey his ideas. A confusion of plants or weeds may, in the mind of a real artist, be reduced to a set of ordered relationships suggestive perhaps, in a small way, of the infinite. While to a lesser, or less sensitive personality, they remain merely tangles of weeds and plants—and even if they are marvelously rendered, they will have value only as botanical textbook illustrations—or *trivially* pretty flower paintings. *The caliber of the man is what determines the order imposed.* A sensitive artist instinctively *detaches a set of harmoniously related forms* from natural chaos which, when reproduced and presented to a sensitive and *properly attuned* audience, are capable of producing a vivid, emotional glow—an aesthetic experience.

In attempting the description of a beautiful form words are inadequate [indecipherable] to "form language," a language not understood by all. But this is no more strange or surprising than to find that there are some people who have little or no musical appreciation, or who do not understand Chinese.

I think, when considered from the standpoint of "ordered form," you will readily see how the artistic products of the world—*of whatever race or time*—savage or civilized—architecture—painting—sculpture, or whatnot, are brought within your comprehension—are made readable and understandable. Their worth can be estimated by the quality of mind that conceived their order. A work truly reflects the quality of its author's ability (which is sometimes a terrible and embarrassing thing). *Insignificance* in a personality produces *insignificant art,* while before a "*great work*" you are conscious of some superior quality in its creator.

Now with this as a preface I am inclined to turn you loose here in the gallery—to give you an opportunity to see what you can discover—how much of *greatness*—as measured by *this great order*—and how much of mediocrity, without assistance from me in pointing it out. There are only two kinds of art—good or bad—there are of course degrees of goodness and badness. These estimates are arrived at instinctively—you feel that you are in the presence of a true artist or not—a man may be a true artist even though not a great one.

You will realize that any relatively short discussion like this, on a subject so elusive, must of necessity fall far short of complete satisfaction, but if I have given any of you a new idea or a new insight into the qualities that enter into the making of a valid work of art—I am very glad and feel fully repaid for my effort. Many of the men and the women represented in this exhibition are friends and acquaintances of mine, etc.

Charles Rosen on Art Appreciation (Lecture 2)

This matter of art appreciation is a rather complicated business. Of course a rather simple but unsatisfactory solution would be merely to fall back on the old, well worn bromide—"I don't know any thing about Art, but I know what I like."

It would be easy, but you'd miss so much fun and pleasure. Mr. James Thurber, in *The New Yorker* magazine, had a rather amusing version of this old saying, though somewhat in reverse—he had a woman who, in speaking of her husband, said, "He knows all about Art, but he doesn't know what he likes."

To be content to merely know what you like without an effort to acquire some further information would be unfortunate, as you'd be in very great danger of missing so much that could be so very enjoyable. One of the reasons for the complications we are confronted with at this time is that through beautiful reproductions in black-and-white and in color, and with the aid of volumes of critical essays, we have at our fingertips a complete record of all the art of all the world almost from the beginning of time—from the "Cave Men" of Southern Europe who did their work some 40,000 years ago, down to and including practically everything that has been done up to 8:15 o'clock this evening.

This means the art of all ages and races—primitive and sophisticated, with as many varieties of expression as there have been artists to create them—academic works—works of the Classical Period—works of a revolutionary character including some adventures in wholly abstract art. We have architectural structures, sculpture, painting and every type of artistic endeavor—works that appeal to every sort of emotion which man is capable of expressing. They have been produced in the midst of an infinite variety of environments—different backgrounds—historical, religious and philosophical. Under conditions where definite limitations have been imposed upon the artist from above and within which he was compelled to work. It is inconceivable that we can understand them from the point of view of the man who made them, so I, for one, must fall back on what I know and understand, and read them from a purely artistic point of view using an aesthetic yard stick as a unit of measure.

I hope I can succeed in making this just a little clear to you. It's a great deal like trying to tell someone about the fragrance of a rose, or the taste of a vanilla soda (or even a "Coke"). Our emotions can be played in such a variety of ways—most of them quite familiar to us—through appeals to our sympathies—our sense of the dramatic. We respond to things that we call old familiar places—to mere recognition—to appeals to our love of nature. I could mention many canvases mostly of fairly recent date in which these things occur—canvases like the doctor at the bedside of a sick child, or canvases with a garish or spectacular sunset, etc. etc.

We can further complicate our problem at this point by the rather frightening realization that any or even all of these various approaches to our emotions can and do occur in vast numbers of extremely bad paintings and sculptures—in calendar pictures, illustrations, chronometers on safe doors, and even on gravestones. So it must be concluded that these things alone are not sufficient to make a great work of art. It must follow then that some *other* quality or qualities *are* necessary, and to indicate or hint at some of them is my intention.

Whether we fully realize it or not, we do respond readily to emotional appeals through form and space. Forms can be terrifically expressive, as in great architecture. Architectural forms, by the way, are purely abstract—they are not descriptive. Their only means of expression is through their shape—their proportion, and their relation to other volumes in space. They have been spoken of as "frozen music."

Form expression is infinite—from the most sublime as in a great temple or cathedral, to the frivolous or gay, as in one of our small townhouses, highly ornamented with meaningless towers and "jigsaw" brackets on the front veranda. I suppose the amusement we get from some of the silly little hats the ladies wear these days could be considered as form reactions. (I don't want to be misunderstood at this point—I confess to liking quite a lot of them—many are so impudent or saucy.) Forms can radiate energy or suggest frailty.

Responses to color and color relations are as common as reactions to form, and are very likely to be more completely understood. Here again the emotions stirred are very similar to form experiences—they can be bright and gay, impressive or funereal. Now when you combine a sense of movement or rhythm with this idea of form, space and color, I feel that you are getting quite close to something of great importance.

Nature is a vast and practically unlimited storehouse of raw material for an artist's use, existing in a chaotic, unorganized state. An artist is a person with certain of his perceptive faculties more highly trained than the average person. Roger Fry, in trying to explain the difference between the artist's and the layman's vision, said "the layman in looking at nature sees a confusion of leaves, trees, twigs, grass, stones, brooks, etc. in great confusion. In a sense, he can't see the town for the houses."

Now an artist has the ability to sense the relationship between a few harmoniously associated things—is able to detach them from the natural chaos, and to order them within his creation.

Probably the first requirement for the creation of a great work of art is a great mind, capable of a great conception, with sufficient technical skill to record it in permanent form, ordered form—all the parts working harmoniously to an inevitable conclusion.

In this order imposed by man on his material, forms and colors take on an importance, a significance infinitely greater than the things they represent.

A life is created within a work of art that is its own reason for existence. It is a definite source of aesthetic pleasure—a sort of overtone. I like to think of it as "form music."

A few specific examples at this time might be of assistance in helping to clarify the idea I'm trying to get across. . . .

[Examples from Michelangelo, Rembrandt, Cézanne, and El Greco]

I believe trivial things look trivial—and that fine, distinguished things radiate fineness.

I think that any of you can sense the difference between a great Beethoven symphony, where a great order has been imposed on sound, and a currently popular song on the radio.

I believe any one of you can easily feel the difference between the Venus de Milo or the Winged Victory, and let us say, a photograph of a bathing beauty. These differences are definitely due to some of the qualities we have been discussing. There is perhaps no short or easy road to a full and complete understanding of so complex a business. I've been interested in, and associated with, the art world for the largest part of my life—I know much more than I did to begin with, and feel that there is just as much ahead of me as there is behind. I can recall so easily and clearly my first impressions as a student in New York—the things I liked. I've watched the changes in my taste over the years—the way things looked to me then and the way they look now—how very much more pleasure I derive from some things now than when I had less equipment.

For you the only thing I can suggest is to look at art, look, and look, and then look again, just as you must listen to music over and over again to arrive at a full understanding and appreciation.

Above all else don't approach the problem with a mind full of preconceptions of just what a work of art should be—it can be so very many things. Keep an open mind—and don't condemn (reference to Havelock Ellis and Cézanne).

It is not necessary to like everything—they are not all good anyway. There is only a small percentage of genius in the world at best, and any group, whether it be conservative or radical, will only have its rightful share—just because a work is conservative in spirit does not necessarily mean that it is, therefore, good, and just as truly, if a thing is of the modern school, it is not necessarily bad.

Don't allow yourself to be too upset by some of the modern developments or to be irritated by them—some of the wholly abstract works may have just as much reason for their existence as music or architecture. Personally I get extreme pleasure from both viewpoints and would be extremely sorry to be deprived of either group.

I'd like to emphasize very strongly at this point that this structural order we've been discussing in no sense interferes with or denies the right of existence to the various other emotional approaches in a work of art. It is, however, highly essential, and definitely exists in all great art—and in progressively smaller quantities as we go down the artistic scale—where when the bottom is reached there is little or no evidence of its existence. It is one of the clues that may aid in determining the value of a work of art.

(May talk in Col Ohio

Well Charlie—"I like the bad ones best."

A good note to close on.)

A Lecture on Monet, October 1940

Delivered at the Witte Museum, San Antonio, Texas

I have been asked to talk to you about Claude Monet—represented here by an excellent example of his very important work. I find myself in the somewhat strange and unusual situation of discussing and making understandable the reasons for the existence and importance of a man who has by now been accorded a very high place in the history of art and has become an important link in the great chain of artistic tradition.

To understand Monet and the group of painters with whom he was associated—to arrive at a clearer conception of their contribution to the sum total of artistic knowledge and practice—I shall have to take a somewhat hasty look into the past several centuries that preceded them. I've no intention of doing this in any very detailed manner—I won't give dates. My chronology may be a trifle inexact. I shall endeavor to point out a few names, characteristics, trends, etc. that led us to the point where we find ourselves today—right in the middle of a discussion of French Impressionism.

Quite early in Italy—more specifically in Siena and Florence—roughly around the 1400s—artists like Duccio and Cimabue brought to painting a more human and naturalistic character than was to be found in the Byzantine Art from which they stemmed. This Byzantine Art was somewhat Oriental in character—rather severe—conventionalized and highly stylized—and on the whole quite decorative. From this period onward, the trend of

the arts was toward a more complete naturalism—a more objective point of view as compared with the art of the Far East which had preceded it. Masaccio, a great Italian of the early Renaissance, carried this naturalistic idea forward and to a very high degree of perfection, as can be seen in his frescoes in Florence.

This tendency toward naturalism led inevitably to a vast amount of study, research, and experimentation, along lines of a scientific nature. The laws of perspective were developed, the study of anatomy was given a lot of attention, great technical advances were made in the rendering of textures and fabrics—attention was given to laws of composition—schemes of geometric division of space within a canvas were developed. All these practices and innovations inevitably colored and influenced the character of art at that time and for the hundreds of years that followed.

Regarding this tendency toward realism—the solution of so many of the artists' problems naturally included a fuller, and more intimate observation and study of natural phenomena, actual appearances in nature—the sky in its changing aspects—the structure of the land—its rocks and trees—light (after a fashion) and of course the sea. Inevitably landscape for itself alone became a thing of importance. It was no longer used merely as a background for figure compositions.

Artists in various and widely scattered parts of Europe simultaneously engaged in the production of canvases in which landscape for its own sake was being used. Dutch and Flemish—men like Claude Lorraine—Hobbema—Ruisdael—Rembrandt—Rubens (to name but a few)—and this list should include some early English. These pictures from different sections of Europe and from artists of different racial stock naturally differed somewhat in their various approaches and characteristics. They had, however, some things in common—the tendency was still toward realism. The element of Romanticism still persisted in some to a greater extent than in others—and compositional elements were differently handled.

Certain traditions of a somewhat universal sort were built up through years of common practice and experience that served to keep them all within certain vaguely defined limits of expression. When a number of artists see and paint nature in some particular manner—*that* is the way nature is seen, and other artists accept it as a point of view and work within the same convention. It becomes in a sense "the fashion," and is generally adopted, like for instance the painting of foliage. Certain definite tonalities were used. Landscapes were dark in value and a brownish scheme was popular and almost universal. The "Brown Tree" was an accepted symbol (but more of that later).

As a logical development, the emergence of the Barbizon group in France—the Men of 1830 (Rousseau, Corot, Millet, Daubigny, Diaz, Troyon, etc.) seems quite natural. They did live and work in the country—got their material through personal contact with nature, rather than from other paintings. Some of them worked directly—like Daubigny, and Corot at times. Diaz romanticized his canvases—Rousseau was more naturalistic but was still bound by the conventions of the classic tradition.

At about this same time in England, John Constable and J. M. W. Turner were active. They were more than active—in such a sense they were (quite unconsciously) staging a "two-man revolution." Constable—a quiet conservative gentleman in his mode of living—sensed a need in landscape for something more closely connected with the realities of nature than was to be found both in the work of his period and in what had been done previously. He even arrived at the somewhat startling discovery that landscapes, sometimes, were *green.* Once, to convince a critic, he placed an old, brownish, mellow toned violin in the center of a green lawn to show (and I hope successfully) that the grass was not *brown.*

Another critic, in commenting on one of his canvases, complained that it had "no brown tree." No wonder that what to us seem not particularly startling innovations caused such a furor at the time. Constable even went further. He became interested in light—the more real and brilliant illumination to be found out of doors—the play of light on foliage—the movement of wind and clouds through a landscape. He had, of necessity, to evolve some method of painting, some new use of pigments to even come close to suggesting these effects which to him were of the utmost importance. He seems to have discovered that in using brighter colors in a somewhat broken manner [indistinguishable—lines erased].

That is, instead of mixing these colors wholly on his palette he used them in a slightly shattered way, and allowed them to mix in the eye—achieving a greater brilliance and much more clarity. Sometimes he even surrounds leaves with a bit of white to emphasize their brilliance. These paintings—his critics called "Constable's *snow storms.*"

Turner, for his contribution, was producing a vast number of pictures of a very wide range of subjects in almost every kind of method—some almost wholly classic—some that even today could take their place in an exhibition of impressionistic painting. He painted skies of great luminosity over landscapes full of vague suggestions rather than highly developed in a detailed sense—a definite departure from the traditional viewpoint.

A number of French artists seem to have traveled in England and to have seen and been deeply impressed by the work of these two men, and to have carried back to France rather glowing and enthusiastic reports concerning it. Delacroix and Géricault were among the earliest to sense the value of these innovations, and through their enthusiasm a great influence was brought to bear on the future of French art.

During the Franco-Prussian war, two other French artists found England to be a much quieter place in which to pursue their profession than war-torn France, and here again were two important and able Frenchmen exposed to the works of Turner and Constable. These men happened to be Claude Monet and Camille Pissarro. Their reactions to this exposure to the work of these two Englishmen were both vigorous and enthusiastic, and on their return to Paris at the end of the war—1872—they carried with them glowing reports of what was being done across the channel. Exhibitions of Constable's work were held in Paris and were enthusiastically received.

In any country—at any time—there can always be found a group of rebellious young men. This was true in Paris—a handful of painters (Manet, Monet, Pissarro, Sisley, Renoir, Cézanne, and others), drawn together because of a similarity in their artistic creeds, were in the habit of gathering together at a café and over a cup of coffee or a glass of wine to discuss the affairs of the world—probably damning the academicians, and laying plans to make the world conform to their somewhat revolutionary ideas.

They had certain, rather fragile ties with the Barbizon Group through Pissarro's friendship and association with Corot—this in turn was passed on to Cézanne. This group, for a time, was under the leadership of Manet (not Monet), but in time Manet was considered to be too definitely a studio painter for this fraternity whose religion took them finally and definitely into the open, where their interest in landscape led to a very careful study and analysis of light—the atmospheric envelopment and its influence in breaking down the wholly materialistic structure of nature and bringing to it something of a subtle and almost spiritual quality. They resorted to a variety of scientific processes to achieve this mystical result. They succeeded pretty definitely in bringing to a conclusion the efforts of painters who for centuries had been working toward a solution of the problem of realism.

If the experiments of Constable and Turner—in the rendering of a sense of greater illumination through a different way of applying pigments—was a spark, it was fanned to a full flame by the concentrated efforts of these Frenchmen. They discarded all "earth colors"—used only the most brilliant pigments—and taking advantage of their own and other scientists' analysis of light and color, developed the idea of breaking their colors into their component parts for the sake of greater vibration and brilliance. For example—and this is in fact too simple—to make a green by combining a yellow and blue—instead of mixing these colors on the palette before they were applied to the canvas—they could place small quantities of pure yellow and pure blue side by side on a canvas, allow them to mix in the eye of the spectator and arrive at a green vastly more pure and brilliant than by mixing them before application.

You can easily see that this explanation is too simple. A glance at any of Monet's canvases will show you that what *really* happens is *vastly* more complicated. They use color also in a complementary, or oppositional, sense to heighten or enliven their canvases. Stated simply—the opposing of yellow to violet—green to red—blues to oranges, etc.—a golden yellow field with blue violet shadow, for example. This again is much more subtle and complicated than this simple explanation.

This resorting to things of a scientific nature was for the sole purpose of arriving at a canvas that would more clearly portray effects of changing light and atmosphere on any chosen subject matter. With this as a guiding light the character of their subject matter underwent great change. Almost anything became grist for their mill. It was no longer necessary to perch on the top of a high hill and paint the universe. Little things, trivial things were just as useful as the spectacular—a single haystack in a field—a lily pond—a stretch of beach—the façade of a cathedral or a bridge over a river—all these and many other simple motifs were used, and over and over. Haystacks! Cathedrals!

The reception of these artists and their work, as you no doubt know, was far from complimentary. They had extremely heavy going and suffered no end of financial hardships. They were not accepted at official exhibitions

and had of necessity to organize their own. A few quotations from the writings of the critics who covered these shows will give a better idea of what they were confronted with than anything I could tell you:

Some visitors burst into laughter on seeing them, but I am saddened. These so-called artists call themselves Impressionists. They take paint, brushes and canvas . . . throw colors on the surface at random and sign their names. In the same way insane persons pick up pebbles on the road and think they are diamonds.

Another . . .

This painting, at once vague and brutal, appears to us to be at the same time the affirmation of ignorance and the negation of the beautiful as well as of the true. We are tormented sufficiently as it is by eccentricities and it is only too easy to attract attention by painting worse than any one has hitherto dared to paint.

Still another . . .

The Rue Le Peletier is an unfortunate street. The opera house burned down and a new disaster has fallen on the quarter. There has opened at Durand-Ruel's an exhibition said to be of paintings. The innocent visitor enters and a cruel spectacle startles him. Here five or six lunatics, one a woman (Berthe Morisot), have elected to show their pictures. . . .

Ian Gordon, in a book on modern French painters, says,

The Impressionists, although they had a belief that they were still walking the paths of nature study, were in truth entering upon a very different road. If we consider nature as something external to ourselves and tangible, the Impressionists opened the door to a study of reactions between ourselves and nature, hitherto unsuspected. As man becomes a less necessary object in painting, by so much more is the personality of the artist demanded in a work. The Impressionists opened the way to a study, not of what man sees in nature, but of how nature affects man.

Lecture Notes 1

Definition—just what it is—(not just present in art) not absolutely certain of ground—what is expected?—what I have elected to talk about.
A phase of art more or less familiar and understood in the East.
Attitude west of N.Y.?
Delusions—immorality—degeneracy—distortion—refuge of incompetent art unmoral.
Certain percent of excellence in any group—modern or otherwise.

Also immorality—
Immorality in conventional art.
Development of Modernism from Impressionistic group.
Cézanne—order of space and color.
Remarks about cubes, cones, cylinder.
Restoring art to solidity of old masters—Poussin.
Cézanne's color idea derived from Pissarro—Corot—Renoir.
Corot and Modern art.
Experiments of Picasso—Braque—Derain, etc. Based on remarks of Cézanne (abstractions—simplified form—research)
Effort to create a pure art like music—no representation—purely abstract.

Line—form—color—space—music.
In music—space—interval—rhythm—emotional qualities possessed by form and color—examples
Creation of a thing that has its own life.
Channels by which the emotions can be reached—
Recognition—nature loving—sentiment—drama—association—all in calendar pictures.

Some qualities underlying all art—greater than subject matter—purely aesthetic pleasure which determines the greatness of a canvas. (Finding some quality in friends—El Greco—early Egyptian—Derain.)

Abstract quality of architecture—frozen music—(shape interval—flavor).

Modern art effort in painting to achieve this aesthetic experience similar to music—architecture.

Distortions—Chinese—Egyptian—Persian—Negro Art—Byzantine—Primitive.

Form that radiates life—effort to achieve this in paint.

Picasso—Matisse—van Gogh—Gauguin—Braque—Maillol—Derain—El Greco—Giotto—Francesco.

The abstract interwoven with the realistic.

Possible that many old masters would get rejections—where abstract has been particularly stressed—(Fra Angelico)—violent opposition to modern art—no clash—only good and bad—lots of each in both camps—public demand and supply.

A knowledge of modern ideas will clarify old painting.

Aesthetics.

Stimulating quality of modern art (paintings that rock you to sleep).

Classification—

1. Pictures wholly without aesthetic significance.

2. (significance) in which the purely artistic is merged with some of the other emotional qualities.

3. Pictures—which depend altogether on abstractions—line—color, harmony, order, organizations—form—space.

Discussion of cubism in art—not a defense of—or argument for but a plea for suspended judgment—open mind.

Don't dismiss with a gesture or a word a whole art that is traditional—whose novelty is the emphasizing of the purely abstract—and the submerging of the imitative—an interesting experiment that is having and will have a great influence.

Lecture Notes 2

Introduction

Story—Who makes you do this?

Something about how and why.

Some driving power other than commercial effort—fame.

Inborn creative impulse—origin vague.

Monkey reading.

Imitative faculty of man played part in art origin.

Cave men—reindeer hunters

 Descriptive—utilitarian

 Then playful—for pleasure

 Origin of design (primitive implements—stone imp—thrones—bronze—basketry to pottery).

Altimira Caves—geometric abstract design.

 Animal paintings.

 Colors—marrow bones.

All art appeals to our emotions through some channel—

 Sentiment—doctor

 Recognition

 Dramatic—Subject

 Love of Nature

 And what we speak of as purely aesthetic emotion.

Aesthetic emotions derived from the purely abstract form relations and order—
 Ordering of form in space
 Rhythmic order
 Creation of life—independent of imitation (except in a larger sense)
 Thrusts—stresses

Emotion derived from pure abstraction
 Modern Art—Picasso
Exists in all art—
Easily detached by sensitive vision
 Michelangelo—prophet
 Rembrandt—woman cutting nails
Quality of *mind* of artist—
GEO. "Are you following?"

Music—organized sound
Architecture—frozen music

FORM EXPERIENCE
 Climbing lines—horizontal
 Clothes—hats—autos
 Space—weight

AESTHETICS—
 How and why we respond
 Projection of self—
 Gothic cathedrals—strain—breathing—pulls

ROGER FRY'S QUESTION

Abstract quality key to all art—regardless of time or place—Chinese—Egyptian—etc.—crucifixion or festival.

Work that survives
Our valuation of things—subject matter changes—
Not so true of form relations

Conclusion
Effort to give artist's attitude to art.

Appendix 2

European Travel Diary, Excerpts

From the Charles Rosen Papers, Archives of American Art, Smithsonian Institution.

Transcribed by Birgitta H. Bond

Many artists of Charles Rosen's generation traveled to Europe in their twenties to complete their education. Rosen's formal education occurred exclusively in New York City, and his only known journey to Europe took place when he was thirty-one years old and already a settled and successful artist. Accompanied by his wife, Mildred, and four-year-old daughter Katharine, Rosen crossed the Atlantic for Italy in November 1909. While it's unclear exactly how long he was there and where he went, he spent a considerable amount of time in Italy, landing in Naples and subsequently visiting Rome, Florence, and Venice.

Fortunately he left behind a travel diary that records his spontaneous impressions and thoughts about what he saw. Many aspects of his personality gradually emerge in these pages: his delightful, self-deprecating sense of humor; his pleasure at being a father; his openness to and excitement about the monuments of European culture that he saw; and his thoughtful, educated mind. A number of passages reveal how much he had his eyes open—he did not simply accept the wonders of Italy uncritically but always was on the lookout for quality and meaning, as when he visited a museum that had, among other things, "one or two marble busts but most were only interesting historically." Rosen may have grown tired of recording his thoughts, as the diary ends suddenly, in Venice, with an odd but entertaining "monologue" about a glass blower, in a comedic, "aw shucks" voice.

This handwritten document provided many frustrations to the transcriber, who spent countless hours valiantly attempting to make sense not only of Rosen's rapid handwriting (he would not have received any awards for penmanship) but the many faded and absolutely indecipherable sections, often at crucial points in the unfolding story. Hats off to Birgitta Bond, the Michener Art Museum's librarian and database coordinator, whose persistence and skill made it possible to share this diary with a wider audience.

—BHP

Charles Rosen (with a very good friend), ca. early 1940s. Courtesy of Charles Rosen Papers, Archives of American Art, Smithsonian Institution

Nov. 10—09
Mid Ocean

The steamship *Arctic* sailed from New York Nov. 6 with the Rosens as passengers for Naples / weather perfect. It being the first ocean voyage of Mr. R. he was naturally curious as to just how he would behave.

Second day out was perfect as was the first. Some motion to the boat [indecipherable] soon accustomed to it and things were all as they should be. Nothing to do particularly except walk, that is, nothing that one cared to do, so that Mr. R. walked, walked, and when he had rested he walked some more. It is a curious thing that one can be induced to say good morning for the privilege of walking to Italy, for I assure you that Mr. R. walked the greater part of the way. . . .

The night of the second day out became stormy. The *Arctic* meeting up with what the ship's log chose to record as "a heavy gale." Thus there was the golden opportunity for discovering just how good a sailor Mr. R. was. Mr. R. has discovered that he is *not* a good sailor and is willing to make affidavit to that effect before any notary public. Mr. R. will further swear that the Captain lied in calling our little blow a gale. . . .

The fourth day out the dose was repeated, there being just a slight difference in duration. . . .

The other Rosens, Miss K. [Katharine] and Mrs. R.—much better. K. being actively ill for one or two short periods . . . Mrs. R. being ill, always in the privacy of her bed . . .

Mr. R. expressed a desire before sailing to see some rough weather before going, to be ill rather than having a smooth but uninteresting passage. Mr. R. is now fully satisfied and the elements can crawl into their holes and stay for all of him. . . .

Impression No. 1 of the Ocean

Perhaps something should be said about the vastness of the Ocean, the poetry—power—etc. There has been enough of this—I found that you could only see seven miles in any direction. You can beat that from any molehill in Squedunk. . . .

Sat Nov. 13—09

Great excitement! Land! The first seen in a week. The Island of Pico (of the Azores) became visible early in the morning, its highest point—O. Pico, a volcanic mountain 7600 feet high being really well worthwhile. The crater was perfectly distinct—possible to distinguish a small spine at the very top, left as Dr. Ami said during an eruption on the side from which the wind came.

[Illustration of the mountain]

The last two days have been [indecipherable]. Gray and rainy. Nothing to do but eat, drink, and try not to be too disagreeable.

Mr. King composed a most touching limerick this morning concerning the amazing "mal de mare" of Mr. Rosen. The following is a copy:

> Much "mal de Mare"
> > had Rosen
> Then loudly he called
> > For the bos'un
> He felt like a wreck
> When he got upon deck
> And what happened [indecipherable] ocean.

Tues night 16th
At anchor in harbor of Gibraltar.

We arrived at night in a driving rain. The only evidence we have of the presence of the celebrated rocks is a mass of [indecipherable] lights in the tower. We stay all night and leave at 10 A.M. . . .

Presented to Dr. Ami a sketch of himself. Wonderful success!

Have just overheard Mrs. Smith confide to her party that when the vessel signaled shore—as we were landing, she thought we were on a rock and were signaling for assistance. (It must have been a gentle bump). . . .

Wed Nov 17—09
"We have met Gibraltar and he is ours."

All were up at 5.30 a.m. for a 6.30 breakfast as to be able to leave at seven for Gibraltar. I got out upon deck long before sunrise and saw the great rock emerge from the fog in the first glimmers of light and in many ways it is the most precious of my impressions. There were four English battleships at its base . . . and these got under way and departed.

At about eight o'c we all boarded the tug and were taken to Gibraltar about a mile away. On our arrival we were besieged by cabbies who begged us (most politely) to use their most amusing carriages, small affairs bright in color and mostly drawn by donkeys. We elected to walk which we did until we tired of it, and then made what we thought a good bargain with a cabby for a drive (two carriages). We were taken to various parts of town, shown buildings of importance and driven right past the base of the grand cliff. . . . The streets were crowded with Spaniards, splendid types that looked just like their pictures; quite a number of Moors in native costume (most picturesque). The shops were all just like the shops in any dinky little town. . . . Most things seem to have been "made in Germany." There seemed to be nothing native except embroideries, etc. . . .

The real interest, and great it was, was the rock itself—what a tower!

. . . On Sat morning at 5.30 a.m. [indecipherable] a note from Mr. Davis (4th Officer) saying that we were now entering the bay of Naples and that he thought it would be worth our while [indecipherable]. We took the suggestion and did not regret it. The conditions were very similar to our first view of Gibraltar.

Mt. Vesuvius was silhouetted against a pale rose color of eastern sky and seemed to be smaller and less impressive than had been anticipated (though when seen later from a greater height it seemed to be all we had imagined). There was little of excitement attached to our landing (we were conducted through the customs by a talkative little Italian guide who left to look after Hotel Britannique). . . . He in his grand manner would bowl over any unfortunate [indecipherable] who claimed to be in our way, and would then loudly exclaim "I am a gooda man."

I found later he was trying to impress me with his worth, with a view to being engaged as a guide by me. Nothing done. I found him helpful in getting things through the customs with little trouble and all went well until I found my trunk missing, and a fairly thorough search failed to uncover it. I left without it and went with the bus to the hotel only to return at once to the White Star office to look again. They sent a man along to help but we were met at the customs house by my [indecipherable]. We announced that we had the lost trunk and it was soon examined and on its way to the hotel with me.

Naples is a wonderful place and almost as [indecipherable] the reputation leads one to expect. . . . The country just surrounding Hotel Britt. seems in many ways the best that I have seen. Great cliffs of a warm soft yellow, groves shoot up apparently hundreds of feet, and there are houses both old and new and of all styles of architecture. Here and there on the slopes are terraced vineyards, interesting old pathways and bridges. The foliage is lovely. . . .

This a.m. (Sunday) was devoted to seeing the town in a carriage; going first to the Museum Nationale, then to the Duomo (cathedral) which we entered and from there to the tomb—memorial of the Principale de Salerni of great interest. . . .

One of the characteristics of Naples is the abundance of soldiers, police, etc., in picturesque costume and much gold lace.

Planning to see Vesuvius and Pompeii tomorrow.

Last night was spent at the arcade in company with Dr. Ami, Mr. H. and Chief Officer Williams of the *Arctic.* Nothing unusual, but all pleasant. Every one wanted to show us something. But we were not from Missouri.

One of the many amazing incidents of our Neapolitan experience was in the purchase of a wicker trunk. Our search took us down into a quarter where no one spoke anything but Italian, and our efforts to produce the trunk were most amusing. My Italian (?) proved invaluable and was further exercised in buying a new lock and having a larger iron bar made.

Nov. 24
This morning found us pulling up stakes in Naples and preparing for a trip to Pompeii, Cava Sorrente, Amalfi, Capri, etc. . . .

We were taken first to the classic Pompeii, and what a classic!! What a glory it must have been in the ruins, placed as it is at the base of Vesuvius and practically at the feet [indecipherable]. . . . What a magnificent sight it was. . . . We were shown through rather hastily but satisfactorily in as much as we were shown the things of great interest and allowed us to miss the less important.

The city must have been a dream of beauty. . . . There was distinct evidence of [indecipherable] loose morals as evidenced by some of the mural decorations seen and [indecipherable] shown by a dealer in souvenirs. . . . At the base of the city were wonders of grandeur . . . and these we were able to study at our own leisure on our way from Pompeii. . . .

On our first train today Katharine did not have to pay because she was not one meter in height—on the next train on the same line (but an express?), where the rules were different, she was not only charged but we were fined an extra fare because we had not provided her with a ticket. . . . It smacks of comic opera, but the magnificence of the country counters any lightheadedness of this variety.

Thurs (Thanksgiving Day) Nov 25
9:30 o'clock found us on our way to Amalfi! Going by carriage and with all the luggage aboard including Mrs. R.'s lost suitcase, which "Mr. Cook" had to go to Palermo to recover, it having not arrived when he went to the station. The country in the vicinity of Cava was almost the most interesting that we met on our entire drive. It consisted of very abrupt hills with dried ravines, and spotted here and there with small villages of a perfect type (of a type that when comparing with a village of like importance in America it really makes one blush—ours are mere phantoms—compared to these little towns that have been perched high upon the steep hillsides for centuries and are still in a state of preservation that is little short of miraculous). . . . They have character and artistic beauty that is something practically unknown among us. There seem to be no towns here that are the equivalent of our country villages and if there ever were any no doubt they have long since rotted down and blown away and so only the good remains. . . .

[Describing a "long cliff drive to Amalfi"] The end of the drive proved a revelation. The country was magnificent. Great mountains swimming right out from the sea and around which [indecipherable] had been carved. Here and there at the base or sometimes at the almost impossible [indecipherable] were villages, all most lovely. . . . At sunset the whole mountain and its back was golden with the glow of the setting sun, and a clear silvery moon creeping out from behind its tallest point. This whole drive was perfect. . . .

Friday Nov. 26 found us up early for a short visit to the slopes of Sorrento to inspect their wares (principally inlaid wood) and to buy (which we did not). Then back to the Hotel [indecipherable] down the "lift" into small boats and from there to the small steamboat for "belle Capri." A small wind disturbed the sea somewhat and the sea disturbed the small boat somewhat and the two natural causes combined to affect the health (temporarily) of many of the passengers including my small daughter. . . .

We landed at Capri in small boats, went up the *finiculare* to the hotel where after a short visit we had luncheon. After luncheon we took the famous drive to Anna Capri (a town at the other end of the island). It rained slightly during our drive (enough to prevent our seeing Capri at its best). K. slept the *entire* time so we were not as enthusiastic concerning Capri, as Capri enthusiasts would demand of us. It was but a short time after our return that the steamer started for Napoli, so again we embarked in small boats and were rowed out to the steamer. This in a pouring rain, and half storm. It is easy to imagine the result of this on a boatload of people—mostly ladies all with raised umbrellas, and so placed that the overflow from one was shot underneath the other so that there was no protection. Our party was good natured though soaked. "Mr. Cook" said it was a beautiful souvenir of Capri. . . .

After another stormy passage via Sorrento we arrived at Naples—stayed at the Santa Lucia all night—took the train 2nd class for Rome and arrived at about 3 P.M. Sat. . . .

We rested Sat. afternoon (and we needed it badly).

Sunday A.M. we started out to do the Borghese gardens and museum. The gardens were in no way remarkable except for an occasional bit of ancient sculpture or some bit of pure classic landscape. The museum (which we found after a struggle) contained countless antique sculptures and pictures most of which were distinctly [indecipherable] one or two marble busts but most were only interesting historically.

Sunday afternoon found us at the Colosseum which we entered and found to be "just as represented." . . . We went in and wandered about more or less aimlessly (with our beloved guide, our Baedeker). . . . These ruins are tremendous even to an outsider, and what they must be to a classical student or historian it is impossible to imagine. . . .

We saw the Forum in the afternoon when the rich golden light of the setting sun lit [indecipherable] the old pillars and the old walls. . . . It was rarely beautiful.

The arch of Constantin Severus was a thing of beauty and a joy forever—it is eroded to such an extent that all of its mechanically perfect carvings are blended into a whole soft mass that is indiscernible in its wonderful color quality—the proportions are of course the last word—to us this seemed the finest of the arches or for that matter of the ruins. We left the Forum with a promise to return, and drove to Pincio Hill for a view of Rome in the eve, and to see the crowd—which was enormous. There were miles of carriages of all [indecipherable], and thousands of people on foot—all out for our purpose—that of seeing the town and its people. (It is a custom.)

Today, Monday we spent the morning driving, going first to the Pantheon, which is a building of rare beauty and proportion and lighted fully from a 28-foot hole in the top of the great dome. Raphael's tomb here is [indecipherable] of white marble with carved inscription.

Katharine here, as is her custom, made certain demands that could not be refused so we added to her distinguished list of commodes the celebrated Pantheon of Rome. . . . I said to the guard who directed us "Grande dati—vina" with both arms lifted over the Forum. He replied "Molto!"

Thurs. We drove to St. Peter's and here we did get a real sensation. The [indecipherable] setting of the church is magnificent. . . . The costumes of the actors were not however in good repair, their gowns were soiled, fitted badly they were not particularly clean and needed shaving. The thing on the whole seemed to them an awful bore and very unimportant. I saw one priest kiss the [indecipherable] bronze of St. Peter after carefully polishing the said member with the corner of his cloak (which to me did not look anti-septic).

From the cathedral we went to the Vatican Galleries to see the sculptures. There are [indecipherable] of them good, uninteresting, and great. We saw the originals of quantities of things which had become familiar to us in the schools. . . . Katharine placed her stamp of approval on St. Peter's. . . .

Wed—We drove again . . . to the Sistine Chapel [indecipherable] is probably the greatest thing we have as yet seen in Italy or for that matter that we will see among all these treasures.

Our preconceived ideas were hopelessly inadequate. The impression we got from the whole as a piece of design, color, conception and construction was "technically" beautiful. There was a depth of tone, and an unconventionality in the design that is to be seen nowhere else that I know. The Raphaels which we saw immediately afterward which were splendid did not in any way compare with the Sistine. Here again Katharine expressed her approval. . . .

While in one of the Raphael rooms they were repairing some of the mosaic on the floor and a workman rather slyly sold me a square composed of colored marbles that had just been removed from the floor. . . .

There certainly come times in this "frenzied education" when to "sightsee" . . . calls up all that is disagreeable in one. In most cases it is a question of going up to the real thing to see if it looks like the "post card" or like the plaster cast that one has [indecipherable] so well.

Of course there are exceptions—some few (a very few) of the marbles are far handsomer through wear and color than the casts, but one gets nothing from them over what can be had from the copy except that we can tell our dear country cousins that we have really "laid our own eyes on the originals." So there!

No description of the Sistine Chapel or no amount of pictures of it can in the least convey an idea of its beauty, and this is true of some of the buildings that depend upon a sensation of [indecipherable] and color, but many, so many "just look like their pictures."

I guess I am probably unromantic, not receptive or maybe just plain [indecipherable]. I know that if I looked upon these things with the eyes of an archaeologist they would craze me with interest but in my poor blind state I can see only the surface with a slight inclination of just what the finer meaning is. . . .

SUNDAY—DEC 12, 09—

We have by now been in Florence one week the greater part of which has been spent in getting settled. We are fairly comfortably established in a small Pensione with an excellent table, good [indecipherable] and little heat! And from now on we can attend to seeing Florence (in I hope, a less hasty manner)—some of our best experiences, which though hasty I have no doubt will have lasting and valuable impressions. As yet we have seen but two pictures since we have been arranging for passes which we expect to get tomorrow. (There will be passes for Florence alone and we may then get them for the whole of Italy. This could have been done in the States before we left had we but known it.)

I have taken [indecipherable] of long walks to the outlying distances in company with Mr. Miller (an architect staying here with us) or Mr. Hasley. This has been a splendid means for getting a good valid idea of the country, and so far some of it at least seems paintable though as yet I have seen but little.

We have made one visit to the Uffizi which is a house of treasures. . . .

At our table we have a Dutch lady, five Americans, and four Italians. Most of the Americans [indecipherable] conversing with the Italians, and Mildred, since she speaks German better than French, uses it to talk with her neighbor at table. . . . You can get a fair notion of what a noise we give when all are conversing at once—a composite of Italian—French—German—Dutch—and English. I'd include Esperanto if anyone had spoken it.

Today we have added to our many [indecipherable] "One Southern lady" Mrs. Rains (as Midge said "It never rains but pours.") She is a [indecipherable] to a New York "son."

This morning at breakfast Katharine suddenly confounded the entire table by announcing from a chair, and in a loud voice, "Me and mother have on woolen drawers."

MONOLOGUE

Now when you go to Venice you want to go to see [indecipherable] the glass! It's the most interesting thing you ever saw in your life. You just look at a book of pictures. Kind of designs with dragons and such things, and tales—take the one you want and the man just looks at it [indecipherable] to work with a chunk of glass and a big pair of shears and makes it just as easy as pie.

We selected one of the most ornamented, a VAZE with a dragon on it, and a lily and lots of other things and he just made it so fast you could hardly see it and without ever looking or measuring or weighing or nothin'.

He just took his big shears, stuck on a piece of glass, cut it off and there was an ear, as you might say, just as natural and without ever sighting or measuring. Then he'd stick on an eye first like a shoe bottom without ever comparing and [indecipherable] they were both alike and just so fast, and never looking or nothing as you might say.

Why Joe seen him make a big VAZE that cost 60 francs with nothing more than a bunch of glass and a pair of pinchers. It's most interesting and you must go! I'll give you a card to Mr. Daraine or whatever his name is and he'll show you it all.

He was awfully nice to us, and we didn't buy much, just a statue, and two VAZES and then some more little things and when we left, he said he'd [indecipherable] his man with us, and I said, says I, we don't want no guide and he says—It won't cost you a cent, I says it won't. Why, I never heard of such a thing in my life so we took him along and he was just as nice as could be as you might say. I said I'd send him some American friends and if you show him this card, he'd look after you and it ain't necessary to buy anything. . . .

[*Note:* Diary ends in Venice, with no mention of return trip.]

Appendix 3

Letters to Charles Rosen from George Bellows, Daniel Garber, William Lathrop, Edward Redfield,
Eugene Speicher; Miscellaneous Letters

From the Charles Rosen Papers, Archives of American Art, Smithsonian Institution.

Transcribed by Birgitta H. Bond

One of the most important sources for information about long-dead artists is their correspondence, which often reveals both their personalities and the specific events and concerns of their lives. There are many letters in the Rosen Papers at the Archives of American Art, but since the source of these papers was the artist's daughter Katharine (thus indirectly the artist himself), the letters are exclusively *to* Rosen, not *from* him. Several attempts were made to locate letters from Rosen, mostly through contacting surviving family members of his artist friends but also through a check of other institutional sources. No such letters were found. So the surviving Rosen correspondence is completely one-sided, and any information about him from this correspondence must be inferred from the thoughts and responses of the writers.

It's clear from these letters that Rosen had an active career and was very much a part of both the social and professional activities of the two communities in which he lived. Perhaps the most interesting revelation contained in this correspondence—and this is admittedly a subjective impression—is that Rosen was a man who knew how to be a friend. There is often a sense of artistic camaraderie, as when Daniel Garber congratulates him for winning the prestigious Altman Prize at the National Academy of Design, or Eugene Speicher gives Rosen the good news that his work has been selected for a juried exhibition while at the same time revealing the inner workings of the jurying process.

But the tone of these letters often goes beyond camaraderie to the kind of intimacy reserved for the closest of friends. Sometimes this intimacy manifests itself in the form of humor, especially from George Bellows, who clearly had an impish streak: in the context of a discussion of whether his letter is decent or indecent, Bellows says, "If Emma [Bellows's wife] was here you might not get this letter. If it never reaches you let me know." Speicher's letters are more newsy than humorous, but occasionally his language shifts and an emotional intensity emerges, as when he closes a very long letter with the words, "My wrist hurts but not before we send you all our love." Sometimes friendship is expressed through simple statements of encouragement: Garber closes one letter with "Hoping you are doing lots of good ones." Edward Redfield ends a short letter about the mundane subject of the potential price of a painting with "Meanwhile—keep working!" These words convey an unspoken understanding between fellow artists—that money is unimportant, a distraction, and what a real artist cares about is to do the work.

One brief letter is included that is not specifically to the artist but is addressed to his second wife, Jean. Since this letter was written in the context of work Rosen was doing (his Depression-era murals), its relevance is unassailable. The address on the letterhead also is of some interest—the White House—as is the writer, Eleanor Roosevelt.

—BHP

POEM
On the Rosen's
=

Semi-stroke and
 'scarlitina!
Mastoiditus on the
 beana!
Poisoned blood! Tonsils
 go!
Charley's rib! Mildred's
 toe!
And now (their
 luck is tough as
 ox-hide)
POLLY'S NOSE IS
STREPTO-COCK-EYED!!

 ⌐ Bill

Postcard to the Rosen family written by a family friend, poet Hughes "Billy" Mearns (1875–1965), ca. mid-1920s. Courtesy of Virginia Callaway

Letters from George Bellows to Charles Rosen

[ENVELOPE]
From
George Bellows
146 East 19th St.
N.Y. City

Charles Rosen Esq.
1427 Eastwood Av
Columbus OH

April 20, 24

Dear Charlie and Mildred,

You know that fur-bearing animal which frequents our nostrils in our mountain home. That's me. It is rather maybe the symbol of my procrastination. The skunk is slow. I hope my slowness is greatly in excess of my odour. I doubt it.

I have felt pretty smart this winter. I went out and got me a stenographer, a sort of second hand one. Very good in appearance, comes from the Vanity Fair kennel.

Second hand in the sense that she only comes to me on Saturday afternoons. Sort of a harlot stenographer in the sense that she stenographs for more than one man-person, or concern. . . . But don't jump at the wrong conclusion. Because you haven't heard from me should mean that we haven't written. But it doesn't. We have stuck strictly to business and that's just it. Whenever I have tried to dictate an expressive letter, tried to write something interesting, I start to stammer and blush. I thought a Vanity Fair stenog. would be good at inspiring [indecipherable] and at understanding strange turns of speech. But it is not so. She only has a [indecipherable] look. She spells correctly.

The result is I have written only one decent letter all winter and sent it to Henri.

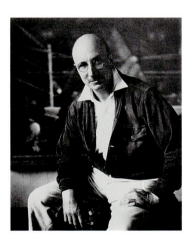

Also all winter I have been making evasive gestures at cigarettes. Usually with the left hand and lighting them with the right. Also, I am none too thin, and have sprained my shoulder playing squash. I have had no exercise all winter. I have made two speeches, a lot of lithographs, one big painting, and the girls happy during the winter. That is no athletic exercise. We have had a number of indoor sports, among which has been chyropractic dancing, Indian clubs and auto intoxication. We have a cat. As the cat needs the fireplace we have had to depend on the furnace all winter.

If Emma was here you might not get this letter. If it never reaches you let me know. The question may be raised: "If this is his second decent letter what must the indecent ones be like?" The question is a fair one.

Dear Charlie—perhaps I had better not address this letter in part to Mildred. You know best. I take her for a broad-minded woman, and trust she will find proper interest and improvement of mind if you will read her the proper parts, and show her only the nice pictures.

The winter has passed in [indecipherable] between revelry and isolation. I have sat beneath Elsie at every formal dinner. A constant note of magnificent red has recurred regularly in her ever-varied costume. Emma is wearing her knot a little lower and her bang a little higher and her figure a little rounder. Both these examples are potato haters
(potatatum magnum est).
(To be continued)

Geo Bellows
Answer requested.
Answer yes or no.

Photograph of George Bellows in front of
Dempsey and Firpo, ca. 1924. Courtesy of
the Historical Society of Woodstock

December 15, 1924.

Charles Rosen, Esq.,
1427 Eastwood Avenue
Columbus, Ohio.

Dear Mr. Rosen:

I have the catalogue announcement of your weed sale for Christmas, and note with disappointment that there are no portraits of grasses in the catalogue.

I would treasure a good likeness of Columbus grasses as a reminder of my mis-spent youth. I was commissioned in 1896 to remove the weeds from the front yard display at 65 East Rich Street, which I carried out with characteristic thoroughness. The result was a skinned diamond.

You can see how I feel.

Very truly yours,
Geo Bellows Esq.

[*Note:* Letter microfilmed from original—carbon copy at Archives and Special Collections, Amherst College Library.]

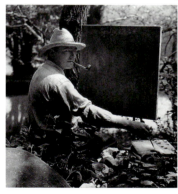

Daniel Garber, ca. 1915. Courtesy of the Garber family

.

Letters from Daniel Garber to Charles Rosen

Philadelphia 19th March
1819 Green Street

Dear Rosen,

Both Mrs. Garber and I send our heartiest congratulations on the Altman Prize! I had hoped to see you in N.Y. but could not get [indecipherable] Friday. I am going [indecipherable] today.

The weather has not been fit to get up your way—but it is just as well as we can now help & celebrate the event.

Cordially yours
Daniel Garber

1819 Green Street
Philadelphia
28th Feb.

Dear Rosen:

I have just had a telephone message from N.Y. replying to my letter, and you are invited to send the painting we spoke of in your studio to the Exhibition at Luxembourg, Paris.

All you need to do now is to mention this to Budworth and give the proper authority to deliver "The Brook Autumn" to The Luxembourg Committee.

You will have, no doubt, a letter from the Committee confirming this.

Cordially Yours,
Daniel Garber

.

1819 Green Street

Dear Rosen

I am delighted to hear of your success in New York and here are my hearty congratulations.

I meant to get [indecipherable] this time but went up the river instead and have only heard of your success upon returning today.

Hoping you are doing lots of good ones.

Sincerely,
Daniel Garber

.

Philadelphia, March 12th

What good luck have you had this year? So far, I have been very much encouraged. The "Wilde Grape Vine" and "Quarries at Byram" got in the Washington show which pleased me greatly.

Do not fail when you come to Phila to look us up. I could take you to some fine places—and would enjoy so much hearing from New Hope. I learnt from Spencer all about your studio, its magic [indecipherable]. Spencer and I had a fine trip down.

Please remember us to the Lathrops and any other of the New Hope friends.

Yours sincerely,
Daniel Garber

· · · · ·

1685 Brandywine St. Phila

Dec. 13th

Dear Rosen,

I had hopes of seeing you in New York last Friday but times were too hard for me to think of the trip. I suppose you were [indecipherable] and thought you could tell me if you saw any of my things and how they were placed? Information from New York is always so scarce and I can only draw on inference to know how I came out.

We are now somewhat in order and I have some work planned and am now at one canvas which I expect to take considerable time to bring to completion if I arrive at that length. Plenty of fine material which I have rediscovered only the City presents more difficulties than Cuttalossa. . . .

Hoping to see you at the opening.

Yours Sincerely
Daniel Garber

· · · · ·

1819 Green Street
Phila. 3rd Mar.

Dear Rosen:

During the week we have all been laid up at times—and the day your letter came [indecipherable] and I were in with tonsillitis—so it was not possible to get me to New Hope to the "Confab."

We are planning to come up soon, however, and we have just agreed upon Rosens' for dinner or lunch! In the meantime I cannot think of any ideas that would help make the group exhibition—so we can go over what has been done when I see you.

It has been a disappointment not to be up there and at work but I can't leave Mrs. G.—just yet—she has not been so well.

I keep hoping that you will [indecipherable] down here. I felt sure you would—but the buyers are very slow this year and damn stubborn at all times.

Give our regards to the friends please—and look out for us some warm Sat. or Sunday soon.

Sincerely Yours,
Daniel Garber

· · · · ·

1819 Green St.
Phila. Pa
20th Jan 1911

Dear Rosen,

I want to congratulate you on the picture of a couple of haystacks with a couple of sheep coming through a fence. I think it is the *best* I have seen of yours—and like it very much as did most of the other gentlemen of the jury. [remainder of letter indecipherable]

Daniel Garber (1880–1958)
William Langson Lathrop, 1935
oil on canvas
50 × 41⅞ inches
Pennsylvania Academy of the Fine Arts,
Philadelphia
Joseph E. Temple Fund

· · · · ·

Letters from William Lathrop to Charles Rosen

June 30—1907
Fishers Island

My dear Rosen,

Thanks for your long and interesting letter. Undoubtedly the accident to the boat was not due to any fault of yours. Probably if I had run the boat another trip or two it would have happened to me. But about once in so often I get anxious about the way things are going in the engine base and I take the plate off and over-haul it looking out for any cutting of the bronze tightening up the connecting rod bolt which always works loose more or less because the crank pin is worn so that it is no longer perfectly round, and adding more lubricating oil to the pool in the base. When the bolt is loose there is, of course, much more strain and shock incurred—the working of the engine especially when she misses explosions. When I went away I felt that I ought to take a look in there, that it was about time.

But I was too hurried as you know. It was just that sort of watchfulness almost instinctive, which has enabled me to run the boat nearly four seasons almost without repairs although she was much worn when I got her. Anyone who has not that instinctive appreciation of the engine's needs will almost certainly be in trouble with her constantly. All are well here, we are doing our housework and managing all things on an economic plan. I get the breakfast and do the marketing and see that Julian gets out of bed on time, which is not the least of my duties. Joe has gone sword fishing with captain Hedge *as a paid hand.* He has been gone several days.

His job is to be lookout at the masthead! An awful job for seasickness, as you can imagine. They do 25 or 20 miles to sea from Block Island running back there usually for the night or to dispose of a catch. When they strike a fish it is intensely exciting and Joe will forget to be seasick.

The children have great times about the shore and with the small boys next door. Clement has been in here for three days. He leaves this morning for Newport. His red and yellow sails are just this moment crossing the bay before a fresh westerly breeze.

I am painting neither as much nor so well as I had hoped. But I am getting something done.

The class is not very large but enthusiastic and interesting. It is growing constantly. To meet—only two days a week is, as I had expected, a very great relief.

Annie wants me to thank you again for your very great kindness to her during the last week of her stay.

I shall expect to see some bully work on your canvasses when I get home. Not having the Lathrops to play with, you should do the work. Tell Mrs. R. that Annie has not much heart for afternoon tea, nobody comes in!

I wish you would keep an eye on Cornelius and the pigeons. I think he will be faithful, but it will do no harm to keep an eye on him, especially in the matter of water, and cleaning out the foul nests. The whole family wishes to be remembered.

Sincerely Yours
W. L. Lathrop

• • • • •

[Postcard postmarked Fishers Island, N.Y., Sep. 20, 1907. Addressed to:]
Charles Rosen
New Hope
Bucks Co. Pa.

My Dear Rosen,
 Look for us on the 6:30 train Sat. eve.
 If you can [indecipherable] the Sunshine down at the bridge it will be appreciated.

W. L. L.

• • • • •

Letters from Edward Redfield to Charles Rosen

Edward W. Redfield
Center Bridge, Bucks County
Pennsylvania

March 31, 1908

Dear Rosen:
 In case it is stormy this afternoon (Tuesday) do not come tomorrow (Wednesday) as I have something that will hold me, anytime after will be O.K.

Sincerely yours,
E. W. Redfield

Thomas Eakins (1844–1916)
Edward W. Redfield, 1905
oil on canvas
30 × 26 inches
National Academy Museum, New York

• • • • •

Edward W. Redfield
Center Bridge, Bucks County
Pennsylvania
Oct. 12, 1911

Dear Rosen:
 In talking to Trask I gathered that he could sell your sheep painting at the Academy for $200 if you think it advisable to sell for this price. Just write him without reference to what I have told you and say that if he can find a buyer for the painting at $200 to do so. I think it would go through without trouble. Meanwhile—keep working!

Sincerely,
E. W. Redfield

• • • • •

Letters from Eugene Speicher to Charles Rosen

[Envelope postmarked, date not readable.]
From Eugene Speicher, 165 E. 60 St. N.Y.

Mr. Charles Rosen
598 Franklin Ave
Columbus, Ohio

Dear Charlie—
 Your letter came this morning and it was fine to hear from you. This is our first night at home in several weeks—I have just finished dinner so here goes.
 I have been trying to get to this for a long time but have not up to date succeeded. This does not mean for a minute that you were not all in our thoughts a great deal—the opposite is the truth.
 The winter has practically gone &—more [indecipherable] than ever, but we had some good times, many in fact. Have sold some pictures, painted some, played a lot of squash with John Carroll, reduced 5 pounds and am thinking of the time when we shall all be together again in old Woodstock. In the first place we are simply delighted to hear about your decision in [indecipherable] the Columbus thing. I know you are doing

George Bellows, drawing of Eugene and Elsie Speicher. Collection of Katharine Worthington-Taylor

the only thing you should do, there are no [indecipherable] about it. I think I can see exactly what it means to you and to Mildred. I am sure you never will regret it in any way. I am sure of this. I think you would have shown wisdom to have done it ages ago—things would have happened to you by now to prove that I am right but be that as it may be and to hell with looking backward, what you have done is right & the only thing you might to have done.

Rehn said some time ago that he had a fine letter from you & said he was going to give you a show. I told him you had some real things & that it was going to be a surprise when it comes off.

It seems to me that if your show occurs in February or March that that date would give you a good amount of time in which to produce more fine things so you could then choose from the last [indecipherable] 10 or 12 aces for the show and 5 aces for the back room & private sales.

Rehn is going to have a fine new Gallery next season somewhere near 57th & 5th Ave. Just where he does not know himself yet—he's looking around now. I am sure he is going to like your things and will land a few at least in collectors' homes.

In our family our pocketbook has given birth to a Buick Sport touring car exactly the model of Whitehead's (5 passenger). [indecipherable] It will be delivered in Kingston about April 1st. At present Elsie is taking a lesson a day in driving while your [indecipherable] is taking a lesson a day (6 in all) at an auto school to get acquainted with the mechanism. My driving lessons start next Tuesday, to continue daily until I can get my license. We hope to get to Woodstock about April 15 or 20. I am hoping I can hop in the car and go out landscape painting—there's where I am going to miss you. Damn it I wish you could get up here for the spring season.

I am working every day on a portrait of an Italian Girl & hope to finish it by the end of next week and before I go to Woodstock I would like to complete another thing if I could.

I painted a 40 × 50 of [indecipherable] and before that I had the pleasure of serving on the criminal court Jury for a month (12 actual painting days) before that was xmas holidays. Before that I finished the portrait of Dr. Cleveland & before that we came to New York from Woodstock & before that old man Hommell's portrait and of course we all know what happened before that—we kissed the Rosens good bye.

23 portraits have been passed up by yours truly (at $4000 per— [indecipherable]).

Oh what the hell what's more I am damn glad I did it. There is no sensation and satisfaction like doing what you want to do & working like many [indecipherable] to do it—I am also sure I am right about this.

Andrew came out of the west for the Carnegie Jury 1st meeting—days ago. He cleaned $6000 in the stock market [indecipherable].

Lee certainly had a fine show and gained new friends & admirers. He got a write up & sold everything but a small one. He's as pleased as punch & has painted a fine still life since the show.

Andrew is booked for a show at Rehn's next winter as is also John Carroll. Sloan and Karfial are letting Rehn show their stuff & I think he's going to have the one place in town where it's going to be a pleasure to show things.

I told him that all he has to do to surround himself with nothing but very good painters & paintings—which is just the opposite policy of most galleries. . . . He is a fine person and I like him more and more all the time. I suggested your name as a member of the New Society which might take a spot this time next year. Hope the rest feel as I do about you.

How's the old pudden head Polly God bless her? Kay said she was absolutely OK again & was mowing em down out there. Some talk I've heard that she is going to Italy for the summer & I say nix—It would spoil my summer & then to whom could I turn to for napkin lifting lessons. Oh no! We'll have to wait until fall. . . .

Give Mildred our best love & believe me when I tell you you have made no mistake in leaving there. I suppose we'll not meet at Woodstock until June 1st. That seems a long time between drinks but it's the best we can do [indecipherable].

The Clements are [indecipherable] for a home in Byrdcliffe this summer. If they come you will all be crazy about them.

With much love from us both
Love Gene

.

[ENVELOPE ADDRESSED TO:]
Mr Chas Rosen
1427 Eastwood Ave.
Columbus, Ohio

Dear Charlie—

We got Mildred's two letters & Elsie will answer them very very soon. I feel pretty sad with myself for not having written you sooner but you must know what kind of winter this was and how many unusual things happened. Life however is getting a little simpler & I have been painting hard for a month past on a full length portrait of Katharine Cornell, a well known actress who is playing "Candida" by Shaw. It's a commission. She's a Buffalo Girl & I am a Buffalo Boy & the directors of the Buffalo Gallery decided to kill two birds with one stone.

It has been going along swimmingly but yesterday bad news came that I could have no more sittings until fall on account by her opening in "The Green Hat" in Detroit after which she's to play indefinitely in Chicago. It's 7 ft by 4 ft full length. This will probably have something to do with our going to Woodstock a little sooner than [indecipherable] possibly April 5 or 6th (around in there).

We have decided not to do any alterations to the house this spring. I want to start right in painting & paint solidly all summer full. I found out this winter that if I could produce some fine things there are [indecipherable] possibilities of placing some of them in good places. The Pittsburgh

Show was "success extreme" [indecipherable] but not sale. New York was kinder. 13 drawings and the total amount was over $10,000 of course commissions and expenses have to come out of that, but I was much pleased because it means in a way great encouragement to paint no more commissions except absolutely ideal ones. I have not painted a commission this winter except the Buffalo one.

Rehn proved himself a great worker & enthusiast & he really did the [indecipherable]. Leon opens a show there Monday—by the way did you hear that his show at Demoines netted him $17,000 & he has also cleaned up $7000 in the stock market so up goes the old [indecipherable]

I am glad Charlie for your [indecipherable] that the school is off for this summer. You must paint a number of fine things this summer & have a show next winter. You have absolutely got to do this for your own sake. If you come out with 12 or 15 top notches you will create a stir I'm sure. This advice costs you nothing & if you do not like it [indecipherable] here.

Will get a car together & go off landscape painting any day or days you say. I want to paint at least 3 large landscapes & really see all of them through. I am going to paint [indecipherable] if she still wants to [indecipherable].

Your landscape at Art Students League formed a great [indecipherable] admirers and included Bellows, Luks and others. It looked very fine and sturdy in what was really a damn good show.

George's show was seen by files of people and they were duly impressed but not as [indecipherable]. By the way did you hear that the Metropolitan Museum has really decided to give George a memorial show next winter. It will come off after Jan 1st 1926.[1]

George is to have an important show of drawings and lithographs at Keppels the later part of this month. Carnegie has just purchased "Portrait of Anne" for $6000 net to Emma.[2]

George Hopkinson & myself have a show at Boston Art Club opened [indecipherable] 11TH—went up to see it & and liked the way it [indecipherable] we each have 15 pictures. The Museum there was looking at George's "Emma & the Children" & I hope they came across.

Emma is doing pretty well, remarkably well in fact, but she looks awfully thin & worn at times. There really are a lot of things for her to attend to & I think it's a good thing. She has had a great many demands for shows & pictures & the way I see it she will not want if she is careful to handle George's work right. The show at the Museum will help enormously to boost the prices.

Tonight we all got to the Glackens for a party & I wish you & Mildred were here & going with us. They sail for Europe in June to be gone two years.

Henris are in California painting & [indecipherable] and write that they have become boosters of California.

We had a glimpse of the Museum & the Greco portrait of a monk had just been cleaned & beautifully so. It looks very much as it must have looked after it left Greco's studio. A marvelous balance of warm & cool which was completely done [indecipherable] under the hot varnish. The palette was simple but not unlike [indecipherable] in the meatiness of each color against the others.

There is a good Lautrec show on here now—the best I've seen but you really did not miss anything really great here, there has not been anything. The Seurat show at [indecipherable] was good but mostly pick ups.

Max Weber had a good show but nothing different than his old stuff. A [indecipherable] show at Whitney studios had some good spots.

I am sending 15 pictures to the Columbus Show & am very glad you & [indecipherable] are going to be there at the same time. I'd like to see [indecipherable] its beauty.

We have been expecting [indecipherable] to call us saying he was in town but up to [indecipherable]. I hear he is working his head off. Mildred said something about the possibility of his coming to Woodstock for a spring painting trip—that would be great from my point of view, tell him.

Charlie, for Mildred, Elsie and myself a little painting trip to Eddyville [indecipherable] etc for a few days at a time—what about it this summer?

My wrist hurts but not before we send you all our love. Gene

▪ ▪ ▪ ▪ ▪

[Envelope postmarked Jan. 11, 1939, Grand Central, N.Y. Addressed to:]
Mr. Charles Rosen
Woodstock
N.Y.
Ulster Co.

Dear Charlie—

We are awfully glad to hear about Jeannie. I am sure that was a very painful business and we are both so very glad she's over most of it. I am sure the benefits she'll get will be worth the nasty experience.

Glad also to hear the studio was coming along so well. Frank knows just what I want & I hope when it's all finished I'll be satisfied that I got the best light I can get. I've done a good deal of worrying about the old light maybe I've [indecipherable] too much anyhow even with this added expense which I was not prepared to take in. I'll have the satisfaction I have left nothing unturned to bring about better quality in what I want to do.

Hope that [indecipherable] goes through, that will help some—I think that practically the whole field of creative artists are up against it during this upheaval. If we come out of it & things get better o.k. And if not—who knows.

I have been reading the papers and find myself very much interested in politics as usual. Can't take exception with the main objectives of J. R. D.—who with a sense of justice can. I am however continually concerned about the financial conditions of the country. How can they ever stop the relief? [indecipherable] in 3–5 or 10 years. As Misses says this morning—maybe the government is taking on too much and senses the inability to carry out the complicated "programmes."

Well I find working the best antidote to too much worrying. I painted one head and I am now in the middle of another. The seated portrait with red shirt I have not shown anyone yet—I want to think about it & make a few adjustments.

The other evening [indecipherable] is tops for me. I think it's somewhere near that and unless I get something better I'll show it at World's Fair.

The pictures at the fair are going to be all chosen by an impersonal vote—probably by an electric vote—something like the Academy uses. They expect 5000–6000 pictures in N.Y. State out of which some 200 will be chosen. I hope the hell you have a fine example. Everything points to a great show of American Contemporary work—nothing but the face value [indecipherable] work to speak. The galleries are going to be a [indecipherable], lighting as good as it can be gotten $15000 for purchases & 2,500,000 people are expected to see the show. Every picture on the line and the galleries all air cooled ventilated.

Well Charlie Good Luck and love to you & Jeannie from us both.

Gene

Am on the Pittsburgh Jury for next autumn.

• • • • •

[Envelope postmarked Jan. 26, 1939, New York, N.Y.]
Eugene Speicher
165 E. 60th St. N.Y.

[Addressed to:]
Mr. Charles Rosen
Woodstock
NY
Ulster Co.

Dear Charlie—

Elsie just read out loud from life's story in Coronet. The reproductions were a wise choice & I thought came out extremely well. The article is all right too but we think a hell of a lot more about fun than the tone of that article. The practical side might be true enough but the pictures tell a much better story. Anyhow it all helps and there should be no serious regrets.

Saw Carl & Helen at the Whitney and they gave us news of Jeannie which we were very glad to get. Hope she is coming along better & better each day and give her lots of love from us both.

It's cold here today and I suppose it's extremely cold up there. We are just sitting down to a game of Rummy Elsie & myself. She's beaten me the past three times but somehow think it's my time tonight.

Our love to you both
Euge
Wednesday night

• • • • •

[Envelope postmarked Mar. 10, 1939, New York, N.Y. Addressed to:]
Mr. Charles Rosen
Woodstock
NY
Ulster Co.

Dear Charlie—

Just a note to let you know that your canvas made a unanimous leap through the jury of the 9 old hawks. The jury that day was—
Max Weber
Karfeel
Lie
Davis
Evergood
Myself
Herman More
Schnalkenburg
Burchfield[3]

We boiled down some 3000 to 76 and about 10 of these were unanimous. It was 100 (in fact a little more) percent democratic and the judgment entirely on the face value of the canvas as it came before the jury against neutral gray surrounding and grey light. It's amazing how well we all got along taking into consideration the wide difference of opinions of each of the jury. It was not a very hard test and I am sorry to say some good pictures did not get through—on the other hand quite a few unknown but vital and [indecipherable] works did go through & by [indecipherable] will practically make up for it. No personalities were mentioned before the judgment was made and no personal appeal was thought of and you can imagine how pleased I was when your canvas got 5–6 7–8 and finally nine votes.

There will be a great many disappointments in Woodstock and elsewhere. There will also be elation by youngsters & institutions. They really lived up to the no politics–no friends—no institution—no prejudice etc. etc. so we shall see what we shall see when the show is hung. A number of good men did not send for some reason or another & there was no going after them. I can safely say that this was a good example of truly democratic judgment and it is well it will have a tryout. This afternoon the finals of the Guggenheim & about 6 pm tonight I'll throw up a picture I am certain.

Love to you both
—Gene

Miscellaneous Letters to Charles Rosen

The National Academy of Design
New York, January 13, 05

Charles Rosen Esq.;
New Hope, Pa.

Dear Sir;

I have received an offer of one hundred and fifty dollars ($150.00) for your painting Union Square now on exhibition here. Kindly, let me know at your early convenience what you desire me to do in reference to the same.

Truly yours,
H V Allison
Salesman

• • • • •

Society of American Artists
215 West Fifty-seven Street

Office of the Secretary

Mr. Charles Rosen
New Hope, Pa.

Dear Sir:

I have just received an offer of $250 for your "The Delaware Thawing." The sales are unusually slow this year. If you are willing to take this price, please let me know.

Yours truly,
W. H. Shellin
April 6, 1906

• • • • •

Office of William W. Renwick
Architect, New York
Telephone 676 Madison Square
West 27th Street

Charles Rosen Esq. New Hope, Pa.

My dear Mr. Rosen:

Thank you for the cutting concerning your work. The picture in question hangs in my bedroom and is very pleasing to look at in this warm weather. Mrs. Renwick thinks that the river-grass in the foreground is a little too strong in color, that it is too dark, and I fancy she may be right.

Nevertheless, I am very well satisfied with my picture and wish you success.

Yours truly,
W. Renwick
July 3, 1906

• • • • •

The Pennsylvania Academy of the Fine Arts
Philadelphia March 30th, 1908

Mr. Charles Rosen
New Hope
Bucks County, Pa.

My dear Rosen:

I have looked up the matter of shipping your pictures and find that they are already boxed and are to go off either to-day or to-morrow. The only reason that you have not received them earlier is that there has been tremendous amount of [indecipherable] in connection with returning the pictures as well as much other work. Redfield has also looked up the matter for you, and you can rest assured that you will receive them in a short time.

I did not have an opportunity of telling you just what I thought about your work, but I want to say that it is the best I have seen you put out, and it struck me as being very frank, with a great deal of honest power in it. I was very glad to see how your work is getting along.

Sincerely yours,
Hugh Breckenbridge
Curator.

• • • • •

Minnesota State Art Society
John A. Johnson, Governor of Minnesota
Cyrus Northrop, President, State University

Minneapolis, Minn. Sept. 30, 1908

Mr. Charles Rosen,
New Hope, Bucks Co., Pa.
Dear Sir :

Your painting "Late Sunlight" was sold to the Art Association of Duluth, Minn. for $400.

We are enclosing herewith a check for the amount less the ten per cent deducted by the State Art Society for selling.

The check for this painting was sent, in error to Miss Bonta, Secretary of the Minnesota State Art Society, on Aug. 4th but, as she was in Europe and has only just returned, it was not discovered until her return. This has caused the delay for which please pardon.

Very truly yours,

Treasurer
716 Fourth Avenue South

Salmagundi Club
Fourteen West Twelfth Street
New York

Dear Rosen,

A group of us are planning to hold an exhibition in the gallery of the Boston Art Club next season and we would like to know if you would care to go in with us providing the date we are able to [indecipherable] would not interfere with other plans of yours.

It is probable that we can arrange to show the group exhibition afterwards at the Worcester Museum and perhaps elsewhere without expense to us.

We do not have to pay anything for the Boston Art Club Gallery and as our expenses will be light, and as the Club is considered the best place to sell in Boston we hope to do some business.

The group at present consists of Charles Bittinger, H. L. Hoffman, Arthur Spear, and myself and we are asking Garber to join us.

I wish you would let me know at an early date if you would care to take part in the show as we are anxious to fill the group and secure a date at the Club—best possible moment, so that we can get the gallery at a desirable season of the year.

Sincerely yours
Everett L. Warner
46 West 55th Street
New York
May 1st 1912

· · · · ·

Salmagundi Club
Fourteen West Twelfth Street
New York

My dear Rosen:

We were very glad to hear that you are going into that Boston exhibition with us and will keep you informed of any new developments.

I should have answered your letter sooner—I have been expecting to hear almost any day from Spear.

It is a pity that Garber did not feel that he had enough pictures on hand to warrant his joining the group.

Of the candidates which the boys have discussed, I think Gifford Beal would be the most valuable addition to the group. The matter is still a little in the air but I believe it is practically decided that we ask Beal.

I am very grateful to you for the kind invitation to run down and have a look at New Hope. Someday I hope to see that country [indecipherable]

Very sincerely yours
Everett L. Warner
46 West 55th Street
New York
—22, 1912

· · · · ·

William Macbeth
450 Fifth Avenue New York
Paintings by American Artists
December 10, 1912

Mr. Charles Rosen,
New Hope, Pa.

My dear Mr. Rosen:

I was very glad when I returned from jury duty last week, to find that you had sent some samples of your new crop. We have all enjoyed them very much and gladly kept two for showing here. I hope you will approve of the choice. They are "The Brook, October," and "Through the Hanging Branches." If our clients do their duty, these will not be returned to you. We will do our best to incite them to do their duty.

Sincerely yours,
Macbeth

· · · · ·

The White House
Washington
January 12, 1940

My dear Mrs. Rosen,

Thank you so much for the photograph of the mural which your husband is painting for the Poughkeepsie Post Office. It looks charming and I am delighted to have the picture.

Very sincerely yours,
Eleanor Roosevelt

· · · · ·

Notes

1. George Bellows died January 8, 1925. His memorial exhibition at the Metropolitan—set for January 1926, according to Gene Speicher—indicates the date of this letter as possibly being late winter–early spring 1925.
2. George Bellows had two daughters, Jean and Anne; Bellows's wife's name was Emma.
3. Unable to confirm the spelling of all these names.

Appendix 4

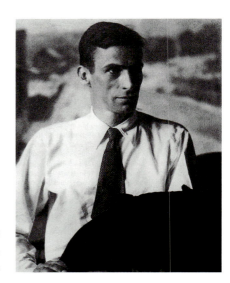

John F. Folinsbee: Commentary on Charles Rosen

From the Charles Rosen Papers, Archives of American Art, Smithsonian Institution

John Fulton Folinsbee (1892–1972) was born in Buffalo and studied art initially at the Albright Art Gallery in Buffalo as well as at the Art Students League summer school in Woodstock. He moved to New Hope in 1916, where he became one of the most important artists associated with the New Hope art colony and where he met and befriended Charles Rosen. Folinsbee's creative path was similar to Rosen's: an early period that was somewhat conventional, followed by a more adventurous mature style that broke with the impressionist land-scape tradition. There is no direct evidence that Folinsbee's knowledge of Woodstock influenced Rosen, but it is certainly possible, if not probable, that Folinsbee's familiarity with the artists and aesthetic mind-set of the Woodstock community had an effect on Rosen's decision to move there. It should be noted that the two artists overlapped in New Hope for approximately four years; Rosen lived in New Hope for seventeen years, from 1903 to 1920, not the fourteen years that Folinsbee mentions. Given that he wrote this undated reminiscence several decades later, Folinsbee's memory lapse is easily forgiven!

—BHP

John F. Folinsbee. Photograph by Peter A. Juley & Son. Courtesy of the Folinsbee family

Charles Rosen, 1878–1950

It is encouraging to know that the work of Charles Rosen will be shown in New York City, after an interim of many years.

Rosen's painting came to a climax of development and recognition in 1920 after he moved to Woodstock, New York and became a member of the vital art colony there. Its leading exponents at that time being George Bellows, Eugene Speicher, Henry Lee McFee, Andrew Dasberg, Henry Matson, and himself.

However, I have been asked (as an old friend who knows of his earlier career) to make brief comments in regard to the years he lived and worked in New Hope, Pennsylvania.

He was born in Westmoreland County, Pennsylvania, in 1878. As an art student he studied at the National Academy school in New York. He was also a pupil in the New York school under the instruction of William M. Chase and Frank Vincent DuMond.

After his marriage to Mildred Holden in 1903 they moved to New Hope. With the exception of a brief trip to Italy and a short sojourn to Maine, he painted in the Bucks County area for the next fourteen years. Scenes along the Delaware River and the adjacent Lehigh Canal were favorite motifs for his paintings.

At the time I first met Rosen (1916) he was talented and well established as a member of the so-called "New Hope Landscape Group." This group was comprised of a few nationally known artists; among their members were William Lathrop, Edward Redfield, Robert Spencer, Rae Sloan Bredin and, of course, Charles Rosen himself. Each man had his own individual style; but the group as a whole was regarded as quite "advanced" in the field of outdoor painting. Some were even accused of painting what was called "the exhibition picture" because of their broader techniques and "carrying" power in exhibitions.

Rosen, personally, was the most modest of men. In any company, he was the affable, quiet philosopher on life and art; a man known for his generosity and friendly cooperation in all local activities.

The business side of his profession was quite alien to his natural inclinations and the marketing of his work often presented difficulties when "sales" were few. I recall his telling me that in this department he had probably made every mistake possible.

Rosen was not, in the accepted sense, an innovator, but was constantly absorbed in new technical approaches. He would show his recent work with disarming enthusiasm, not from his [indecipherable passage] but from the point of view of showing what he had discovered. His work in Italy as a young painter was fervently decorative in design and somewhat mannered. From this style he turned toward an atmospheric type of French Impressionism. [indecipherable passage] Later on came a trend toward greater value contrast and broader brushwork. His message became increasingly effective and finally culminated in 1916, when he received the National Academy's Inness Gold Medal and also the Altman Prize for a larger canvas entitled *Winter Sunlight*. This last was hung in the place of honor in the Vanderbilt Gallery where it achieved acclaim from critics and public alike.

It was characteristic that after this initial success he remarked "That is the last picture of its kind I will ever paint." It occurs to me now that he (like many of us) had become conscious of the new art from Europe shown in 1913, at the first Armory Exhibition.

Such books as Roger Fry's eulogies on Cézanne and articles by Clive Bell, who popularized the term "significant form," were being published and were ushering in a new day. Even at this time Rosen was considering form in relation to "warm and cool colors," and lost and found edges, all of which contributed to intensify the "illusion of space" on a flat canvas. Abstraction for him gained a new importance.

Charles Rosen's accomplishment was the product of artistic thinking always based on a genuine love of nature and man. In his own time he made a valuable contribution to American art.

John Folinsbee
New Hope
Bucks County
Pennsylvania

Appendix 5

The Lineman: *Image and Commentary*

Text courtesy of the Charles Rosen Papers, Archives of American Art, Smithsonian Institution

The Lineman

A cloudburst had made it impossible for me to keep my appointment with Charles Rosen, famous American landscape painter, in New Hope, Pennsylvania. This was in 1918 when I was art editor of the Cincinnati Enquirer and was writing a series of articles about America's foremost painters. Rosen had won medals at Pittsburgh's Carnegie Institute and the San Francisco Exposition, also the $1,000 Altman Prize at the New York Academy of Design, and the $500 Shaw Prize given by the New York Salmagundi Club. Three of these awards were for the artist's characteristic, brilliantly painted Delaware River scenes in winter.

When I eventually reached the artist's studio the subject of the large canvas on his easel was quite different. Against storm clouds and swaying trees a linesman was seen high up on a telephone pole working away at this dangerous type of repair work.

"I stood at the window looking into the storm," said Rosen, "with the wind and rain trying to break the glass, when I saw a little flivver bravely chugging up the road. Abruptly it stopped and out came a repairman loaded with wire and tools. Seemingly undisturbed by the raging elements he climbed like a monkey up the pole. For a while I was fascinated watching a superb professional at work. Then intuitively I placed a bare canvas on my easel and rapidly recorded the whole powerful scene. Well, here it is, what you might call a hymn to a linesman."

[*Note:* An attempt was made through sources in Cincinnati to determine the author of this appendix, without success.]

Charles Rosen
The Lineman, ca. 1918
medium, size, and location unknown
Photograph courtesy of Peter A. Juley & Son
Collection, Smithsonian American Art Museum

Appendix 6

Rosen "Drawing Lesson"

Transcribed by Katharine Worthington-Taylor from a letter sent to her in 1939 by her grandfather, Charles Rosen,

when she was ten years old (sent with a box of pastels for Christmas)

This is a drawing lesson for a KITTEN:

It is not *HOW* TO DRAW. It is just *ONE WAY.* You will notice that it is not just *outlines* filled in very carefully and neatly with color. The color is allowed to "spill" over the edges, and you will also notice that no great care has been taken to draw too accurately. I mean by that that the leaves and flowers don't look too much like real ones.

But you will also notice that a lot of care was taken to make good looking "shapes"—to get them nicely distributed on the page—that care was taken to get colors nicely placed and in the right quantities (sizes).

Thought was given to textures—by that I mean rough and smooth—lines and sharp angular (hard) ones.

Everything that was done was just so that it would be nice to look at.

Maybe you don't think it is!

I do!

You might try to make a drawing by putting the color on first—you can make the "lines" in color as well as in black—

I love you—"Granddaddy"

When you do one—send it to me!

Rosen still life and "drawing lesson" sent to his ten-year-old granddaughter Katharine ("Kit"). Note that the drawing in the upper right is a version of plate 80, page 157. Courtesy of Katharine Worthington-Taylor

Appendix 7

Charles Rosen and the Juried Exhibits: Art Institute of Chicago, Carnegie Institute, Corcoran Gallery of Art, National Academy of Design, Pennsylvania Academy of the Fine Arts, Panama-Pacific International Exposition, 1915

Prepared by Birgitta H. Bond

The Annual Exhibition Record of the Art Institute of Chicago, 1888–1950		Record of the Carnegie Institute's International Exhibitions, 1896–1996	
1905	*Midsummer*	(* indicates an award-winning entry)	
	A Limestone Ledge	1904	*The Safe Movers*
	Old Barn, Spring	1905	*March Morning*
1906	*Late Sunlight, Lambertville*		*Spring Morning*
	Old Sycamore	1907	*The Grey River*
1907	*The Creek, Winter*		*A Winter Day*
	A Winter Day	1908	*Below the Dam*
1908	*October Afternoon*	1909	*The Freshet*
1910	*Wind Tossed Sycamore*	1910	*The Apple Tree*
1911	*The Farm, Frosty Morning*		*Old Sycamore, Winter*
	Along the Delaware	1911	*The Farm, Frosty Morning*
1912	*A Rocky Ledge*		*September Evening*
1913	*A Winter Morning*	1912	*Frozen River, Winter Morning*
1914	*The Mouth of the Creek*		*The Lineman*
1915	*Icebound River*	1913	*A Winter Morning**
	Wind-blown Trees	1914	*Bluff Point*
1916	*Autumn Tangle*		*Icebound Coast**
1917	*Winter Sunlight*	1920	*The Ravine*
1918	*The Island*	1921	*Small Town*
1919	*Hills and River*		*Under the Bridge*
1924	*Old Saw Mill*	1922	*The Iron Bridge*
1925	*Group of Houses*	1926	*Fireman's Hall*
1926	*The Roundhouse*	1927	*Red Bridge*
1928	*Rondout Bridge*		*The Roundhouse*
1930	*Derelicts*		*Vosburg's Mill*
1936	*Quarry and Crusher*	1930	*Sully's Mill*
			Tug in Drydock
		1931	*Cliff Dwellings*
			River Boat
		1933	*Ponckhockie Steeple*
		1934	*Quarry Hill*
		1935	*Quarry and Crusher*
		1936	*Trees*
		1937	*Hudson River Landscape*

Rosen with fellow jurors, Carnegie Institute, 1931. Courtesy of Charles Rosen Papers, Archives of American Art, Smithsonian Institution

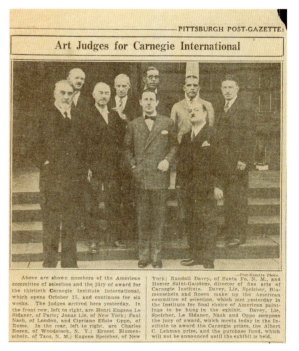

PITTSBURGH POST-GAZETTE

Art Judges for Carnegie International

Above are shown members of the American committee of selection and the jury of award for the thirtieth Carnegie Institute International, which opens October 15, and continues for six weeks. The judges arrived here yesterday. In the front row, left to right, are Henri Eugene Le Sidaner, of Paris; Jonas Lie, of New York; Paul Nash, of London, and Cipriano Efisio Oppo, of Rome. In the rear, left to right, are Charles Rosen, of Woodstock, N. Y.; Ernest Blumenschein, of Taos, N. M.; Eugene Speicher, of New York; Randall Davey, of Santa Fe, N. M., and Homer Saint-Gaudens, director of fine arts of Carnegie Institute. Davey, Lie, Speicher, Blumenschein and Rosen make up the American committee of selection, which met yesterday in the Institute for final choice of American paintings to be hung in the exhibit. Davey, Lie, Speicher, Le Sidaner, Nash and Oppo compose the jury of award, which meets today in the Institute to award the Carnegie prizes, the Albert C. Lehman prize, and the purchase fund, which will not be announced until the exhibit is held.

1938	Saugerties Night Boat					
1939	Hill Town					
1940	Blacksmith Shop					
1943	Town Hall					
1944	Villita Water Works					
1945	Scow in Dry Dock					
1946	Derelicts					
1947	Rondout					

Biennial Exhibition Record of the Corcoran Gallery of Art, 1907–1967

1907	Snow Patched Meadows
1910	Along the Delaware
1912	Old Quarry—October
1914	Wind-blown Trees
	Icebound Coast
1916	Along the Canal
	Spring Breeze
	Becky's Point
1919	Old Willow
1928	Eddyville
	The Roundhouse
1930	Ship Yard
1932	Church Street
	Crane House
1935	Tannery Brook
	Tug Boats
1937	Quarry Hill
1939	Trees
1943	Town Hall

The Annual Exhibition Record of the National Academy of Design, 1901–1950

(* indicates an award-winning entry; "W" indicates winter exhibition)

1903	Late Sunlight
1905	Spring Day: Union Square
1906	A Limestone Ledge
	A March Day
1907	The Creek, Winter Morning
	Creek through Village
	Floating Ice
1907W	Mill Race
	Frosty Morning
1908	The Freshet
	Old Willow Tree

1908W	Below the Dam
	Along the River
1909	Old Willow: Winter
	The Sycamore
1909W	Clearing after Rain
	Old Sycamore: Spring
	Morning after the Snow
1910	Old Willows
	Summer Breeze*
	Winter Evening
1910W	September Evening
1911	Along the Delaware
	A Shaded Bank
1911W	Misty Spring
	The Grey Quarry
1912	A Rocky Ledge*
1912W	The Hanging Branch
	Shore Ice: Early Morning
1913	Floating Ice, Winter Morning
	The Lineman
1913W	First Snowfall
	The Mouth of the Creek
1914	Sun and Mist
	Winter Morning: Maine Coast
1914W	The Farm: Winter
	September Morning: Sun and Mist
1915	Old Willow Tree
	Icebound River
1915W	Autumn Tangle
	Coast of Cape Elizabeth
1916	Tangled Trees
	Winter Sunlight*
1916W	An Autumn Day
1917	Brook and River
1917W	The Island
	Hillside
1918	The Grey Channel
	The White Hill
1918W	The Brook: Autumn
1919	Hills and River
1920	Opalescent River
1921	Old Houses
	The Iron Bridge
1921W	Small Town
1922	The Railroad Bridge
1947	Derelicts

The Annual Exhibition Record from the Pennsylvania Academy of the Fine Arts: vol. II, 1876–1913, and vol. III, 1914–1968

1904	A Spring Day
1905	The Workers
	The Safe Movers
1906	Driftwood
	March Morning
	Washed-out Bottomland
1907	The Old Mill: Winter
	Creek through the Village
	Late Sunlight: Lambertville
	October Afternoon
1908	Golden Glow
	The Thunderhead
	An Old Quarry
	Before Sunrise
	A Winter Day
1909	A Spring Freshet
	A Clear Evening
1910	The Apple Tree
	Autumn Afternoon
	Old Sycamore: Winter
1911	Winter Grays
	The Farm, Frosty Morning
1912	The Frozen Delaware
	Gray Quarry
1913	The Highroad
	First Snowfall
1914	Autumn Breeze
	Early Morning
	A Winter Morning
1915	The Farm: Winter
	September Morning: Sun and Mist
	Wind-blown Trees
	Bluff Point: Maine Coast
	The Mouth of the Creek
1916	Late Afternoon
	Autumn Tangle
	The Brook: Autumn
1917	From Shore to Shore
	Windy Day
1918	Hillside
	A Group of Trees
	Autumn Sunlight
	September Day

1919	Spurwink Point
	Opalescent River
1920	Apple Tree
	A Sunny Morning
1921	Midsummer
	The Ravine
	Ice Patterns
1926	Short's Corner
	A Group of Houses*
1929	Saugerties Landing
	The Shipyard
1930	Vosburg's Mill
1931	Town Hall
1932	Crane House
	Church Street
1933	Spring
	Village Houses
1934	The Yellow House
1935	Rondout
1937	Trees
1939	Two Tugs
1941	Sully's Mill

Panama-Pacific International Exposition, 1915

Charles Rosen
Silver Medal
The Delaware: Winter Morning
Floating Ice, Early Morning
Winter Morning: Maine Coast

Appendix 8

Selected List of Honors and Awards

Compiled by Birgitta H. Bond

1898	The Suydam Bronze Medal, Night Class, National Academy of Design, New York
1900	The Silver Elliot Medal, Life School, National Academy of Design
1910	Third Hallgarten Prize, National Academy of Design: *Summer Breeze*
1912	First Hallgarten Prize, National Academy of Design: *A Rocky Ledge*
	A.N.A. (Associate National Academician), National Academy of Design
1914	Shaw Purchase Prize ($500), Salmagundi Club, New York
	Honorable Mention, Carnegie Institute, Pittsburgh: *Icebound Coast*
1915	Silver Medal, Panama-Pacific International Exposition, San Francisco: *Floating Ice, Early Morning;*
	Winter Morning: Maine Coast; The Delaware: Winter Morning
1916	Inness Gold Medal, National Academy of Design: *Winter Sunlight*
	Altman Prize, National Academy of Design ($1,000)
1917	N.A. (National Academician), National Academy of Design
1925	First Prize, Columbus Art League, Ohio
1926	Jennie Sesnan Gold Medal, Pennsylvania Academy of the Fine Arts (awarded for best landscape):
	A Group of Houses

Professional Associations

National Arts Club

American Society of Painters, Sculptors, and Engravers

Salmagundi Club

Juries

Art Institute of Chicago: Juror, 1908, 1917

Carnegie Institute: Juror, 1931

National Academy of Design, Jury of Selection: 1915–18, 1920, 1925

Pennsylvania Academy of the Fine Arts: 1916, Painting Juror; 1920, Painting and Hanging Juror

Two medals awarded to Charles Rosen by the National Academy of Design. Courtesy of Katharine Worthington-Taylor

Index

197